AVIATION

A HISTORY THROUGH ART

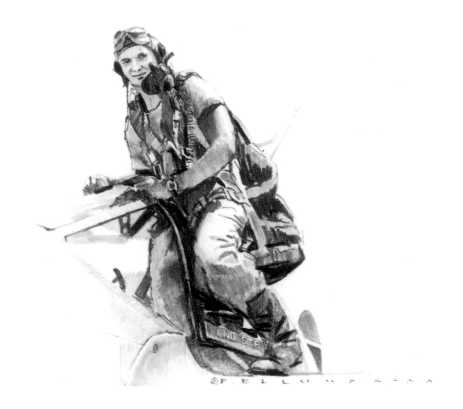

P-38 PILOT by Jack Fellows.

To the memory of Bob Cunningham.

Designed by Hilde G. Lee, Hildesigns. Jacket design by Carolyn Weary Brandt.
Edited by Melissa E. Barranco, Claudia J. Garthwait, and Ross A. Howell, Jr.

Library of Congress Catalog Card Number 92-53121
ISBN 0-943231-55-8

Printed and bound in Hong Kong.

Published by Howell Press, Inc., 1147 River Road, Bay 2,
Charlottesville, VA 22901, telephone (804) 977-4006

First Printing

AVIATION
A HISTORY THROUGH ART

INTRODUCTION BY WALTER J. BOYNE

TEXT BY PHILIP HANDLEMAN

PAINTINGS FROM
THE AMERICAN SOCIETY OF AVIATION ARTISTS

HOWELL PRESS

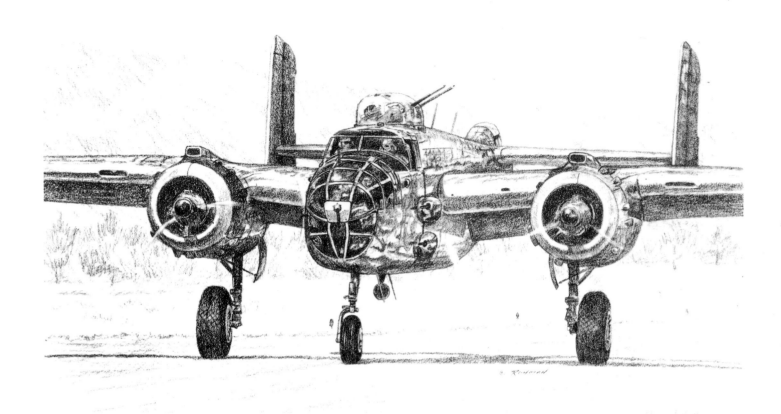

AIRSHOW B-25 by Rick Ruhman.

Acknowledgements

This important project showcases the artwork of the members of the American Society of Aviation Artists. It would never have progressed beyond the discussion stage were it not for several helpful individuals.

Publishing executive Carl Apollonio, an avid flier, possessed the vision to see the possibilities for this idea and gave the crucial first affirmative nod. Former U.S. Air Force pilot Walter Boyne, consummate gentleman, erudite historian, and exemplary leader, interceded at numerous critical junctures to keep the dream from petering out. His introduction to this book provides exquisite insight into the origins of today's aviation art. Aviation artist Mike Machat, inexorably imbued with the boyhood fascination of flight, volunteered so much time and exerted so much effort that words can hardly express my gratitude.

Publisher and editor Ross Howell believed in the concept as strongly as anyone. His willingness to proceed in a way that ensured the employment of uncompromisingly high standards is a tribute to him.

Philip Handleman

Contents

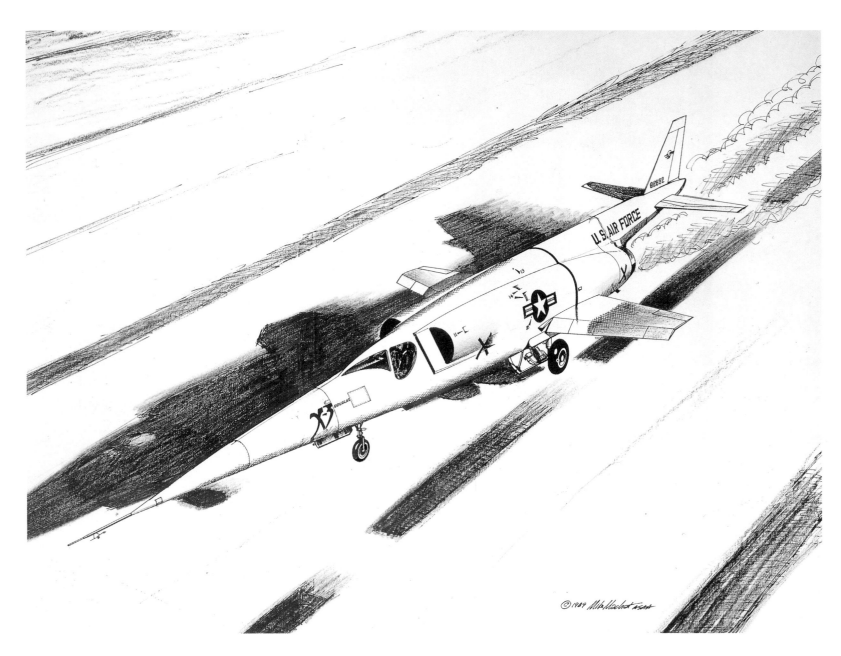

DOUGLAS X-3 by Mike Machat.

Preface

by Mike Machat
American Society of Aviation Artists

As the representative of the American Society of Aviation Artists, it is my privilege to welcome you to this exciting and unique collection of America's finest aviation art. Through these pages, you will meet our members and discover the range and scope of aviation art in America today.

The core of ASAA is composed of America's most accomplished aviation artists, many of whom are renowned for having produced some of the most famous and award-winning works of art depicting aircraft and the men and women who make them fly. Our founding members, Keith Ferris, Jo Kotula, Bob McCall, R. G. Smith, and Ren Wicks, banded together more than six years ago to form an organization dedicated to affirming the standards of craftsmanship and authenticity in aviation art and to seek a wider understanding and recognition of our craft as a fine art genre.

The society has grown from an initial charter membership of twenty-five dedicated professionals to more than 125 artists who share a love of flight. As you read and enjoy the pages of this book, you will notice that there are no restrictions to the choices of era and subject matter. From the early biplanes of World War I, through the "Golden Age" of barnstorming, on into the technological explosions of World War II, supersonic flight, space travel, and today's "Stealth" aircraft, we have shown through our artwork the rapid and expansive evolution of all facets of aviation.

You will also notice the wide range of techniques and styles represented by the thirty-two artists chosen to be in this book. It is through this variety of approaches that each artist achieves a fresh and totally personal way of conveying his or her message about aviation. Whether it is the song of the wind through the struts of a biplane or the turbine whine of a modern jet, the sounds of flight almost spring from these pages as each visual image captivates the viewer with convincing believability.

The makings of an aviation artist bear some examination as well. Notice in the biographical sketches that many were inspired at an early age to pursue their dreams of depicting flight. Perhaps a parent, relative, or friend was involved in aviation and provided both the exposure and spark that launched a career. Youthful, fun-filled years of model building, airplane books, movies, and magazines surely followed, as childhood sketches led to more professional-caliber artwork. Many of these artists are pilots as well, enabling themselves to "live the experience" of the sky, and bring their personal moments of flight to the canvas.

On behalf of the ASAA, I invite you to enjoy the many images of flight within these pages. Each and every artist has spent a lifetime building the skills with which to convey, through art, the beauty, drama, and excitement that is aviation. This book is the very first compilation of works by members of the ASAA. They represent the best that American aviation art has to offer.

Introduction

by Walter J. Boyne

One of the most popular periods of aviation history is the Golden Age of Flight. While not everyone agrees upon the exact period when the Golden Age occurred, all agree that it characterizes a time when airplanes matured from a functional gawkiness to a pure aesthetic beauty.

This comprehensive, well-selected collection of paintings, wonderfully integrated by Philip Handleman's excellent text, proves beyond a shadow of doubt that *aviation art* is entering its own golden age, where rising public acceptance is matched by the ever-increasing levels of skill and taste of the artists themselves. It is fair to say that a book of this uncompromising quality, with its combination of diversity, accuracy, and artistic skill, could not have been done in this country even ten years ago.

With few exceptions, aviation art labored for decades under the unkind and often untrue critical categorization of "illustration." In the past ten years the situation has changed dramatically, with veteran artists at last receiving proper recognition in the galleries and in the marketplace. More importantly, they have provided younger artists entering the field with high standards to match.

Ironically, in a culture which demands total freedom of expression, there is a reluctance to accept certain subjects as meriting artistic rendition. The Western art of Frederic Remington was for years sneered at by critics and gallery owners alike—a situation which was unexpectedly favorable for the collectors of Western paintings at the time, for now Remington and his peers are highly valued. An early member of the Hudson River school, Thomas Cole,

was at first similarly undervalued, but through participation with the Art Union, his paintings gained popularity and paved the way for the great success of Albert Bierstadt and others. Then, as now, for some unknown reason, the experts took exception not to the paintings but to the subject matter.

Perhaps there's something to be learned from the past, from the Artist's Union. The name is somewhat deceptive—it wasn't a trade union of artists but rather an organization for those interested in art. In the middle of the nineteenth century, when our nation was truly roughhewn and growing, the Artist's Union had nearly twenty thousand paying members. For their membership dues they received many things, including newsletters and the opportunity to attend art shows and buy prints. And they received something that would have tremendous appeal today, a lottery ticket for which the prize was an original painting.

In stark contrast to this almost random rejection of subject matter, one can find among the stunning masterpieces of the Louvre paintings of subjects with no apparent intrinsic interest—gutted game, glaucous-eyed dead fish, and arrays of cups and saucers. They may indeed be admirable examples of the artist's skill, yet they are far from stimulating themselves. Why then have aviation subjects, which are far more central to our lives and certainly of greater intrinsic beauty, been proscribed automatically as "illustration"?

The problem might be that aviation art is the only art that was conceived thousands of years before its subject's birth; poets spoke of flying and artists

depicted it for millenniums before the Wright brothers' first flight in Kitty Hawk in 1903. Could it be that this long contemplation of the ethereal delights of flying inhibits a critic's enjoyment of its portrayal? That would be reasonable, even encouraging. Another possible rationale is that critics might feel a knowledge of flying is necessary in understanding aviation art. This is possible, but I think that there is a more visceral element—critics may dislike the portrayal of flying because they, like many others, dislike or fear the concept of flying itself.

We should first understand, however, that by its very nature aviation is perhaps the most difficult of all art subjects. It requires that an object naturally enhanced by the fluidity of its motion be stopped in an instantaneous representation which captures all of its mobile grace. More demanding is the need to convey humanity in a mechanical and often threatening device, rising from illustration to art, to make the viewer *know* that there is heart and soul in the event depicted. Perhaps even more difficult to understand is that the subject of aviation art is an art form itself. The art of *painting* flying is secondary to the art of flying itself, even in the minds of most of its practitioners. This distinguishes aviation artists from others.

To illustrate, Edgar Degas painted ballerinas without being a dancer; Henri de Toulouse-Lautrec, an aristocrat, painted dancers of the demimonde. But in neither instance did Degas or Toulouse-Lautrec have to do what aviation artists do routinely— submerge themselves in the mechanics of another discipline, flying. Few other breeds of artists must so deeply immerse themselves in the complexity of the subjects they are painting. Like all artists, aviation artists must be conscious of their subject's reaction to lighting, shadows, and shade, but they must also be able to bring to life the scintillating factors of speed,

height, and even gravity—all indefinable elements immensely difficult to capture with pen or brush.

To elaborate, and without in any way diminishing the artistry of Degas, he, in his luminescent portrayal of ballet dancers, never had to face a problem as difficult as portraying two aircraft—hard mechanical objects arrayed one hundred meters apart in space, their speeds differing as they close, the sun glinting across their skins at precisely different angles, the very air incandescent with the fury of their passage. And *because* of the essential humanity of Degas' subject, he did not have to illuminate a mechanical object with human purpose, an airplane hurtling across an inexhaustible sky at hundreds of miles per hour. Even M. C. Escher, that master of perspective, never dealt with a problem like the portrayal of two aircraft locked in combat, their angles shifting constantly, their contained energy spilling with each spinning degree of a roll.

Yet art preceded man's flying by many centuries. In every representation of a bird, a kite, a winged dragon, ancient artists presciently depicted what was to come. The legends of winged horses, of men drawn to the moon by flasks of dew, of eagles' feathers attached to muscular arms by wax, all hearkened to the future when man would in fact fly.

The first authentic portraits of flight— done by artists painting what they had actually seen— came with the hot air balloon, which grandly lent itself to colorful representation. No labor expense was spared, and the early balloonists immediately grasped the importance of combining art with flight. The results were great colorful balloons which were huge (eighty meters in diameter), exciting, laced with every element of danger, and nobly decorated. No wonder the lithographers of Europe seized upon every launch, every flight, to portray a Tennysonian heaven filled with balloons. And contemporary entrepreneurs were quick to interpret the potential

economic role of balloons. The result was an international "balloonomania" in which table services, silverware, furniture, and even dresses used a ballooning motif.

And yet as popular as ballooning was in all its forms, it was ignored by the great painters. We find no "masterpieces" that feature anything so exotic as a balloon in flight. Why, when Joseph M. W. Turner's ships, lurking in the gauzy seaboard light, turned the heads of Europe, when Adolphe Bouguereau won medals with saccharine sexuality, when Jacques Louis David obsequiously and retrospectively painted Napoleon's coronation, and when Rosa Bonheur's horses captivated critics, did none of the great painters wish to portray a view of a balloon from the ground or an image of the world from the air?

The situation did not change markedly with the advent of the aircraft. There was one great master, Henri Farre, a war artist who captured the emotive beauty of flight in a way that still evokes a heartfelt response from the viewer. Farre still has much to teach us; his aircraft portrayals were not clinically accurate but their creamy white wings, torn by their passage through the air, capture the spirit of speed and motion in a way that still eludes many.

After Farre, aviation art was stagnant. Two great sculptors emerged whose works evoked images of flight: Constantin Brancusi, immortal with his *Bird in Space*, and more recently John Safer, who has executed a whole series of air- and space-related sculptures. But conventional artists tended to dwell on the aircraft as the subject of the painting, forgetting that the shell of canvas and wood and the sleeve of metal that is the airplane is not the reason for a painting. It is instead the employment of that airplane, the man or woman doing the flying, and the moment in time when this human/airplane combination speeds towards its goal that is important.

There were exceptions. Charles Hubbell attained popularity with his portrayals of the Thompson Trophy racers, but his paintings still did not achieve acclaim in galleries or in art magazines. Instead they were considered calendar art, disposable paintings aimed at the buff.

Things began to change with the recognition of emerging major talents such as Frank Wootton, who would soon be followed by many others. Yet the process was slow. A number of artists were doing extraordinary work yet were only gradually getting the recognition they deserved. The problem was not their painting, it was their subject matter. No matter how beautifully executed, meaningful, or inspirational their images were, the fact that they were painting airplanes automatically discounted their work. There was a similar phenomenon with automobiles, where only the surrealists gained any renown.

But talent cannot be denied, and a number of extraneous events occurred to facilitate recognition. Perhaps most importantly, the general level of affluence increased and the purchase of a painting, print, or lithograph was not so difficult, nor so relatively expensive, as it once had been. Aviation artists banded together on both sides of the Atlantic and began to arrange art shows. The military services had long employed combat artists and one of the great influences on the expanding art market was the Air Force Art Program, brought to a high level of competence and service under the gentle guidance of Alice Price.

Of all the great traditions of art, the artist starving in a garret is the one that came most easily to the aviation scene. For many years it was simply impossible for an artist to follow his craft on more than a part-time basis. "Keep your day job" was not a jest but a credo. One of the greatest boosts came

under the entrepreneurial guidance of business men and women who recognized that the work merited intelligent, aggressive marketing. They realized that the combination of excellent artistic effort with symposia on the war heroes represented would draw both crowds and customers. In linking wonderful artwork with living, genuine heroes, they facilitated the sale of high-quality, limited edition prints. Their pioneering efforts helped the market to bloom and to boom.

Coincidental with this new phenomenon—the possibility of making a living as an aviation artist—came an understanding among the artists themselves which was central to bringing aviation art into the mainstream. They realized that regardless of how much they and the hard-core buffs loved the subject matter, their paintings had to transcend rendering a supremely accurate representation of an aircraft. They had in fact a harder task—to render paintings which would be reviewed on their artistic basis irrespective of the airplanes being portrayed.

This did not represent a change in the artists' love affair with airplanes, which would always remain as a central element of their work, but it did represent a shift in viewpoint, a consciousness that they were no longer painting for themselves and for the initiated. They were instead thrusting into the formerly closed circles of the art world, which were cruel, critical, and demanding.

Demanding as it is, this new venue is also promising, for it gives aviation artists a chance to exercise their talents and explore new techniques. Why can there not be impressionistic or surreal representations of aircraft and aviation subjects? Much of flying is impressionistic—the glorious feeling at the instant you slip through a cloud layer, the multicolored haze of a breaking dawn, the incredible panorama of lights of a city at night. And, the good Lord knows, there are moments when flying is suddenly surreal—the sickening realization that you are lost, out of fuel, or have just had a near miss.

Let me return to another exacting element—the task of breaking through the barrier of criticism with education. I alluded earlier to the possibility that the refusal of critics to accept aviation art might be because of their fear and lack of knowledge of the subject. I believe that if a concerted effort is made to expose the critics to real flying, to get them to air shows and to bring them to symposia, a general turn around could be effected that would thrust aviation art into the mainstream. Because the art world is now looking in at aviation art, aviation artists must reach out to that world with every means at their disposal.

And yet as I glance over the paintings in this marvelous book, I realize that nothing else may be necessary to achieve that turnaround, for the artists represented here have such talent that they cannot long be denied, and their success will pave the way for others.

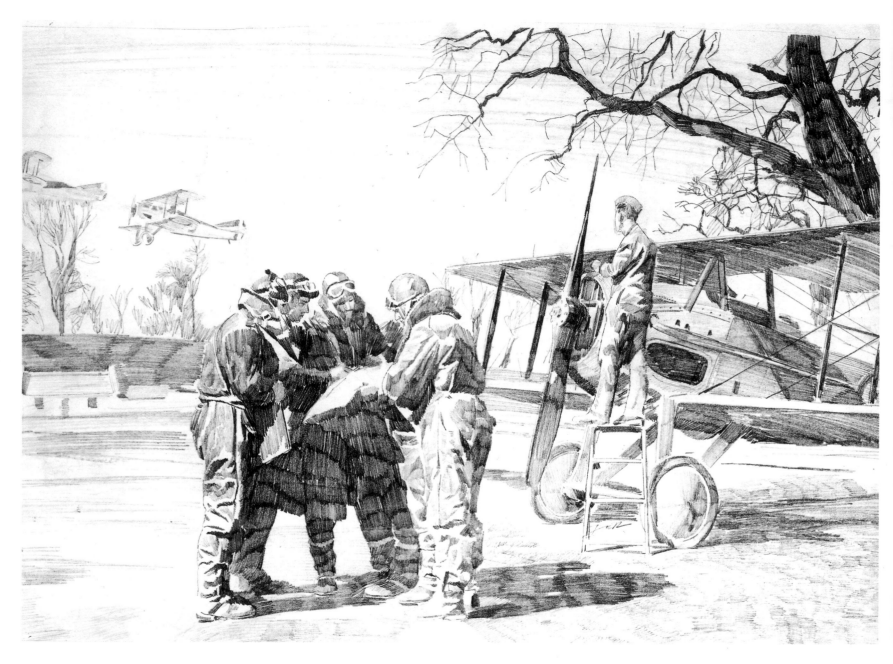

SPAD/PILOTS by Jim Dietz.

12

World War I

As the twentieth century opened, the sky ceased to be the exclusive domain of birds, balloonists, and dreamers. With the Wright Brothers' momentous achievement one blustery December day in 1903 at Kill Devil Hill, North Carolina, man's view of the vast ocean of air would never again be the same. Europeans, fascinated by this remarkable invention that allowed powered flight, pursued myriad refinements. By the next decade Europeans had assumed leadership in the burgeoning discipline of aeronautics. The airplane's noble promise gave way in a swirl of geopolitics to a quest to maximize its destructive potential.

Three years before the outbreak of World War I, the airplane received its baptism of fire as Italy employed small numbers of fragile aircraft in its conquest of Libya. When war finally embroiled Europe, airplanes were at first assigned mainly scout duties. In the course of such missions, passing over enemy lines, the reconnaissance pilots encountered the enemy's observers in the air. Much has been written about the mutual accommodation between the aerial adversaries in these early days of military flying. But before long, the pilots from opposing sides ceased to be courteous as they cruised over the bleak landscape of battle where their comrades were locked in mortal combat below. Instead they began to take aim, at first using ordinary sidearms to eradicate their foe from the sky.

Progressive enhancements in armament made the airplane an increasingly formidable weapon. The airplanes, primarily wood and fabric affairs, underwent a noticeable transition in performance characteristics like speed, climb rate, and maneuverability. Nevertheless, the intrinsic limitations of the prevalent technology rendered World War I airplanes demanding to fly and generally unreliable. A fighter pilot in the war would not uncommonly face as much trouble from his machine as from the enemy.

With the state-of-the-art models so rudimentary, lead times for implementing innovations were short. When improvements such as airframe streamlining, increased engine power, and synchronized machine guns were introduced to aircraft in operational squadrons, the advantage in air fighting shifted back and forth, depending on which side held the technological edge at the moment. Sometimes sheer quantity of aircraft or the level of training received by the pilots dictated who exercised the initiative in the seesaw air warfare of World War I.

Despite the many drawbacks imposed by the hardware, it was in this first great air war that basic fighter tactics were established. Pilots learned to attack with the sun to their back. Maneuvers such as the Immelmann turn were developed, adding to the fighter pilot's repertoire. Amazingly, even with the tremendous strides in aerodynamics and electronics since that time, the air combat precepts of World War I retain much of their validity to this day.

World War I also fostered an institution—the air combat ace. The stuff of legends, these skillful and reportedly fearless pilots were rewarded with celebrity status for knocking a specified number of enemy aircraft out of the sky. They became national heroes, lionized by their countrymen, the highest scoring known by name to all schoolboys.

Visit from the Brass

by James Dietz

At an airfield in France, pilots of the Royal Flying Corps No. 19 Squadron are visited by a staff officer who has just arrived in his chauffeur-driven Rolls-Royce. Undoubtedly, they are discussing the results of recent flights, as well as plans for the upcoming morning mission at this impromptu meeting. The pilots, with maps in hand, are already in their full leather-lined flight suits.

During 1916 and 1917, No. 19 Squadron flew the SPAD VII, which was powered by a 150-horsepower Hispano-Suiza water-cooled engine. Designed by Louis Bechereau of *Société pour Aviation et ses Derives*, the fighter could achieve a very respectable top speed of 120 MPH. Later models of the SPAD, with a higher horsepower version of the advanced Hispano-Suiza engine, could fly even faster. Armament of the SPAD VII consisted of a single fixed Vickers machine gun.

The opinionated leader of the RFC, Sir Hugh Trenchard, believed in denying the enemy the initiative. This meant throwing up masses of airplanes over enemy lines, even when the continually shifting technological balance favored the Germans. At times the sacrifice was high, but the strategy, backed by the Anglo-French aircraft industry's resilient productive capacity, prevailed. On April 1, 1918, the RFC and its naval equivalent, the Royal Naval Air Service, controlled by the War Office and the Admiralty respectively, were combined into a single organization, the Royal Air Force. Trenchard, the towering advocate of air power, became its first chief of Air Staff.

James Dietz

Following graduation from the Art Center College of Design in Los Angeles, Jim embarked upon a career as a commercial illustrator, eventually settling in Seattle and specializing in aviation art. Not content merely to portray the hardware of flight, he introduces the human element into his aviation paintings so that the important interaction between man and machine is revealed. He is active in both the Air Force and Navy Art Programs. His artwork has been exhibited in the Smithsonian Institution's National Air and Space Museum, the San Diego Aerospace Museum, and the Experimental Aircraft Association's Air Adventure Museum. He and his wife, Pattie, reside in Seattle.

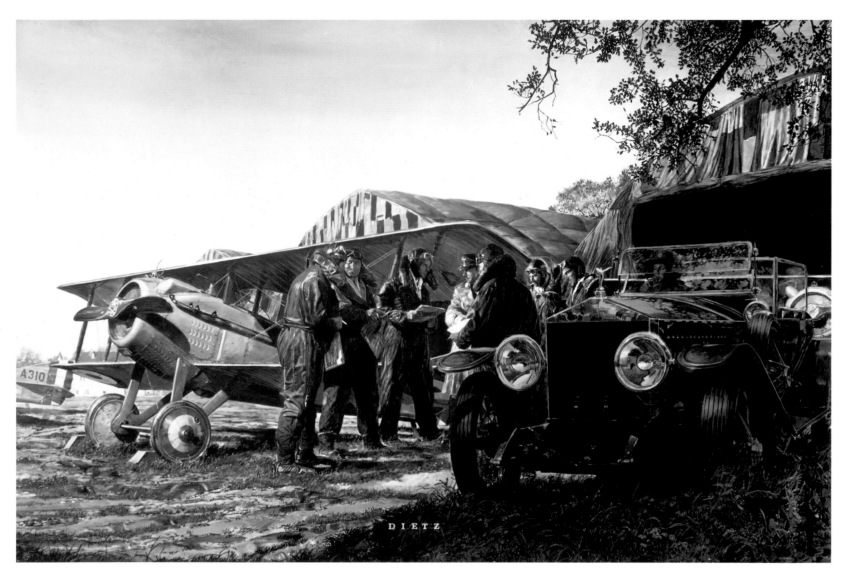

VISIT FROM THE BRASS by James Dietz, oil, completed 1987, private collection.

Man without Fear

by Merv Corning

There was little in his early life in Owen Sound, Ontario, to suggest that William Avery "Billy" Bishop would become a successful fighter pilot. At Canada's Royal Military College he was such a poor, undisciplined student that his instructors called him "the worst cadet RMC ever had" and were on the verge of dismissing him when war erupted. When shipped to England in 1915 as a lieutenant in the Seventh Canadian Mounted Rifles, he so detested life at the Shorncliffe military camp that he soon requested a transfer to the presumably less austere Royal Flying Corps. Accepted into the RFC as an observer, Bishop eventually went through pilot training.

Bishop, it turned out, possessed many traits beneficial to a combat pilot—keen eyesight, sharp reflexes, and good marksmanship. By Easter Sunday, 1917, less than two years after Bishop had arrived in England as a disenchanted cavalryman, he had become an ace.

Noted for his aggressiveness in combat, Bishop constantly took the initiative, never waiting for the enemy to come to him. The leading American ace of World War I, Eddie Rickenbacker, once remarked, "Bishop was the raider, always seeking the enemy wherever it could be found . . . I think he's the only man I ever met who was incapable of fear."

On June 2, 1917, a lost Billy Bishop, flying his silver Nieuport, had strayed far across enemy lines. When he got his bearings he went looking for a fight. He came upon Estourmel Aerodrome near Cambrai, depicted in this image by Merv Corning. He immediately began strafing the exposed Albatros scouts, trying to demolish as many as possible before they could get airborne and harass him. He got two just as they were taking off and a third in a dogfight. Low on ammunition, he sped away after scaring off a fourth Albatros.

In less than six months on the front he had fought in over 170 aerial engagements and achieved seventy-two victories, becoming Canada's highest scoring ace ever. Three years after his near expulsion from the RMC, Bishop returned to the campus wearing the Victoria Cross, the Distinguished Service Order, and the Military Cross, having been the first man ever to receive all three of the British Empire's highest military awards in a single ceremony.

Merv Corning

During World War II, Merv served in the Merchant Marines where he received his first commissions sketching his shipmates' sweethearts at five dollars a portrait. During his prolific commercial illustration career, he created a remarkable series of forty-four paintings depicting noteworthy World War I aerial engagements. While these paintings gained much recognition in the aviation art world, he is perhaps best known as the official artist for the National Football League Super Bowl from 1977 to 1982. Devoted primarily to fine art painting since 1968, he has had his work exhibited in the National Portrait Gallery, the Smithsonian Institution's National Air and Space Museum, the Air Force Museum, and the Pentagon. He and his wife, Tula, reside in Solvang, California.

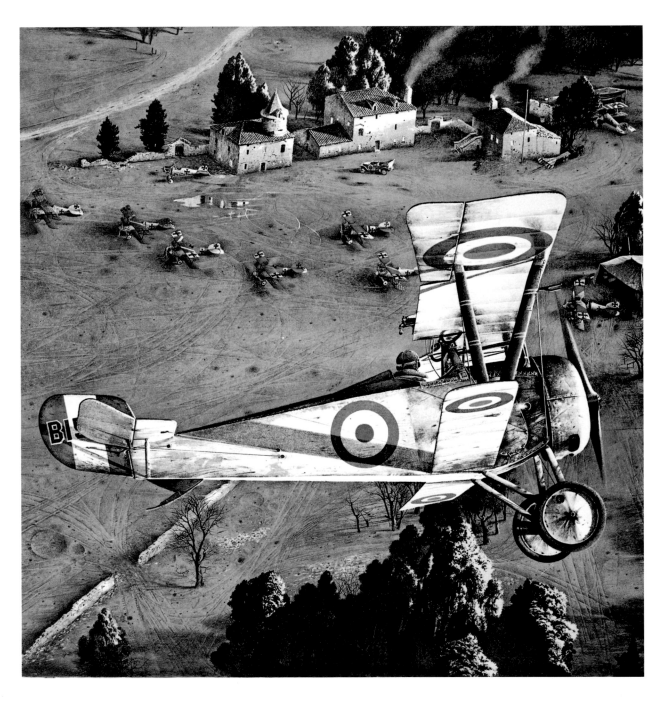

MAN WITHOUT FEAR *by Merv Corning, watercolor, completed 1978, private collection.*

The Circus Rolls at Dawn

by James Dietz

Born into an aristocratic Prussian family, Manfred von Richthofen enjoyed a charmed youth, growing up on family estates and gaining exposure to hunting and riding. He was titled *Freiherr*, which translates loosely into Baron. He entered the war as a cavalryman, but the mud and stench of the trenches prompted him to request a transfer into the air service. After his initiation as an aerial observer, he made a shaky start at piloting. But under the watchful tutelage of the famed German ace and air tactician Oswald Boelcke, he soon began to prove himself as an outstanding fighter pilot.

Here, depicted by James Dietz, the bright red Albatros D Vs of Jasta 11, commanded by Rittmeister (Captain) Manfred von Richthofen, eagerly depart from a dew-moistened airfield on a summer morning in 1917. The dawn patrol hopes for an encounter with intruding airplanes along the border.

During World War I the European aircraft industries on both sides made considerable strides in the refinement of the airplane as a weapon. The Albatros D V represented a logical progression from earlier models. Known for its expansive middle section, the fuselage tapered to a slightly bulbous spinner on the nose and to a streamlined tail section. It was powered by the 160-horsepower Mercedes D III engine which provided for a top speed of comfortably over 100 MPH. Twin Spandau machine guns gave the ship its firepower.

It was on July 6, 1917, that von Richthofen, already an ace many times over, came close to his death. Maneuvering against a two-seat British pusher, the famed German flier, mistakenly thinking himself too distant to be hit by the gunner in the opposing plane, was suddenly knocked senseless by a bullet, causing a gashing head wound. Temporarily blinded, von Richthofen shut off his engine and the Albatros D V descended toward the ground. He regained his sight at about twenty-five hundred feet and wisely landed behind German lines at the first opportunity. His Jasta 11 comrades flew protective cover as their leader inexplicably fell through the sky. The indefatigable fighting spirit of this great pilot was not dampened. He later voiced the view that has become many a fighter pilot's credo, "It is only in the fight that the battle is won."

For information about the artist, James Dietz, please see page 14.

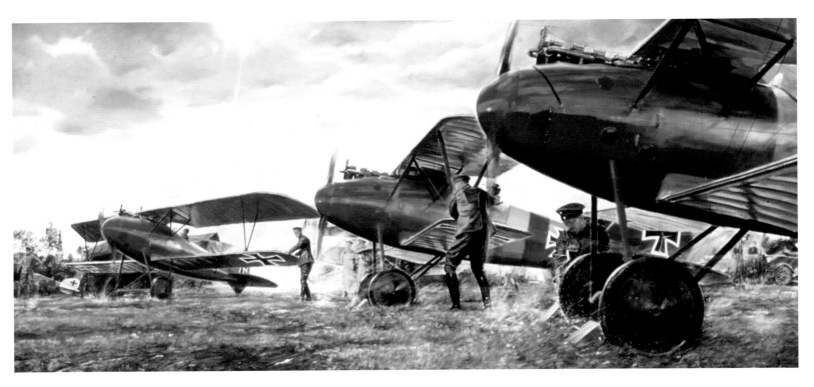

THE CIRCUS ROLLS AT DAWN by James Dietz, oil, completed 1989, private collection.

Waiting for the Tender

by James Dietz

What went wrong? A lucky and perhaps chagrined Royal Flying Corps pilot contemplates his smashed Sopwith Camel as he awaits the arrival of a squadron tender to lift and remove the aircraft. Meanwhile, Rolls-Royce armored cars pass on the road to the French town of Ypres, and some British infantry troops pause in curiosity. Incidents such as this, where an airplane was wrecked through some mechanical quirk or a pilot's misapplication of the controls, were common during World War I as aviation was still in its infancy. The new demands of air combat required rapid advances in aeronautical technology.

The Sopwith Camel, first delivered in large numbers to units of the RFC in 1917, was considered fast for its day and also quite maneuverable, important assets sought by fighter pilots of all periods. But the rotary-engined Camel had its peculiar traits. The engine's torque needed correcting in steep turns, and if one was not careful the result could be entry into an unintentional spin. For those pilots who could accustom themselves to the Camel, it proved to be an excellent fighter, particularly at altitudes up to twelve thousand feet.

For information about the artist, James Dietz, please see page 14.

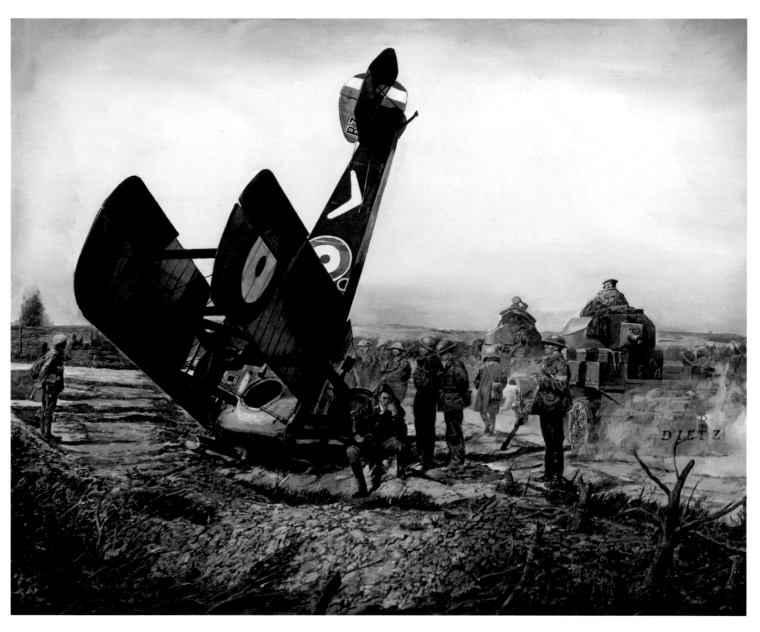

WAITING FOR THE TENDER by James Dietz, oil, completed 1990, collection of the artist.

Hunting the Hunter

by Nixon Galloway

In this image by Nixon Galloway, the pilot of a Royal Flying Corps Sopwith Pup tries desperately to shake a brightly decorated Albatros off his tail. The cloud bank just ahead offers protection, but is there time? As the Pup's pilot strains to look over his shoulder, he catches a welcome glimpse of one of his compatriots in another Pup closing in on the attacking Albatros. The pilot of the second Pup almost has the Albatros in range. As his squadron mate escapes into the clouds, he will ensure that the pesky German fighter bothers them no more. But at this very instant the pilot of the second Pup realizes another Albatros at the ten o'clock position is turning tightly to engage him. The hunters have become the hunted in a twisting and turning aerial battle where it is not certain who will emerge victorious.

Air-to-air combat came of age in World War I. What began as a chivalrous sport quickly turned into deadly business. Where pilots from the opposing sides were at first reported to have waved as they passed each other in flight while on unarmed reconnaissance missions, the encounters became progressively less hospitable, beginning with simple sidearms and leading to synchronized machine guns. Warfare would never be the same, nor would the public's perception of the still freshly invented flying machine.

Like the gladiator of ancient Rome or the gunslinger of the Old West, the fighter pilot would go into a kind of personalized battle against one like himself. World War I air fighting sprouted a set of doctrines and tactics aimed at besting the adversary in one-on-one encounters, called dogfights, where situational awareness was paramount. The great German ace, Oswald Boelcke, established broad principles for his fellow fighter pilots that included the need to always watch the opponent, the desirability of attacking from behind, the use of the sun to advantage, and the importance of surprise. These precepts, voiced early in the development of air combat, held validity for air wars to come and even have application to today's "high tech" aerial engagements.

Nixon Galloway

Nick was drawn to aviation from childhood, since both his father and grandfather, who were pioneer aviators in southern California, took him along for countless hours on idyllic flights in open cockpit biplanes. After graduating from the Art Center College of Design in Los Angeles, he embarked on a career as an illustrator with a special interest in aviation art. As a free-lance artist he has developed a corporate clientele that includes many of the major aerospace contractors. Notably, he has produced the forty-three paintings in the historical United Airlines series and the sixty paintings in the *Wings of Agriculture* calendars for Union Carbide Corporation. He has received the Life Achievement Award from the Society of Illustrators of Los Angeles. He is an artist fellow of the American Society of Aviation Artists. He and his wife, Marilyn, reside in Manhattan Beach, California.

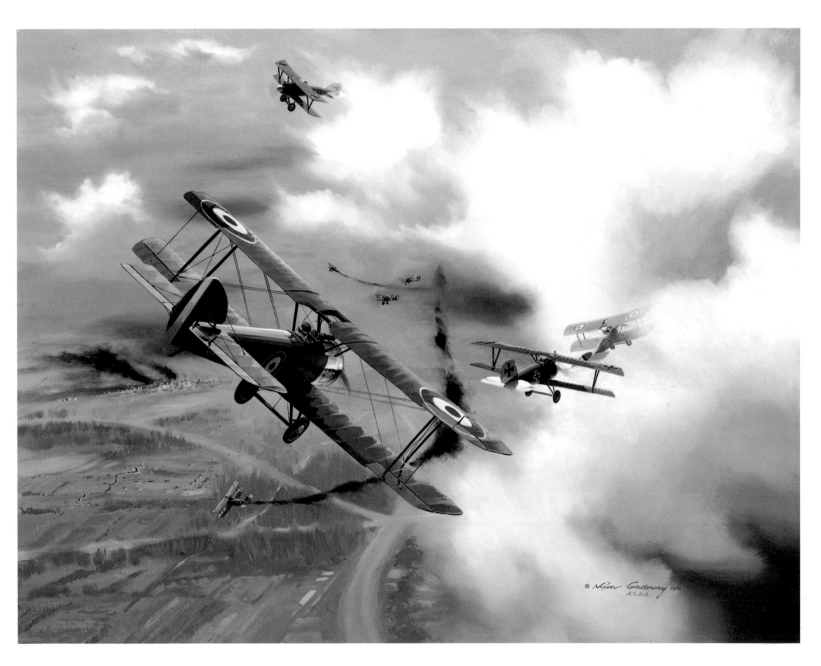

HUNTING THE HUNTER by Nixon Galloway, oil, completed 1990, collection of the artist.

The Baron

by David Poole

Contrary to legend, most of von Richthofen's victories were not scored in the Fokker Dr I triplane. Only the last nineteen of his eighty confirmed kills were achieved in triplanes. But for the greatest ace of World War I, the triplane was a treat to fly—small and supremely agile, its triple-decker design gave it swift responsiveness to the pilot's control inputs. It could also outclimb other fighters of the day. It did, however, suffer from being slow with its inadequate 110-horsepower Oberursel rotary engine. He had it painted a glaring red, for von Richthofen wanted to be seen by friend and foe alike. As his notoriety increased through the war, his aircraft's color and his aristocratic background were combined into the moniker "the Red Baron."

Strongly influenced by the principles laid down by his mentor, Oswald Boelcke, he believed it advantageous to attack from above, which made the Fokker triplane with its fast climb rate an ideal mount. In this image by artist David Poole, the Red Baron with his twin Spandau machine guns, has sent one of his last victims to the bottom, trailing a plume of black smoke. It is an SE-5a of the newly constituted British Royal Air Force. Up until his death on April 21, 1918, the German hero fervently believed that when fighter pilots "see an opponent they must attack and shoot him down. Anything else is rubbish."

David Poole

David studied fine art at both Virginia Commonwealth University and the Corcoran School of Art. He worked as a free-lance illustrator for five years in Richmond, Virginia. Now he devotes full time to aviation art, producing commissions through a well-known private gallery. His recent commissions have included a series of seven oil paintings for the Washington office of British Aerospace. He is a member of the Air Force Art Program. He and his wife, Brenda, live in Roanoke, Virginia.

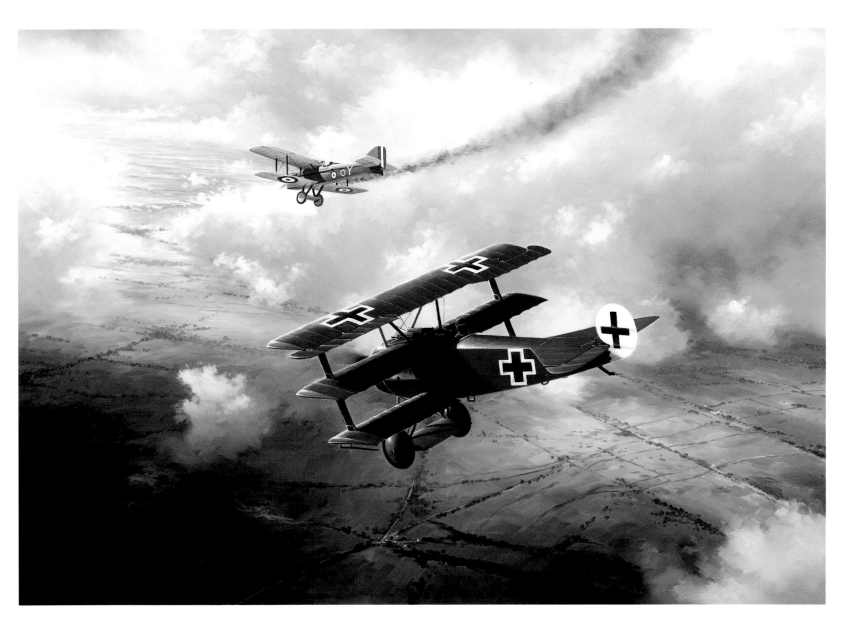

THE BARON by David Poole, oil, completed 1988, private collection.

Just Airborne, at Sea
by Keith Ferris

On August 11, 1918, the ominous shape of a Zeppelin L.53 appeared near ships of the British fleet operating in the North Sea. Although the threat of German airships bombarding London had receded, the huge blimps were still feared reconnaissance platforms. By this time, late in the course of World War I, the Royal Navy had devised an as yet un-proven defensive measure for just such a contin-gency. At 08:58 that morning Flight Sub-Lieutenant S. D. Culley, at the controls of a Sopwith Camel 2F.1, lifted into the air after a mere five-foot takeoff roll from a small flattop barge, or lighter, which was being towed into the wind by the destroyer HMS *Redoubt.* Conditions were less than favorable as the sea was choppy and a fog was rolling in.

After an hour's climb, Culley had neared the dirigible that hovered at nineteen thousand feet. Pointing the nose of his Camel toward the huge hull three hundred feet above him, Culley fired his two Lewis machine guns. While one jammed, the other emptied into the L.53. The Zeppelin burst into flames and plummeted to sea, the last dirigible to be downed in the war. Someone on board jumped from the floundering L.53 without a parachute, fell into the sea, was fished out, and miraculously survived uninjured.

In the low visibility conditions, it took Culley two hours from his successful attack to locate the British fleet. Unable to reach land with only a pint of fuel remaining, he ditched his Camel in the sea in close proximity to HMS *Redoubt.* He and the airplane were hoisted onto the ship.

Keith Ferris

The son of a distinguished air force pilot, Keith grew up surrounded by military aviation. Following formal training in both aeronautical engineering and fine art, he set out on an art career that took him to the New York area, where he established himself as a leading commercial illustra-tor and free-lance artist. He has flown in almost every jet in the air force inventory and has had the rare experience of flying with the Thunderbirds, the U.S. Air Force aerobatic team, as well as accompany-ing fighter and bomber air crews on combat missions during the Vietnam War. He has influenced the military services by designing high-visibility paint schemes for training and flight test. He also holds nine patents covering aerial camouflage paint schemes. His artwork has been exhibited in virtually every major aviation art museum and many fine art galleries. Notable among his commissions are two huge murals decorating the Smithsonian Institution's National Air and Space Museum. As a founding member of the American Society of Aviation Art-ists, he is widely regarded as a leading force in the aviation art movement. He and his wife, Peggy, reside in Morris Plains, New Jersey.

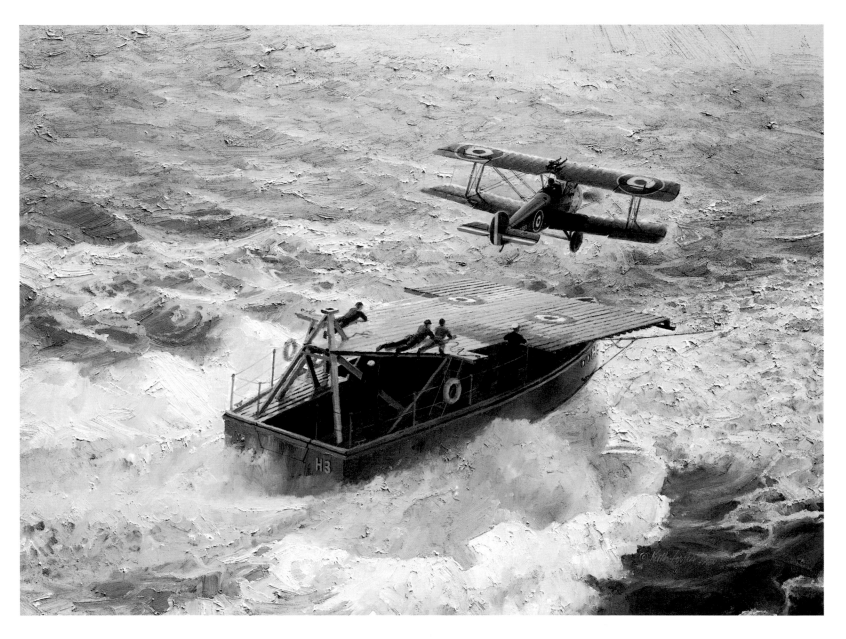

JUST AIRBORNE, AT SEA by Keith Ferris, oil, completed 1980, collection of the artist.

Lt. Brooks' Last Victory

by Roy Grinnell

In the waning months of World War I, a Massachusetts-born and educated army lieutenant by the name of Arthur Raymond Brooks took to the dangerous skies over France, not expecting to survive but willing to give his all. In short order during the summer and autumn, he became an ace, having recorded five confirmed victories. As a member of the 22nd Aero Squadron, his sixth and final victory would come with little more than a month remaining in the war.

On October 9, 1918, Brooks led seven other SPAD XIIIs on patrol between Souilly and Verdun. He and his men were glad to be flying a more powerful SPAD that also carried more armament—two fixed Vickers machine guns instead of the SPAD VII's single gun. Inscribed on his plane's fabric just below the cockpit was *Smith IV* in honor of his fiancée's college as well as the number of airplanes that had been assigned to him since the start of his combat tour.

The SPADs encountered four D.F.W. (Deutsch Flugzeug-Werke) observation planes escorted by almost a dozen of the highly regarded Fokker D.VII fighters. In the fighting that broke out, Brooks and one of his squadron mates, Lt. Clinton Jones of San Francisco, each shot down a D.F.W.

The bullet-riddled SPAD flown by Brooks was used in a publicity campaign to sell Liberty bonds and afterwards found its way into the collection of the Smithsonian Institution's National Air and Space Museum. A debate raged for years over whether the fragile World War I biplane should have its authentic fabric, studded with bullet holes covered by black patches, removed and replaced as part of an extensive restoration, or be left in its battle-scarred state. The deterioration was so severe that the museum finally had little choice but to authorize its master craftsmen to proceed. Over time they restored *Smith IV* to its original elegance. On hand for the presentation of the finished restoration in 1986 was a spry and approving Arthur Raymond Brooks.

Roy Grinnell

Roy graduated from the Art Center School of Design in Los Angeles and then went east to New York, where from a studio on Madison Avenue he pursued a career as a free-lance illustrator. His art work graced the pages and covers of many books and national magazines. He resided for a while in Santa Fe, New Mexico, but has now settled in Santa Barbara, California. His artistic interests are the American West and aviation.

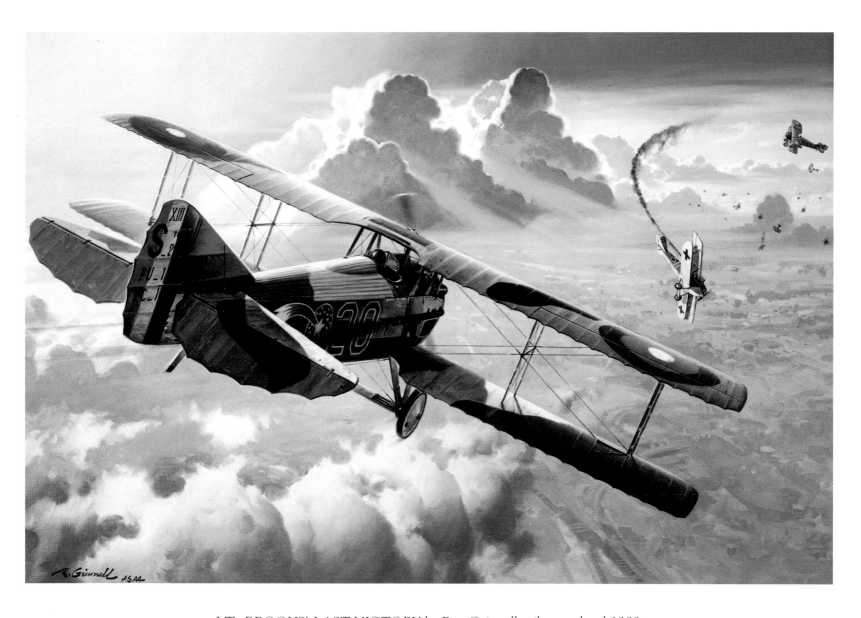

*LT. BROOKS' LAST VICTORY by Roy Grinnell, oil, completed 1989,
collection of American Fighter Aces Association, Mesa, Arizona.*

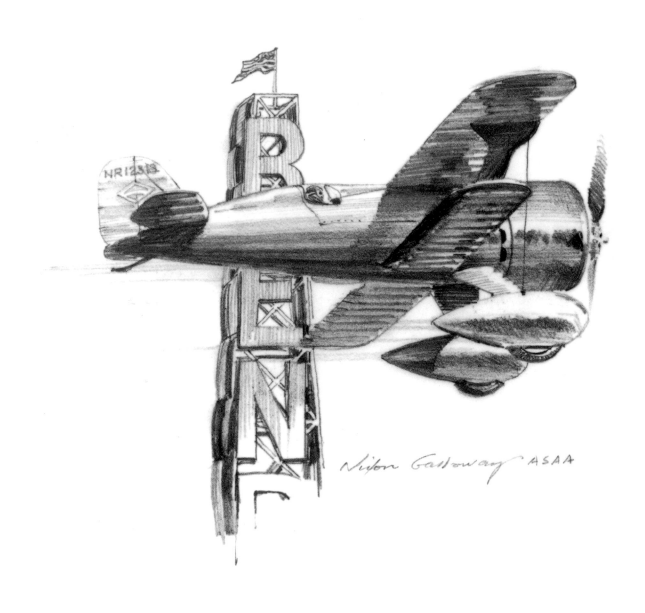

DOOLITTLE RACER by Nick Galloway.

The Golden Age

With a huge surplus of military trainers on the market following the end of World War I, the great American pastime of barnstorming came of age. Veteran combat pilots and newcomers to the world of flying crisscrossed the country in rickety crates as vagabonds of the air, putting on impromptu aerial performances at county fairs or selling five-dollar rides from cow pastures behind town halls. It was the era of wingwalkers, air racers, and aviation daredevils who enthralled the public with death-defying showmanship.

Aircraft manufacturing was still, by and large, a cottage industry, driven by intensely individualistic entrepreneurs. Often working out of garages or rented space in hangars at local airports, these unheralded designers, some with impressive formal education and others with little more than everyday machine shop experience, scribbled ambitious designs for airplanes on the corners of restaurant napkins. Often the product that was rolled out for inspection and first flight was elegant and graceful. There was a conspicuous boldness to the new designs that enhanced speed, altitude, range, and payload.

The world was captivated by the aeronautical breakthroughs of this enchanted time. No achievement so captured the imagination of the public as Charles Lindbergh's nonstop solo flight in May 1927 from New York to Paris. A thunderous outpouring of emotion greeted the "lone eagle" who had bridged the Atlantic as no one had before. He became among the greatest of world heroes, a permanent fixture in history books, an icon against which succeeding aviation personalities would be compared.

Speed and distance records continued to be smashed with breakneck rapidity. During the Labor Day holidays of the 1930s, attention focused on Cleveland, Ohio, site of the National Air Races. The great names in aviation assembled with exotic one-of-a-kind airplanes, designed and built with the sole objective of maximizing speed. As crowds in the grandstands looked on, the speed demons tore through the air, banking steeply to round the pylons, pushing for ever faster performance. Some of the lessons learned from these special designs would be incorporated in more common aircraft that could be mass produced.

The period between the two world wars witnessed a breathtaking transformation of the airplane in the daily pursuit of commerce. No longer a mechanical oddity, the airplane was recognized as an invention that could offer a commercial payback. Intrepid pilots pioneered airmail routes flying crude open-cockpit biplanes, sometimes over hostile terrain and at night.

New and bigger airplanes with a higher level of reliability, such as the Ford Trimotor, were assembled on production lines like automobiles, and they made air travel appealing to more people. The period's airliner development culminated in the introduction of the remarkably efficient and reliable Douglas DC-3, which allowed domestic airlines to earn profits hauling passengers without having to rely on airmail contracts. Fantastic progress was made in transoceanic air travel as well, with massive and luxurious flying boats providing regularly scheduled service.

The Transatlantic Curtiss NC-4

by Keith Ferris

With German U-boats hounding Allied shipping during World War I, the U.S. Navy perceived a need for a long-range sea-based anti-submarine patrol bomber. These airplanes, it was believed, should be able to reach the war zone in Europe on their own. The navy turned to Glenn H. Curtiss, a leader in the still new field of aircraft design and manufacture, to produce four aircraft with that capability.

By the time the first NC (for Navy Curtiss) was ready for flight, the war had almost ended. Nevertheless, the navy decided to pursue a transatlantic flight of all four airplanes. The NCs were huge float biplanes, with the upper wing measuring 126 feet, longer than the wingspan of some of today's jet airliners. A dense lattice of struts and wires braced the two wings. The tail was a triple-fin body structure. The crews of five or six were carried in a massive pontoon fuselage. Power was supplied by four 400-horsepower Liberty engines in a peculiar arrangement—three were tractor-style while the fourth was a pusher. These ungainly beasts of sea and air could fly at between fifty-eight and seventy-four knots when fully loaded.

Before the NCs embarked on their daring odyssey, one of the four, the NC-2, had to be cannibalized for the benefit of another that had suffered storm and fire damage. With high hopes, on May 8, 1919, the three remaining NCs departed the Naval Air Station at Rockaway, New York. Their charted route called for them to fly up to Newfoundland, then the longest leg to the Azores, on to Lisbon, Portugal, with a final leg to Plymouth, England. Along the way they would be assisted by a chain of dozens of American destroyers.

The NC-3 was drawn off course when its crew mistook an unrelated American cruiser for one of the chain's destroyers. The aircraft landed roughly into choppy waters, wrecking its flying ability. Sailing on the ocean's surface, the NC-3 arrived at the harbor of Ponta Delgada in the Azores a few days later. The NC-1 also landed off course and eventually sank due to the battering of strong waves. Fortunately, all crew members of both aircraft survived.

The sole remaining flying boat, the NC-4, was under the command of Lt. Comdr. Albert C. Read, who combined dead reckoning and radio signals from the destroyers and thereby managed to penetrate the fog in an amazing navigational feat that brought him to Horta in the Azores. When the weather improved, the NC-4 continued on its route. On May 27, it reached Lisbon, becoming the first aircraft to cross the Atlantic. From there, it flew to Plymouth on the English coast, the starting point of another historic Atlantic crossing—that of the *Mayflower*.

For information about the artist, Keith Ferris, see page 26.

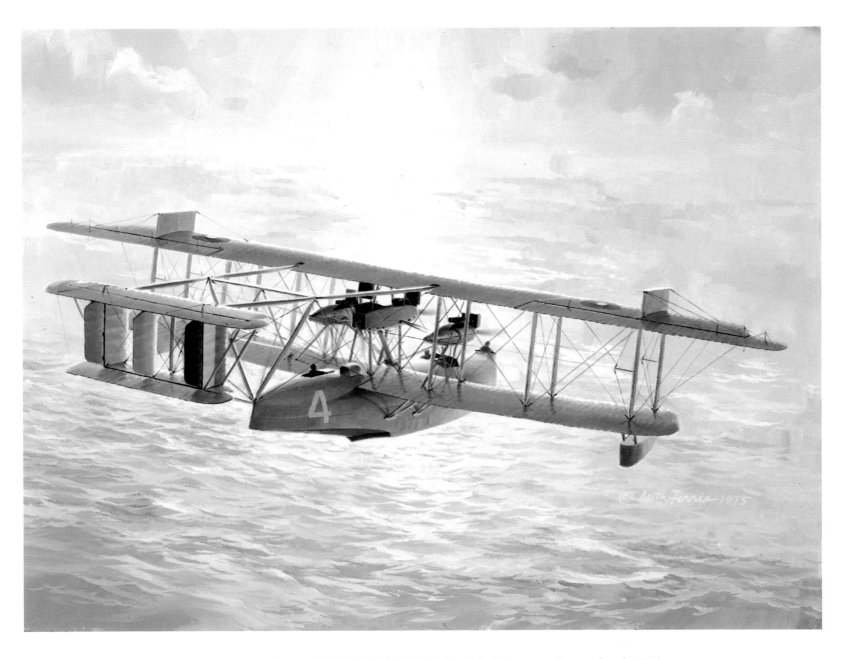

*THE TRANSATLANTIC CURTISS NC-4 by Keith Ferris, oil, completed 1975,
collection of Keith Ferris/Aviation Week & Space Technology.*

Border Patrol

by John Paul Jones

Mexico's unstable political situation in the early twentieth century contributed to festering tensions with its neighbor to the north. Rebels like Pancho Villa would cross into American territory raiding border towns, then retreat with impunity to Mexico. By June 1919, the situation had escalated to the point where Washington ordered strict new measures that included organized air surveillance along the troubled border.

Depicted here is an American DH-4 Liberty Plane of the 11th Aero Squadron flying border patrol between El Paso and its home aerodrome at Marfa, Texas. The squadron had adopted for its emblem a rendering of the character "Jiggs" from the popular comic strip *Maggie and Jiggs*, which can be seen just aft of the wing.

It is just after noon on a hot, dusty day soon after a provocative Villa incursion. A part of the cowling has been removed to keep the water-cooled engine from overheating. The pilot and his observer are at low altitude and have their eyes peeled for hoof tracks in the arid flatlands that might give them some clue where the rebels have gone. If they pick up a trail, the notification procedure involves either dropping a message at a nearby cavalry post or landing at Marfa and conveying the information to the duty officer.

The Liberty Plane was an American-built model of the de Havilland DH 4 which used the Liberty engine rather than the Rolls-Royce Eagle engine. It was an airplane notorious for its handling qualities. A sixty-seven-gallon fuel tank separated the observer in the rear cockpit and the pilot in the front cockpit. This arrangement was inherently unsafe. Many were rebuilt to the DH 4B standard which sensibly moved the fuel tank forward. This had the added advantage of bringing the pilot and observer cockpits closer together, which contributed to better communication. Some of these improved planes reached the Border Air Patrol in 1920.

John Paul Jones

As a schoolboy, John delighted his classmates but frustrated his teachers by incessantly doodling airplanes. Born during the Golden Age of Flight, he became fascinated at an early age by the curious contraptions that transported people by air. His first flight was in an open-cockpit aircraft and now after many years of piloting experience he still prefers the joy and excitement that come from open-cockpit flight. His artwork has been displayed at the Air Force Museum, the Experimental Aircraft Association's Air Adventure Museum, and the Smithsonian Institution's National Air and Space Museum. He and his wife, Valorie, reside in El Paso, Texas.

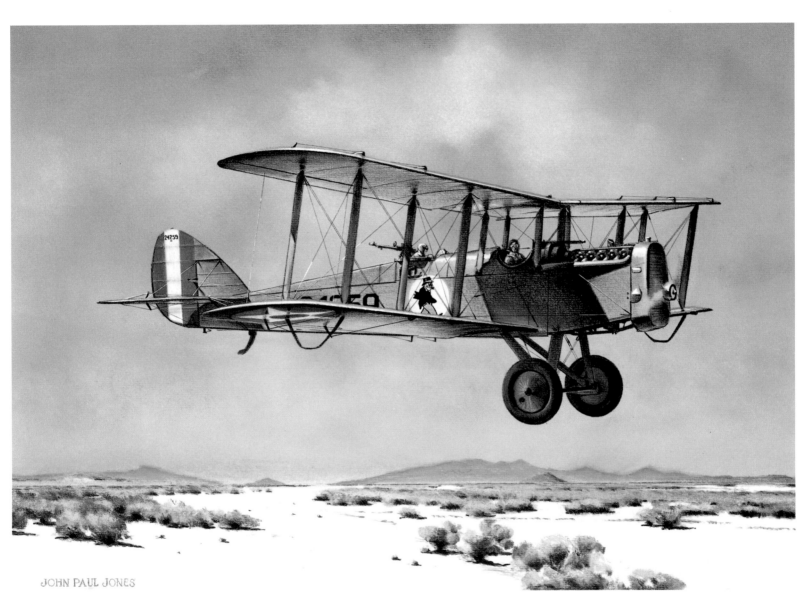

BORDER PATROL by John Paul Jones, pastels, completed 1978, private collection.

Harbinger

by Bob Cunningham

The period between world wars, known as the Golden Age of Flight, saw many aeronautical advances. These two exciting decades were marked by an unbounded belief in the possibilities for aviation and by the lively pursuit of those possibilities. An airplane far ahead of its time was the Dayton-Wright Company's RB-1, shown here at the Gordon Bennett Aviation Cup races, near Estampes in the French countryside, on September 28, 1920.

The RB-1, named after the company's chief test pilot, Howard Rinehart, and the principal designer, Milton Baumann, incorporated design features that were precursors of technological changes in the world of aeronautics. The RB-1 was the only monoplane among the fourteen international race entrants. Its cantilevered wing was ribless, containing balsa wood with pieces strategically removed so as to reduce the weight while retaining structural integrity. This was a forerunner of today's honeycomb structures. The wing sported both leading and trailing edge flaps that acted in concert with the one-of-a-kind retractable landing gear to alter the wing's camber such that the wing became a high-lift airfoil when the gear was extended and a low-drag, high-speed airfoil with the gear up. The trailing edge flaps also worked differentially as ailerons.

The pilot sat in a completely enclosed cockpit, which allowed forward visibility through a moveable back-and-forth side window. The fuselage was of monocoque construction. Small vertical fins were attached to the tips of the horizontal stabilizer to enhance stability at high speed.

Race rules called for each airplane to fly the three-hundred-kilometer course individually against the clock. But due to a broken rudder cable, the promising RB-1 had to withdraw from the competition, losing the opportunity to prove its new concepts. In some cases the RB-1's revolutionary advances were not adopted by the aviation industry until many years later. This harbinger of designs to come is now on public display in the Henry Ford Museum in Dearborn, Michigan.

Bob Cunningham

A graduate in fine arts from Texas Christian University, Bob worked for over thirty-five years for General Dynamics Corporation where he was manager of marketing concepts. During a distinguished career as both executive and artist he designed three postage stamps with aviation themes for the U.S. Postal Service. In addition to his painting, he wrote and co-directed the award-winning documentary film about famous aces, *Out of the Sun*. He has received the rare accolade of Honorary Ace from the American Fighter Aces Association. Until his untimely death in July 1991, he and his wife, D'Aun, resided in Fort Worth, Texas.

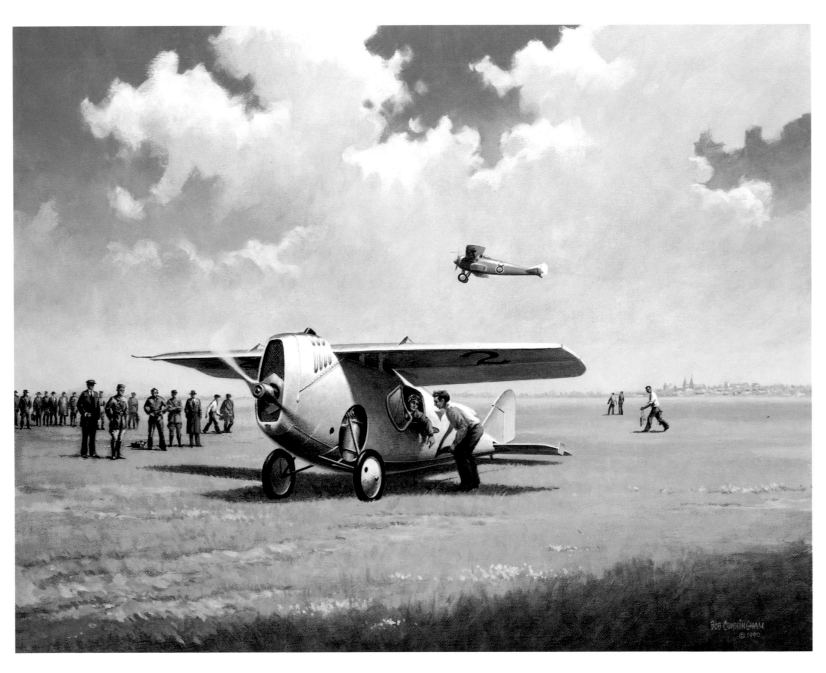

HARBINGER by Bob Cunningham, acrylic and oil, completed 1990, collection of the artist's family.

Lost in the Panhandle

by Roy Grinnell

Following World War I, many ex-military pilots sought fame and fortune applying their special talents in flying circuses. They would crisscross the nation, putting on daring aerial shows at town gatherings and county fairs. Often, though, the real danger lay not in performing the practiced routine before awed spectators, but in traveling over wide stretches of land without benefit of any navigational aids more sophisticated than a rudimentary map.

In 1919, there were reportedly only about 150 established airports in the United States, so the itinerant pilots usually landed in any reasonably spacious clearing that looked firm and flat from the vantage point of an open cockpit. This unique breed of airman who wandered over the landscape flying low and slow had little choice as to which airplane they would pilot. With the war over there was an oversupply of the widely used Curtiss Jenny trainers. Indeed, many of these airplanes had not even been uncrated. Curtiss went so far as to repurchase two thousand of its planes from the government and then marketed them at prices ranging from $4,000 to $5,000 each.

Depicted in this image is a military surplus Curtiss JN-4 Jenny, emblazoned with a colorful air show scheme, parked in the open space of the Texas panhandle. The pilot, unsure of his whereabouts and not wishing to waste his fuel supply, has landed near a cattle roundup to seek directions to his destination—a town scheduled to host his flying circus. As the pilot discusses directions with an obliging cowpoke, the horse-mounted ranch hands disagree over the best way to go. In the background, the traveling mechanic is returning from a nearby water tank to refill the radiator of the airplane's temperamental OX-5 engine.

One of the sidekicks of famed barnstormer Clyde E. "Upsidedown" Pangborn was said to have landed a brilliant red Jenny in a field like the one shown here. Agitated, a bull charged the fragile fabric plane, which lifted back into the air just in time. The quick-reflexed pilot circled overhead and did not land again until he saw that the ornery animal was restrained.

For information about the artist, Roy Grinnell, please see page 28.

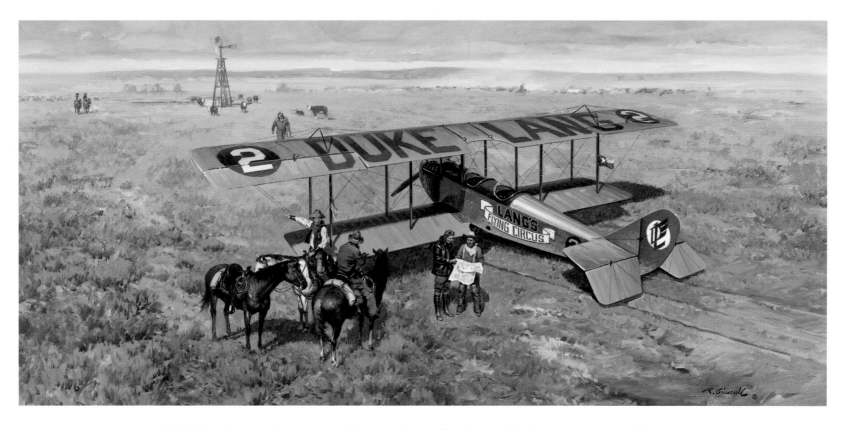

LOST IN THE PANHANDLE by Roy Grinnell, oil, completed 1987, private collection.

When a Sure Grip Meant Survival

by William Phillips

Aerial barnstorming developed into a way of life for stunt pilots and wingwalkers in the years after World War I. These daring performers toured the United States, sometimes calling wherever they happened to land that afternoon"home." Accommodations were sparse. Often they slept under the fabric-covered wings of their flimsy surplus biplanes. By selling rides to townspeople and by charging admission to "death-defying" air shows, these entrepreneurs would earn enough to make it to the next venue. These groups of twentieth-century vagabonds often included friends and spouses who shared a common vision of aviation's romantic heights.

Among the chilling feats performed by these adventurers was the mid-air transfer of a wingwalker from one airplane to another. In this heart-stopping rendition, a wingwalker grabs the underwing skid of a Curtiss JN-4 as he, atop the wing of another Jenny, braces himself against the onrushing wind. In a moment, with the two pilots trying their utmost to steady their airplanes, he will hoist himself across the void, clutching the exposed pieces of wood and wire of the flying crate above him. The audience below in the calm prairie town is undoubtedly breathless. Because of the obvious dangers of such shows, the federal government.began to impose regulations to provide a greater margin of safety.

William Phillips

Bill's interest in aviation stems from his boyhood afternoons watching Air National Guard fighters operate from a suburban Los Angeles airport. Although he had planned a career in law, he chose instead to pursue his true love, aviation art. His insight into painting realistic scenes has been enhanced by a stint in Vietnam while serving in the air force, a tour to the Persian Gulf as a navy combat artist, and the accumulation of flight time in a wide array of military aircraft. He is a member of the Air Force Art Program and has had the rare honor of having a one-man exhibition at the Smithsonian Institution's National Air and Space Museum. He and his wife, Kristi, reside in Ashland, Oregon.

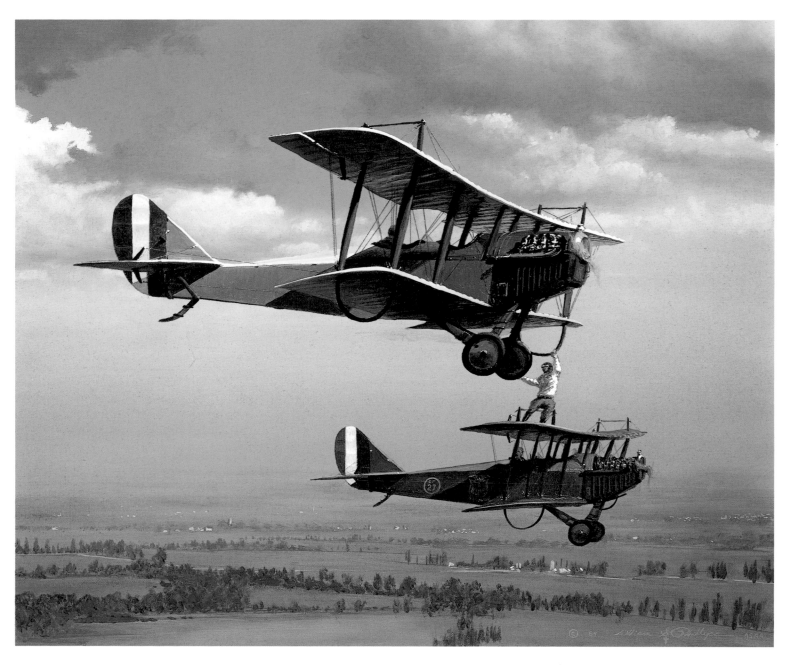

WHEN A SURE GRIP MEANT SURVIVAL by William Phillips, oil, completed 1989, private collection.

Douglas World Cruisers

by R. G. Smith

In this age when manned satellites circle the earth in ninety-minute orbits, it is hard to imagine that time in 1924 when man first successfully circumnavigated the globe by air in an arduous and colorful odyssey that lasted six months. Embarking from Seattle, Washington, on their epic journey three years before Lindbergh's historic Atlantic crossing, the U.S. Army Air Service team of eight pilots and mechanics was to be assisted at many planned stops around the world by special maintenance and support crews.

Impressed with the endurance capability and sea/land interchangeability of a new U.S. Navy torpedo bomber, the Army Air Service approached the airplane's designer, thirty-two-year-old Donald Douglas, to see if the navy plane could be adapted for the bold around-the-world flight. What emerged from the drafting table was the Douglas World Cruiser, a two-place, open-cockpit biplane, powered by the familiar twelve-cylinder, water-cooled Liberty engine. Weighing four tons when fully loaded, it typically had trouble achieving a ground speed of more than 80 MPH. The airplane was rugged, however, and would stand up well to the extreme climate variations encountered during the world flight.

The chief of the Army Air Service ordered that each World Cruiser be named after a major city and christened with a beverage reflecting the country's prohibitionist sentiments. Accordingly, the World Cruisers were called *Seattle*, *Chicago*, *Boston*, and *New Orleans*, representing the four corners of the country bordered by bodies of water. Each aircraft was christened with a bottle that contained water from the respective lake, gulf, or ocean.

Early in the circumnavigation attempt, the lead plane was lost, but fortunately without casualty. Much later in the journey another of the World Cruisers suffered a disabling accident, but again, thankfully, no one was hurt. While the first world flight was fraught with hazards, it included an itinerary of exotic places and glamorous moments. The world fliers' route included stops in Shanghai, Rangoon, Karachi, Bandar Abbas, Constantinople, Budapest, Vienna, and Paris. At virtually every stop, the army airmen, recognized as brave explorers and ambassadors of goodwill, were greeted warmly. Maj. Frederick L. Martin, Sgt. Alva Harvey, Lt. Lowell H. Smith, Lt. Leslie P. Arnold, Lt. Leigh Wade, Staff Sgt. Henry H. Ogden, Lt. Erik H. Nelson, and Lt. John Harding, Jr., showed both courage and statesmanship.

For information about the artist, R. G. Smith, please see page 104.

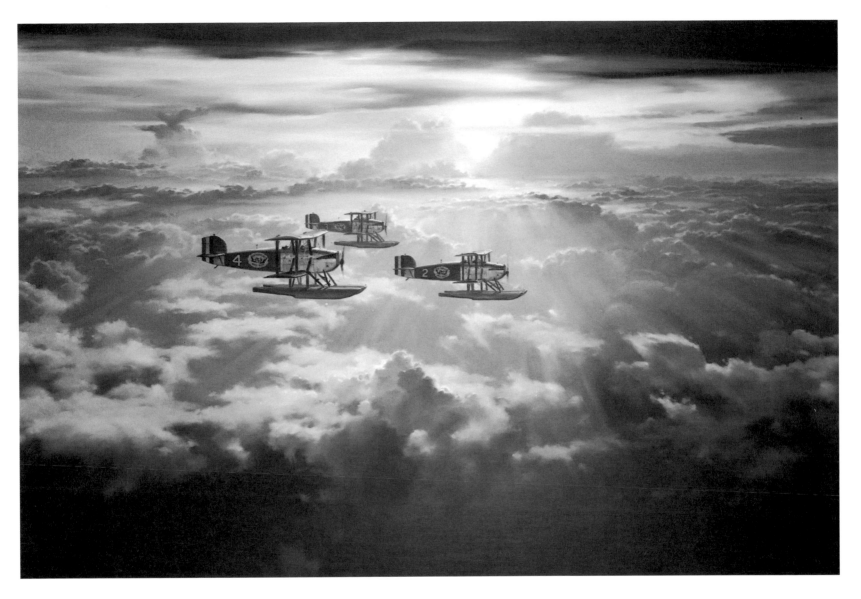

DOUGLAS WORLD CRUISERS by R. G. Smith, oil, completed 1975, collection of McDonnell Douglas Corporation.

Poleward—the Third Attempt

by Don Connolly

The great explorer Robert Peary reached the North Pole on foot in 1909. Yet the Arctic vastness was still barely investigated and remained the subject of scientific curiosity. As aviation advanced, researchers hoped that aerial explorations could answer some of the persistent questions. Aviators, meanwhile, were eager to conquer the Arctic, and by the mid-1920s the competitive mentality that had taken hold in flying was spurring two teams who sought to be the first to fly over the North Pole. The leaders of each group, however, pronounced publicly that their respective aerial expeditions were for the enhancement of knowledge rather than for personal glory.

As chance would have it, these two teams were, in the early spring of 1926, preparing for the trip over the pole at the same departure point, Kings Bay on the Norwegian island of Spitzbergen. Richard Byrd, a young U.S. Navy officer known for his competence and ambition, along with Floyd Bennett, a naval mechanic and an extraordinary pilot, had sailed to Kings Bay with their airplane, the Fokker F.VIIA/3m Trimotor. The aircraft, recently constructed, had participated in the fifteen-hundred-mile Ford Reliability Tour across the United States late in the prior year. Automotive heir Edsel Ford bought the impressive plane and made it available to Lieutenant Commander Byrd. Named the *Josephine Ford*, for the patron's youngest daughter, the aircraft also had the Fokker name in large print emblazoned on the wings and fuselage upon the insistence of the designer, Anthony Fokker. The other team, led by the Norwegian Roald Amundsen, the American Lincoln Ellsworth, and the Italian Umberto Nobile, was going to make its attempt in a dirigible named the *Norge*.

The *Josephine Ford* was readied first, on May 9. The Trimotor lumbered into the sky, heading for the top of the world. Fifteen hours later, Byrd and Bennett returned triumphant, although doubts linger whether Byrd's navigational log substantiating his claim of flying over the North Pole was correct. On May 11 the *Norge* embarked on its trip which called for a flight not merely to the North Pole but all the way to Alaska. In a show of goodwill, as depicted in this image by artist Don Connolly, Byrd and Bennett took off in their Trimotor and for a brief time accompanied the *Norge*, even circling the mammoth airship. Afterwards, the two Trimotor pilots landed at Kings Bay and stood by to fly a rescue mission should the *Norge* run into trouble. But the *Norge* proceeded on course, reaching the North Pole in about fifteen hours. The remainder of the journey was strewn with disastrous weather, the *Norge* barely making it to Alaska, but Amundsen had finally fulfilled the goal he had set for himself long ago.

Don Connolly

After a seventeen-year career as a navigator with the Royal Canadian Air Force during which he accumulated approximately four thousand flight hours and attained the rank of squadron leader, Don embarked on a career in book retailing and picture framing. By 1978 he devoted full time to painting. Because of his years of RCAF service, he is at home with aviation subjects. His art has been widely collected, with works in the Canadian National War Museum, the RCAF Museum in Trenton, and the Naval Air Museum in Shearwater. He and his wife, Liane, reside on a lake near Sydenham, Ontario.

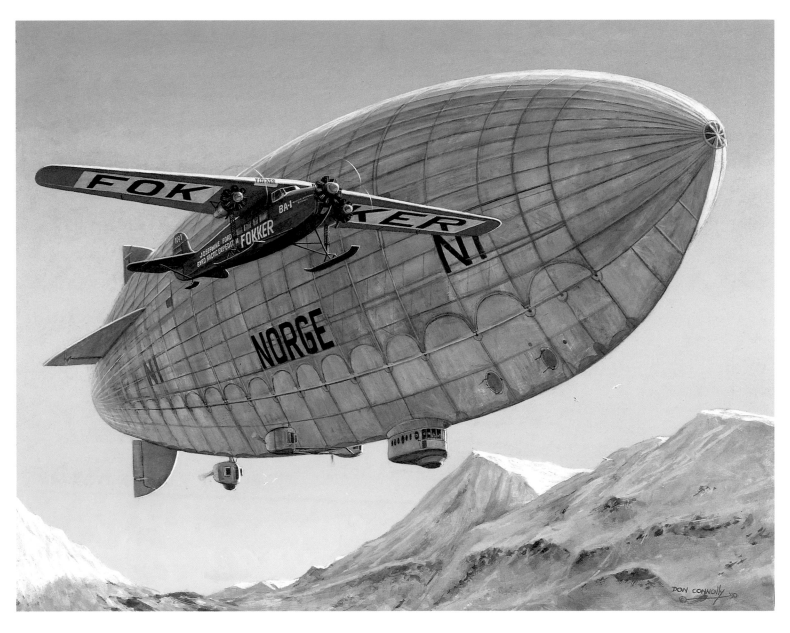

POLEWARD—THE THIRD ATTEMPT by Don Connolly, acrylic, completed 1990, collection of the artist.

Almost Time to Go

by John Paul Jones

On a winter afternoon in 1926 on an airstrip near a midwestern hamlet, a pilot, snug in his lined leather coveralls, prepares to face the daily hardship of flying the mail. As postal officials load mail bags into the DH-4's forward cargo section, the local dispatcher, scarf flapping in the wind, approaches with information of the weather ahead, gleaned by telephone from sighting reports along points en route. Hardly a soul is venturing out into the inhospitable elements, except for the pilot's sweetheart, who has come to see him off. The pilot has suddenly become a touch aloof, engrossed in thought about his upcoming flight, for he has glanced at his pocket watch and realizes that to stay on the demanding post office schedule he must leave momentarily.

This scene, often repeated in the open-cockpit era of the 1920s, reflects the unyielding dedication of the airmail pilots to getting the mail through. They were expected to plunge ahead and stay on rigid schedules except in the most adverse of conditions. It was, in fact, during long, lonesome airmail night flights on routes such as St. Louis-to-Chicago that Charles Lindbergh first contemplated his famous transatlantic flight.

Seeking to improve postal service in remote areas and to speed mail delivery in general, the post office sponsored the creation of the U.S. Air Mail Service in 1918. As second assistant postmaster general, Otto Praeger wisely guided the new organization through its fledgling years. Eventually, Praeger was succeeded by Paul Henderson who, with the help of engineer Joseph Magee, enhanced the practicality of flying the mail at night.

In August 1923, the Chicago-to-Cheyenne night airway, which stretched 885 miles, was successfully tested. The route featured electric arc beacons mounted atop thirty-five-foot towers at the primary airports. These powerful lights could be seen from over a hundred miles away. There were thirty-four emergency fields located about every twenty-five miles, each strongly illuminated to help the service's night-fliers who might be in trouble. This new system for transcontinental mail carriage cut the time en route to under thirty hours, approximately one-third the time required by rail.

For information about the artist, John Paul Jones, please see page 34.

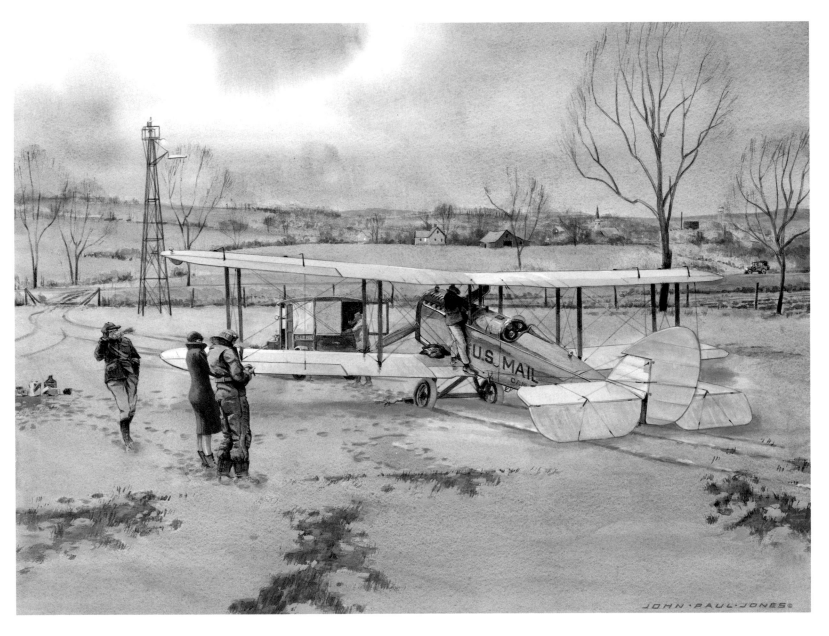

ALMOST TIME TO GO *by John Paul Jones, watercolor, completed 1987, collection of the artist.*

28th Hour

by Keith Ferris

No other aviation event before or since has captivated the public as did Charles Lindbergh's nonstop solo flight across the Atlantic on May 21-22, 1927. The lanky and unassuming airmail pilot had resolved to accomplish the elusive feat by flying an original Ryan design predicated on the Brougham B-1. The *Spirit of St. Louis*, as the youthful pilot dubbed his one-of-a-kind airplane, was designated the Ryan NYP (for New York-to-Paris). It was a high-wing monoplane powered by a Wright J-5 Whirlwind engine. The NYP was made to carry the enormous fuel load calculated to sustain the power for the planned New York-to-Paris trip. Forward visibility was blocked by the need for extra fuel storage in front of the cockpit, so a periscope was installed.

Lucky Lindy, as Lindbergh would become known, had an inauspicious beginning to his transatlantic journey as the Ryan NYP, heavy with fuel, barely rose after a long takeoff roll. En route, the courageous pilot encountered bouts of rough weather. He skillfully navigated over the vast body of water despite crude instrumentation. Worst of all was the monotony of the flight. After twenty-eight hours of flight, the *Spirit of St. Louis* approaches the rugged southwestern coast of Ireland. From this vantage point over Dingle Bay, Lindbergh should be able to reach his destination of LeBourget Aerodrome in roughly five and a half hours, if he can fight off fatigue and if his aircraft continues in good mechanical order.

Upon landing, Lindbergh was mobbed by an adoring crowd. Instantly, this quiet and shy hero was transformed into an international celebrity. His accomplishment would be forever etched in the memory of civilization.

For information about the artist, Keith Ferris, please see page 26.

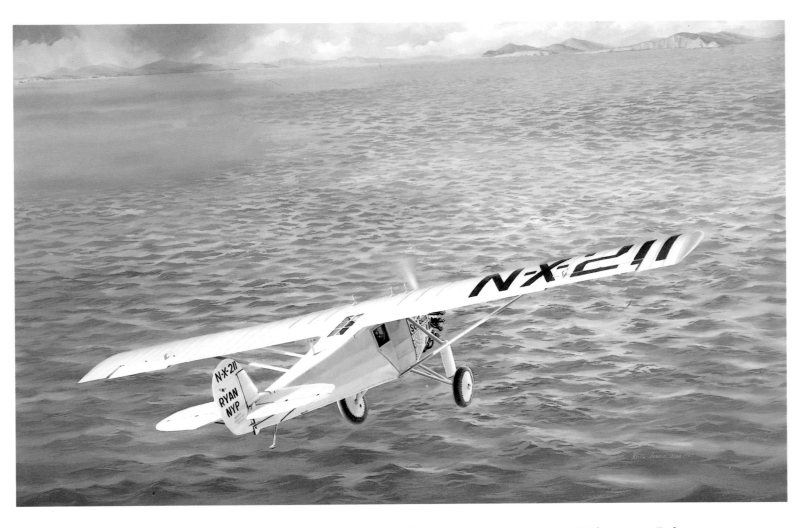

28TH HOUR by Keith Ferris, oil, completed 1987, collection of Atlantic Aviation, Wilmington, Delaware.

Breath of Magic

by Kristin Hill

The airmail pilots of the 1920s navigated with little more than maps and seat-of-the-pants dead reckoning. In good weather or bad, the airmail pilots were expected to deliver their important cargo, to prove that flying the mail could be as cost effective and as reliable as the time-honored method of using the rails. The pay was paltry and the conditions were at times horrendous, but the challenge of establishing the airmail routes coupled with the adventure of frequent flight served as irresistible inducements to the hardy aviators of the period.

Depicted in this image by artist Kristin Hill is a strikingly handsome Pitcairn PA-5, the first of the noted Pitcairn Mailwings. While carrying a full five-hundred-pound load of mail on Contract Airmail Route 19 from Washington, D.C., to Atlanta, Georgia, the Mailwing has been pushed off course by strong winds into the hill country of North Carolina, where there is, thankfully, a pocket of calm skies. The airplane's presence breaks the morning stillness, causing the wildlife to stir. Inhabitants of the area rush to the river's shore to wave to their fleeting visitor, who has in the past followed the same course when his normal route became impassable.

The U.S. Air Mail Service strove for a high level of professionalism as it pioneered commercial air routes. As early as October 1918, it issued a set of twenty-six rules strictly governing the airmail pilots. Under these rules, pilots were required to inspect their aircraft before each flight and aerobatics (called "stunts") were prohibited. Yet in the early days of airmail the equipment and the environment could be unforgiving. Such hazards as fog and engine failure took a heavy toll, claiming a total of thirty-four

pilots during their flights for the Post Office between 1918 and 1927. The foundation, admittedly tenuous, was laid for airmail flying to come at the end of the decade and beyond.

Kristin Hill

From the time she was an infant, Kristin accompanied her father on plane rides. She grew up in Lancaster, Pennsylvania, and received a degree in fine arts from Mary Washington College in Fredericksburg, Virginia. With the ever-present influence of the family's aviation business there was hardly any doubt that she would combine her love of flight with her artistic talent. Her assorted flight experience includes rides in hot air balloons, vintage biplanes, and military jets. She is a participant in the Air Force Art Program. She resides in her hometown of Lancaster.

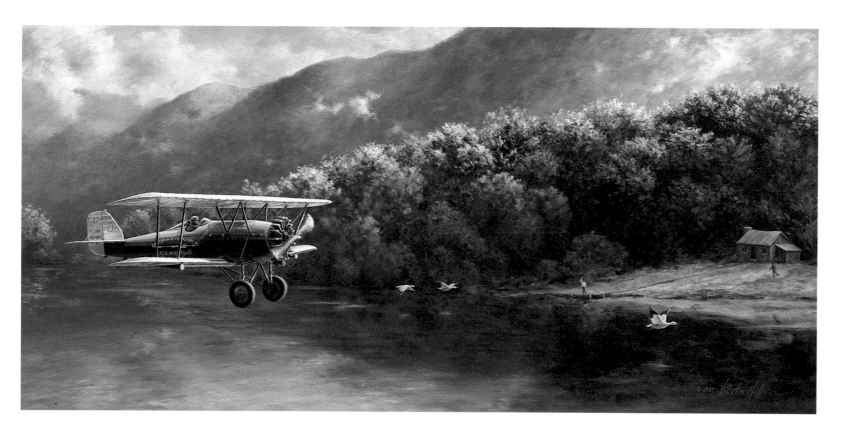

BREATH OF MAGIC by Kristin Hill, oil, completed 1987, private collection.

Hamilton Metalplane Landing in the Rain

by Randy Penner

Northwest Airlines, which until 1934 operated as Northwest Airways, searched in the late 1920s for a rugged passenger airliner that could withstand the severe winters of the upper Midwest and thereby augment revenues of its successful airmail route between Chicago and Minneapolis/St. Paul. The company settled on nine all-metal high-wing monoplanes from the Hamilton Metalplane Company of Milwaukee. In September 1928, using the first of these planes, Northwest provided the nation's first coordinated airmail service.

These boxy airliners, with their reinforced corrugated skin, were designated either H-45 or H-47, with the latter model having the more powerful 550-horsepower Pratt & Whitney Hornet engine. The H-47 could carry seven passengers for five hundred miles at a cruise speed of 120 MPH. Perhaps it was not a pretty airplane, but for its time it served the purpose.

This Northwest Hamilton Metalplane H-47 is on short final approach for landing at an airport on the outskirts of a growing midwestern city in 1934. A light rain shrouds the city's skyline in mist, suggesting that scheduled passenger airliners are beginning to cope successfully with the vagaries of weather and are finally providing a semblance of reliable service.

Randy Penner

Growing up near Wichita, Kansas, home of the general aviation industry, Randy became intoxicated with airplanes and flying. After earning his pilot's license, he eventually owned several aircraft. He worked as an illustrator for Boeing in Wichita, moved to another employer in Minnesota, and then became a free-lance artist producing work for a wide range of commercial clients. In recent years he has devoted most of his time to commissioned work in his favorite though demanding medium, transparent watercolor. He and his wife, Lu, live on a picturesque lake in Hudson, Wisconsin.

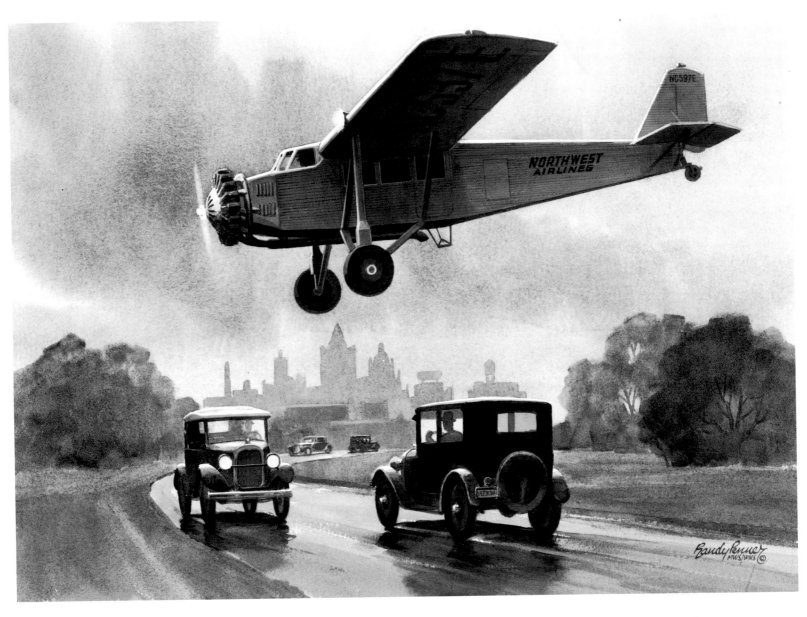

HAMILTON METALPLANE LANDING IN THE RAIN by Randy Penner, transparent watercolor, completed 1986, private collection.

Women's Air Corps Reserve

by Nixon Galloway

Tired of the exclusionary treatment they often encountered in the male-dominated world of aviation, a group of West Coast women, mostly fliers and health care professionals, banded together in the early 1930s. Led by the effervescent Florence "Pancho" Barnes and calling themselves the Women's Air Reserve, the group was registered with the Bureau of Air Commerce. The members loosely patterned their organization after the U.S. Army Air Corps.

Attired in military style uniforms with ties, puttees, and berets, the aviatrixes would assemble on the first Sunday of each month for drill on the parade ground of an obliging army facility. They took courses in the administering of first aid and in the techniques of aerial search and rescue. Their periodic training prepared them for service in such emergencies as forest fires, floods, earthquakes, and other calamities requiring relief from the air.

In this group portrait, a gathering of the Women's Air Reserve, also known as the Women's Air Corps Reserve, is shown posing with a few Army Air Corps officers in front of an observation plane at March Field in California. Notable among the gathering is the group's leader, Pancho Barnes (fifth from right), Mitzi Mantz (far left), Nancy Chaffee (second from left), Melba Beard (third from left), Eileen Curly (fourth from left), Mary Wiggins (third from right), and Ruth Evelyn "Smitty" Smith (second from right). Pancho Barnes achieved fame as a gregarious stunt pilot in the movies and as the holder of the women's speed record. She was assisted in her efforts to establish the Women's Air Reserve by another accomplished California aviatrix, Bobbi Trout.

For information about the artist, Nixon Galloway, please see page 22.

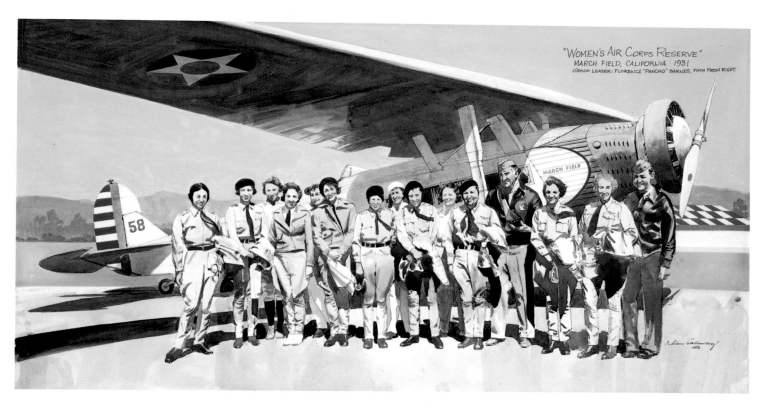

Inside image: "WOMEN'S AIR CORPS RESERVE"
MARCH FIELD, CALIFORNIA · 1931
GROUP LEADER: FLORENCE "PANCHO" BARNES, FIFTH FROM RIGHT.

WOMEN'S AIR CORPS RESERVE by Nixon Galloway, oil, completed 1976,
collection of U.S. Air Force Art Collection.

Jimmy Doolittle Wins Again

by Nixon Galloway

By the time of the first Bendix Trophy race in 1931, James H. "Jimmy" Doolittle had already distinguished himself as one of the world's great aviators. He was the first person to traverse the United States by air in less than twenty-four hours, he won the Schneider Trophy in 1925 by setting a new world speed record for seaplanes, he made the first deliberate takeoffs and landings in the "blind" while pioneering the development of new flight instruments, and he was among the first Americans to earn a doctorate in aeronautical science.

Always interested in expanding the performance envelope of airplanes, Doolittle teamed with the designer Emil M. "Matty" Laird to improve the speed of the Laird Solution which had won the 1930 Thompson Trophy. This new version, called the Super Solution was a streamlined biplane with a supercharged 535-horsepower Pratt & Whitney Wasp Junior engine.

Sponsored by industrialist Vincent Bendix, the Bendix Trophy annual cross country race would require more than mere speed. Because of the distance involved, planes would have to be rugged and their pilots adept in flight planning and navigation.

There were eight contestants in the Burbank-to-Cleveland race, of whom six were flying Lockheeds; Doolittle's Super Solution was the only biplane entered. As the airplanes took off early on the morning of September 4, 1931, it became clear that Doolittle's plane had the speed advantage. Making an eight-minute prearranged fuel stop in Albuquerque and another one of ten minutes duration in Kansas City, the Super Solution landed at Cleveland 9 hours, 10 minutes, and 21 seconds after its start, cinching the Bendix Trophy. The next contestant did not arrive for another hour.

But Doolittle did not rest. Not even pausing to accept a sandwich from his wife who was present at Cleveland, he took off for Newark immediately after his third refueling of the day in an attempt to break the existing transcontinental speed record. Despite severe thunderstorms along the way, he established a new record that shaved more than an hour off the old one.

For information about the artist, Nixon Galloway, please see page 22.

JIMMY DOOLITTLE WINS AGAIN by Nixon Galloway, oil, completed 1985, collection of Jimmy Doolittle.

Is It a Bird? . . . Is It a Plane?

by Charles Thompson

The father of practical rotary-wing flight was Juan de la Cierva, born in Spain on September 21, 1895. Early in life he developed a fondness for aviation in general and a fascination for safe low-speed flight in particular. As a young man with many interests, Cierva became enthralled with a helicopter-like toy, and theorized that airplanes would benefit in a number of ways by the addition of unpowered rotor blades overhead. The rotor would turn like a horizontally-mounted windmill as the normal propeller pulled the aircraft through the air. If the engine failed, the rotor would keep turning, providing lift and a safe descent. Also, the rotor would allow lower forward airspeeds so that the aircraft could take off and land with less runway. Another considerable advantage was the rotor's ability to prevent the aircraft from stalling. On the negative side, the autogiro, as this type of aircraft came to be known, was burdened by the extra drag of the rotor and was not able to compete with the speeds of fixed-wing aircraft.

In 1925 Cierva moved to England and formed a company to develop his beloved autogiros. The staff of de Havilland, the large aircraft company, was interested in comparing the flight characteristics of the Cierva autogiro with their conventional three-passenger DH 80 Puss Moth. Therefore, a Puss Moth-style cabin was outfitted as an autogiro and after some initial testing was given a double-fin tail. The autogiro, designated C.24, had tricycle landing gear. Rather than a free turning rotor, the C.24's three-blade rotor was driven by a linkage to the de Havilland Gipsy III engine. It was piloted on the morning of November 19, 1931, by Cierva's chief pilot, Arthur H. C. A. "Dizzy" Rawson, who always wore a hat. The performance of the C.24 was unimpressive, and so de Havilland did not pursue it.

However, Cierva continued to refine his invention, incorporating such improvements as collective pitch for the rotor blades. About five hundred Cierva autogiros were built under license in seven countries, including those assembled by Pitcairn in Willow Grove, Pennsylvania. The autogiro never overcame its inherent conceptual drawbacks, but after enhancements from years of Cierva's tinkering, it brought the practical helicopter within reach.

Charles Thompson

Charles grew up in India where his father was a British army sergeant. In 1949 the family returned to England where he landed a job with Briggs Motor Bodies as a trainee draughtsman. He was an airframe mechanic in the British Royal Air Force as fulfillment of his national service obligation. He then rejoined Briggs as an automobile stylist. When Briggs was taken over by Ford Motor Company, he participated in the design of many memorable cars. Always interested in airplanes, he pursued aviation art at first as a hobby but as a profession since the late 1970s. He is one of the few individuals who is both a full member of the British Guild of Aviation Artists and an artist fellow of the American Society of Aviation Artists. He and his wife, Grace, live in Rayleigh, Essex, England.

IS IT A BIRD? . . . IS IT A PLANE? by Charles Thompson, oil, completed 1989, collection of the artist.

Sikorsky S-38

by Randy Penner

The Sikorsky name is most often associated with helicopters, but the young Russian émigré, Igor Sikorsky, had established his career as a designer and builder of large biplanes. After fleeing Communist Russia and settling in the United States in 1919, Sikorsky worked diligently on marketing a number of his designs. Success was elusive until the late 1920s, when Juan Trippe of Pan American Airways decided that Sikorsky's new S-38 amphibian was the ideal airplane for his airline's Caribbean routes. In 1929, Pan Am used the S-38 to inaugurate its airmail route from Miami to the Panama Canal.

Other airlines with overwater routes followed suit and ordered the S-38. Among the buyers of this funny-looking biplane was Northwest Airways, which on May 30, 1931, began service to Duluth, Minnesota. At the time Duluth did not have an airport, so air transport had to be provided by seaplane from Lake Superior as depicted in this image of a Northwest S-38 taking off aft of the stern of a passing freighter. Northwest operated only two of the amphibians.

The S-38 was powered by a pair of 420-horsepower Pratt & Whitney Wasp Junior engines and could achieve, despite its framework of angled struts and wires, a cruise speed of 110 MPH with ten people on board. In fact, the S-38 was the first twin-engined aircraft, when fully loaded, to maintain level flight on one engine. It also established a world altitude record of over nineteen thousand feet.

Thanks to a persevering designer, the age of the flying boat as a viable passenger airliner for prolonged overwater flights had arrived.

For information about the artist, Randy Penner, please see page 52.

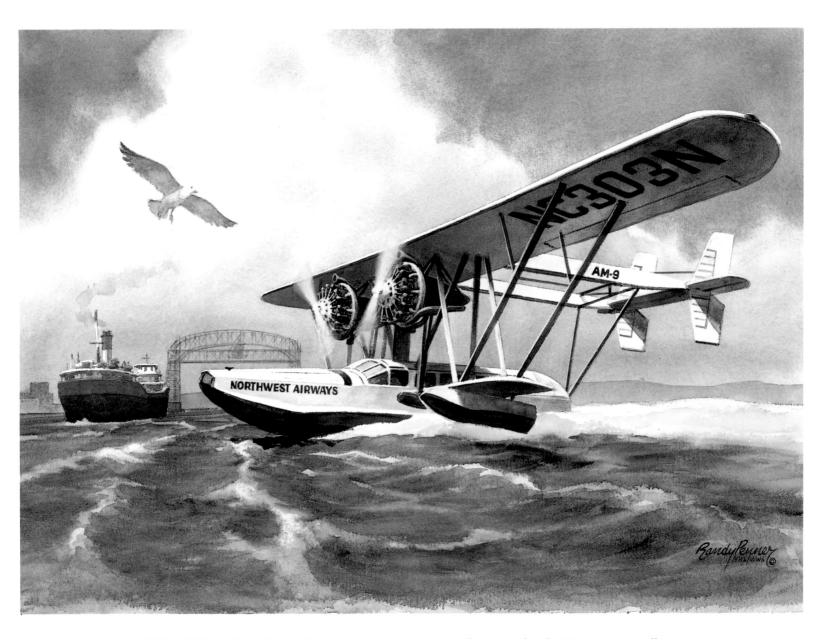

SIKORSKY S-38 by Randy Penner, transparent watercolor, completed 1986, private collection.

Jimmy and the Gee Bee

by Craig Kodera

The glamorous Golden Age of Flight was punctuated by a flurry of new speed records. Nowhere was the nation's obsession with speed more visible than at the annual National Air Races held in Cleveland during Labor Day weekend. All variety of speedsters, designed expressly for racing and record-setting, appeared at Cleveland.

Symbolizing the period's infatuation with speed was the stubby, clipped-wing barrel of an airplane produced in a converted dance hall in Springfield, Massachusetts, by Zantford D. "Granny" Granville and his four brothers. The Super Sportster R-1, popularly known as the "Gee Bee," was simply a winged encasement for the burly eight-hundred-horsepower Pratt & Whitney Wasp engine. The pilot was enclosed in a small cockpit immediately forward of the vertical stabilizer. The Gee Bee, with an exceptionally high stall speed and poor control response, was notoriously wicked in its handling characteristics. Both models built, appropriately highlighted in numbers favored by crapshooters—7 and 11—crashed, and a third constructed from the salvageable parts of the first two also crashed. But the Gee Bee in its short life had moments of glory.

On September 3, 1932, with famed daredevil Jimmy Doolittle at the controls, the Gee Bee made four qualifying passes parallel to the grandstands at Cleveland, with timekeepers clocking each one. The Gee Bee's fastest pass, depicted in this image by artist Craig Kodera, was at a speed of over 309 MPH. The average speed for the four passes measured in excess of 296 MPH, a new world's record. The closed-course Thompson race, held the next day with the contestants rounding pylons in heart-stopping banks and turns, was won by Doolittle in his Gee Bee at an average speed of 252.7 MPH, another record. This unstable and tricky racing plane met disaster the following year, but Jimmy Doolittle had earned the coveted Thompson Trophy. He would go on to serve his country heroically during World War II and add further accolades to an already distinguished aviation career.

Craig Kodera

Born into an aviation family that includes an uncle who was second in command of the famous World War II Doolittle raid on Tokyo, Craig was destined to pursue aviation as a career. He earned his private pilot's license at age seventeen. He graduated from the University of California at Los Angeles with a degree in mass communications and worked for McDonnell Douglas Corporation as an illustrator. He obtained a commission in the Air Force Reserve and soon found himself flying the HC-130H Hercules and later the KC-10A Extender for the Strategic Air Command. Now an MD-80 pilot with American Airlines, he has accumulated over five thousand flight hours. He served as the first vice president of the American Society of Aviation Artists. From his studio in Anaheim Hills, California, he produces a steady flow of realistic airplane images.

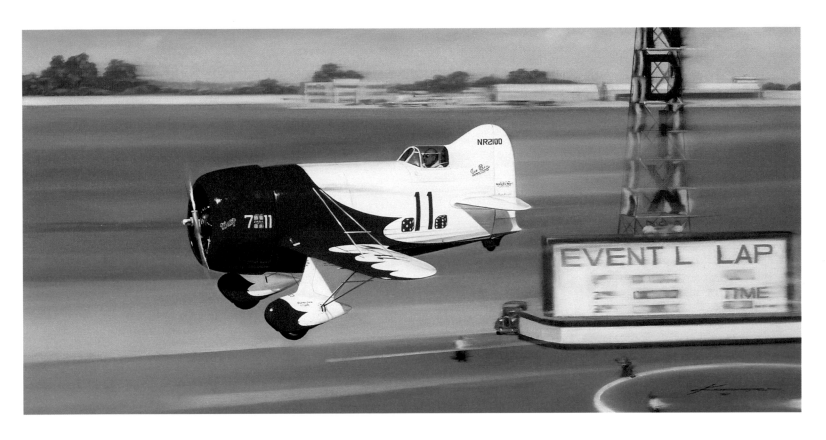

JIMMY AND THE GEE BEE by Craig Kodera, oil, completed 1990, collection of The Greenwich Workshop.

The Winnie Mae

by Bob Cunningham

Wiley Post lost his left eye in an oil field accident, but it did not deter him from pursuing his dream to fly. Hired by wealthy Oklahoma oil man F. C. Hall as a personal pilot, Post flew a Lockheed Vega known as a fast airplane and built in quantity with the demands of businessmen in mind. The airplane was named the *Winnie Mae*, after Hall's daughter.

Not content to ferry his employer from meeting to meeting, Post sought to make a mark in the exciting world of 1930s aviation. His first noteworthy success came with his win, at the controls of the *Winnie Mae*, of the 1930 Men's Air Derby from Los Angeles to Chicago. This accomplishment put him and his specially modified Vega in the public spotlight.

The following year, Post's undertaking would be a flight around the world in the same airplane. His plans called for further modifications to the *Winnie Mae*, including replacement of the standard pilot's seat with a comfortable armchair. Because of the distances involved and the still primitive state of aids to aerial navigation, Post wisely chose to be accompanied by Harold Gatty, a skilled and experienced navigator. The two men departed on the momentous journey into marginal weather conditions. Their route was strewn with hazards of every variety. But the determination of Post and Gatty, coupled with the help of people they encountered along the way, led to the completion of the globe-girdling course in only 8 days, 15 hours, and 51 minutes, a new record.

Post's appetite was by no means sated. In 1933 he set out to fly the *Winnie Mae* around the world again, this time by himself. New instruments, an autopilot, and an automatic direction finder, crude though they may have been, were installed in the airplane. The obstacles on this marathon journey were, like the prior global flight, immensely challenging. Nevertheless, Post pulled through, incredibly knocking nearly a whole day off the time of his previous flight. This represented the first solo aerial circumnavigation of the world. The *Winnie Mae* can be seen today at the Smithsonian Institution's National Air and Space Museum, along with one of Post's pilot pressure suits which he used in high altitude research.

For information about the artist, Bob Cunningham, please see page 36.

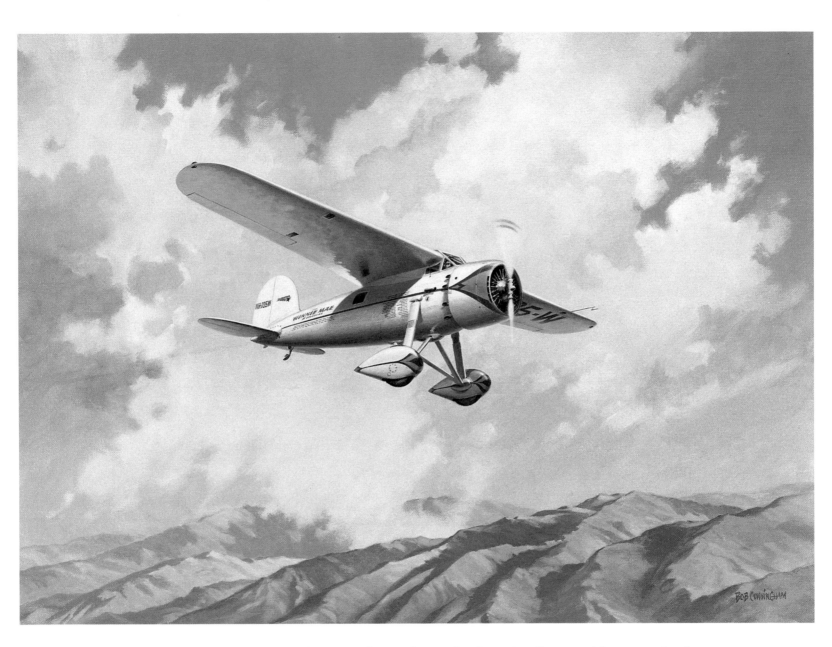

THE WINNIE MAE by Bob Cunningham, oil, completed 1987, collection of the artist's family.

The Gamma

by Merv Corning

The speed king of long-distance record-setting, Frank Hawks, wanted a faster cross-country airplane than anything yet built, and the brilliant John K. "Jack" Northrop was willing to oblige. In 1933, the airplane that emerged was the Gamma 2A, a sleek all-metal, cantilevered monoplane. Northrop determined that the Gamma would perform better with fixed landing gear shrouded in aerodynamic spats than with the extra weight that retractable landing gear would entail. The power plant was the fourteen-cylinder Wright Whirlwind with a full cowling. The wing, boasting the strength of the trademark Northrop multicellular construction, had full-span flaps and unusual "floating" or "parkbench" ailerons. Huge, elegantly tailored fillets between the wing and fuselage added classic lines to the harmonious design.

Sponsored by the Texaco Company, the Gamma 2A was emblazoned with the oil giant's bright Sky Chief markings. Frank Hawks piloted this airplane on June 2, 1933, nonstop from Los Angeles to New York. His speed of 13 hours and 27 minutes set a new transcontinental record. Only sixty-two Gammas were built, but they gained fame disproportionate to their numbers. The likes of financier Howard Hughes and aviatrix Jacqueline Cochran flew the Gamma. Notably, the aerial explorer Lincoln Ellsworth, also sponsored by Texaco, flew the second Gamma, dubbed the *Polar Star*, on a successful expedition to Antarctica.

For information about the artist, Merv Corning, please see page 16.

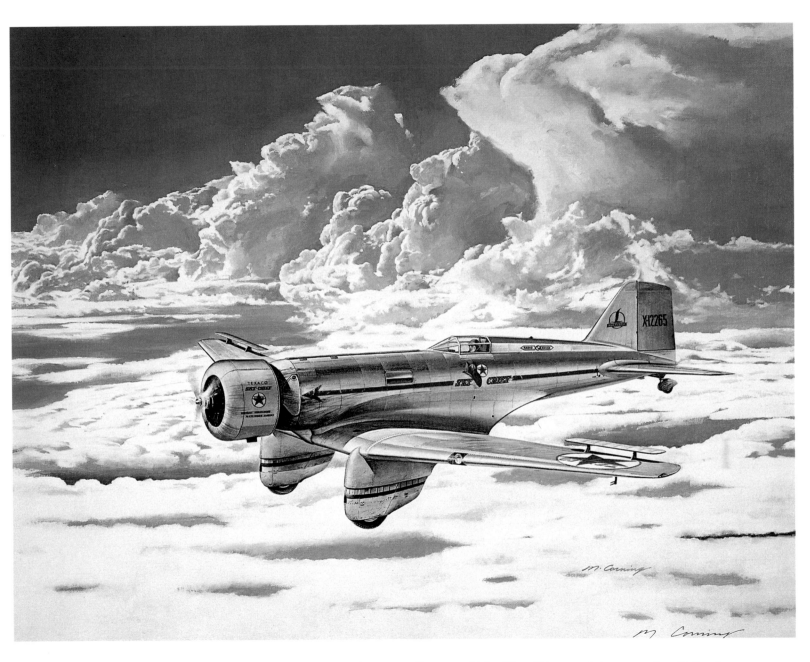

THE GAMMA by Merv Corning, oil, completed 1974, collection of Nut Tree Historical Aviation Art Collection,
Nut Tree, California.

When the Air Corps Flew the Mail

by Nixon Galloway

The early 1930s saw the emergence of airline companies that profited from government airmail contracts if not from Depression-era passenger travel. There were those in Congress, however, led by Alabama's Senator Hugo Black, who cried foul over what they perceived as favoritism in the awarding of airmail contracts to the larger airlines. Sympathetic to these criticisms of big business, President Franklin Roosevelt asked if the Army Air Corps could handle the job of flying the mail. Maj. Gen. Benjamin Foulois, chief of the Army Air Corps, responded affirmatively, perhaps interpreting the inquiry as an order and also, as an advocate of an independent air arm, wishing to prove the efficacy of his branch of the army. What followed was an episode marked with gallantry and tragedy.

As the Army Air Corps took over the airmail routes from the established carriers in February 1934, the country was suffering the worst winter in years. Depicted in this image of a Douglas B-7 is the harsh environment army pilots confronted when they first got the call to fly the mail. These pilots were fiercely determined to make a success of their mission.

Unfortunately, the army pilots were not skilled in cross-country navigation by instruments; they had been trained, by and large, to fly daylight missions against an enemy they could see. Furthermore, the army's airplanes were ill-equipped to carry the mail. In the first three weeks of the Army Air Corps' participation in the "airmail emergency," ten army pilots died in crashes.

The public uproar over what was called "legalized murder" by World War I ace and then airline executive Eddie Rickenbacker brought a reversal in the government's position. The army instituted stricter maintenance measures, pilot training, and permissible weather minimums. These actions helped to improve the performance of the Army Air Corps dramatically. But too many deaths had occurred, marring the Air Corps' image, even though it carried on until June 1, 1934. The airlines, with perfunctory changes mandated by the government, resumed carriage of the mail in their well-suited passenger planes.

For information about the artist, Nixon Galloway, please see page 22.

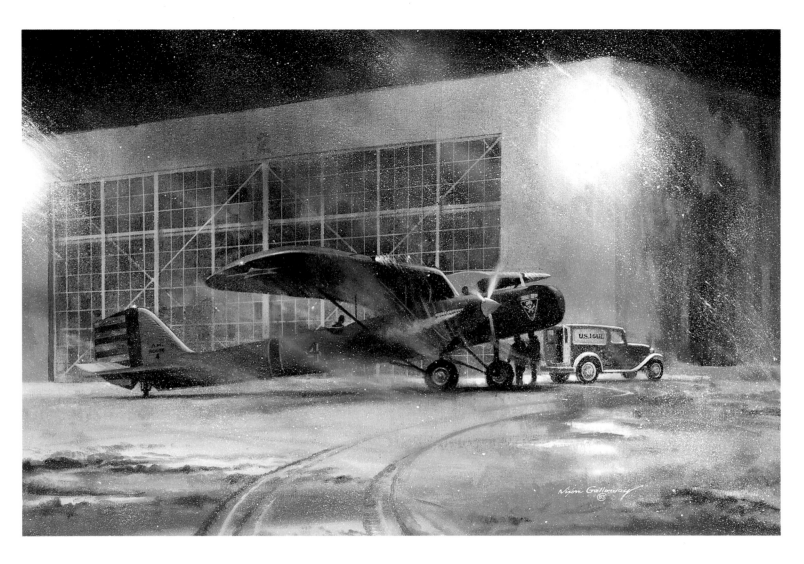

*WHEN THE AIR CORPS FLEW THE MAIL by Nixon Galloway, oil, completed 1983,
collection U.S. Air Force Art Collection.*

Midnight to Breakfast

by Walter Jefferies

During its infancy, commercial air transport was anything but glamorous for passengers. In 1926 the ungainly Ford Trimotor was introduced. Nicknamed the "Tin Goose" for its extensive use of corrugated duralumin, the Ford actually did little to enhance comfort as the airplane was noted for its high noise level and poor temperature control. Nevertheless, its ruggedness and reliability were welcomed by the airlines.

The manufacture of the Trimotor benefitted from the mass production expertise of the great automobile magnate Henry Ford. The modern plant that turned out Trimotors employed the most advanced manufacturing techniques of the day. The assembly-line methods used to build this metal goliath were as visionary as the airplane itself. The most successful version of the Trimotor was the 5-AT (for "air transport") which featured three 420-horsepower Pratt & Whitney Wasp radial engines.

Here, a United Air Lines Trimotor 5-AT-D, registration number NC 439H, cruises at a speed of between 100 MPH and 120 MPH through a partly cloudy sky with a full load of thirteen passengers. It is on its way to New York City after a midnight departure from Chicago. Estimated time en route is 7 ½ hours—just in time for breakfast on arrival. The cluster of lights below represents a town, which serves as a landmark for the two pilots. While the landscape below seems oblivious to the passing airliner, a new age in air travel has been born. In the progression of airliner development, however, the lumbering monumental Ford Trimotor would eventually be eclipsed by Boeing and Douglas aircraft designs.

Walter "Matt" Jefferies

Matt served as an electrical specialist with the Army Air Force during World War II where he accumulated overseas flight time in bombers like the B-17. Following the war, he worked for the Engineering Research Corporation, manufacturer of the unique Ercoupe, as an illustrator and salesman. He eventually became an artistic consultant to the film and television industry and developed a long list of credits including the design of the imaginary spaceship *Enterprise* for the "Star Trek" television series. He and his wife, Mary Ann, are often found tinkering with their immaculately restored 1935 Waco Custom YOC at Santa Paula Airport in southern California.

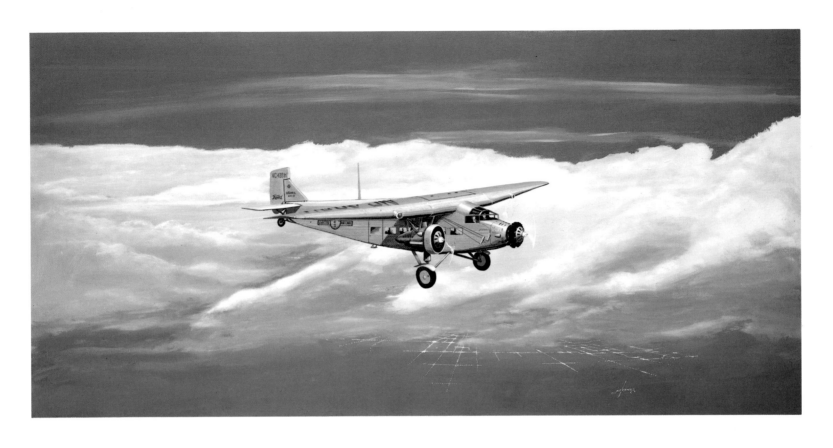

MIDNIGHT TO BREAKFAST *by Walter Jefferies, acrylic, completed 1981, collection of the artist.*

Dusting the Ridgeline

by William Phillips

When the newly founded Beech Aircraft Company introduced its first product in 1932, the airplane's curvaceous lines and superior performance turned more than a few heads. Indeed, as the design evolved over the next few years, Beech offered the option of a 690-horsepower Wright Cyclone engine. With this power plant installed the airplane could fly at 250 MPH, faster than the U.S. Army's pursuit planes at the time. This special Beechcraft was once owned by Howard Hughes. A different version of the same basic design was the airplane of choice for the first female winner of the Bendix Trophy. And in a Pratt & Whitney powered version, famed aviatrix Jacqueline Cochran set speed and altitude records. This splendid flying machine was officially tagged the Beechcraft Model 17, but was called the "Staggerwing."

Many biplanes had staggered wings. Ordinarily the upper wing's leading edge was forward of the lower wing's leading edge, making for what is known as a positive stagger. Instead, the Staggerwing had a pronounced negative stagger. The fuselage was of an aerodynamic "teardrop" shape, and the wings were joined by a single "I" strut on each side of the fuselage. Later models incorporated fully retractable landing gear, and the occupants traveled in the comfort of an enclosed cockpit that could be upholstered in leather. The military saw the utility of this airplane and ordered large quantities as personnel transports during World War II.

The Staggerwing, designed as the successful businessman's ultimate mode of transportation, lived up to customers' expectations and put the company started by Walter and Olive Beech along with their associates on a sound footing for the explosive growth of future years. From their humble beginnings borrowing space in Clyde Cessna's Wichita factory, the tiny band of Beechcrafters established a solid reputation for excellent products, quality workmanship, and caring service.

For information about the artist, William Phillips, please see page 40.

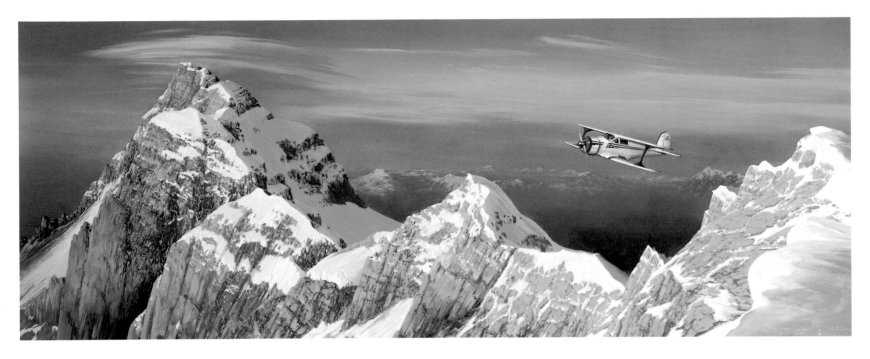

DUSTING THE RIDGELINE by William Phillips, oil, completed 1990, collection of the artist.

Felix Leaves Sara

by James Dietz

From 1932 to 1938, the stylish Boeing F4B-4 single-seat, open-cockpit biplane was part of America's first line of defense in the event of war. By the end of its service life it had become an anachronism for enclosed cockpits and monoplanes had come to dominate aircraft design, but its sharp performance and good looks made it a navy favorite of the time. The F4B-4 had a sheet aluminum fuselage and the five-hundred-horsepower Pratt & Whitney R-1340D engine. A fifty-gallon auxiliary fuel tank fitted to the belly could substantially enhance the aircraft's range.

Cartoon character "Felix the Cat" was adopted as the symbol of the navy's VF-6 (Fighting Squadron 6), which was assigned with its F4B-4s to the aircraft carrier USS *Saratoga* from October 1932 to June 1936. The squadron's airplanes showed a black silhouette of "Felix the Cat" running with a short-fused bomb. This tradition of squadrons painting a figure onto the sides of their airplanes is still very much alive today.

Aircraft carriers like the *Saratoga* had straight flight decks which brought arriving or departing airplanes close to the island, the massive superstructure atop the deck. The safer and more efficient angled flight decks were not introduced until after World War II. Deck space was freed up by mounting the tails of the F4B-4s on outriggers that protruded outward perpendicularly from the flight deck. This F4B-4 is launching from the flight deck by means of a flywheel-type catapult. Hydraulic catapults were introduced next, and today's carriers use steam catapults.

The view provided by this image also shows the eight-inch gun turrets that equipped the *Saratoga*. These were later replaced with twin five-inch dual-purpose guns.

The F4B-4s were not heavily armed. They were the last fixed-gear biplane fighters in the U.S. Navy inventory. In the early war years many were destroyed as radio-controlled target drones.

For information about the artist, James Dietz, please see page 14.

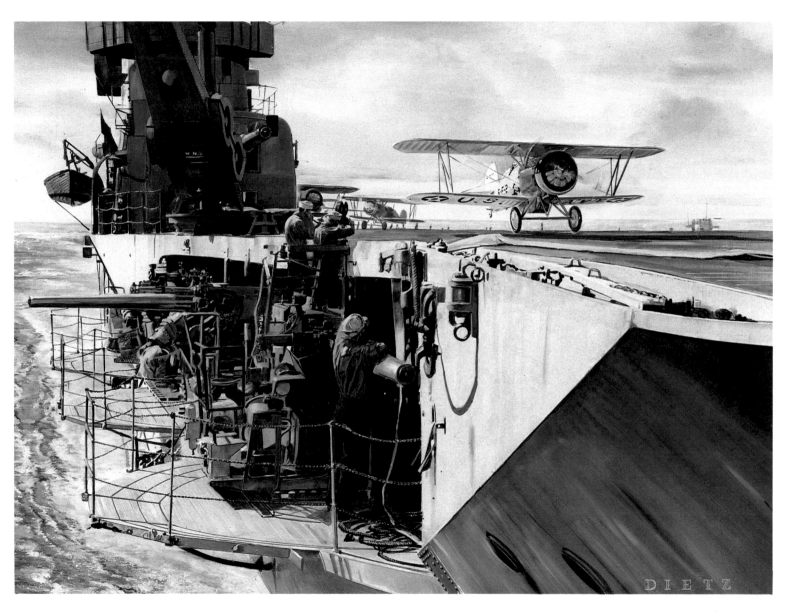

FELIX LEAVES SARA by James Dietz, oil, completed 1989, private collection.

Early Risers

by John Paul Jones

The last of the U.S. Army's biplane pursuit aircraft, the Boeing P-12, was a product of the Boeing Airplane Company's in-house development. It was a peppy performer, endearing itself to the pursuit pilots of the early 1930s. Not only were army pilots afforded the opportunity to fly this nimble open-cockpit job, but in a rare instance of joint use of the same design, the navy acquired the same basic airplane (with such obvious modifications as tail hooks) as the F4B series.

The first prototype of this biplane fighter, known as Model 83, flew initially on June 25, 1928, and then underwent an extensive navy evaluation. A subsequent prototype, Model 89, was lent to the army, which soon recognized the aircraft's potential. Delivery of the first production batch of P-12s to the army was completed by April 1929.

The P-12E, which entered army service in the fall of 1931, was powered by the five-hundred-horsepower Pratt & Whitney R-1340-17 Wasp radial engine. It was barely over twenty feet in overall length and normally weighed just 2,674 pounds at takeoff. Not surprisingly, the agile pursuit plane could achieve a maximum speed in level flight of 189 MPH. Signalling the increasingly sophisticated nature of aircraft, the traditional tail skid was re-placed with a tail wheel.

In this image by artist John Paul Jones, a pair of P-12Es of the 77th Pursuit Squadron, 20th Pursuit Group, have taken off on a training mission in the pre-dawn darkness. The two pilots have guided their planes through the breaks in the cloud layer and climbed to a cruise altitude in calm air. At that moment, the first hint of a brilliant sun shines over the clouds, casting them in a purplish tone and illuminating the morning sky. The onrushing air is no doubt whistling through the flying wires as the big radial engines roar. The pilots are probably exercising their toes, as it is cold in the morning at cruise altitude. Being pursuit pilots they are adept at aerobatics so instead of flying straight and level, they limber up by banking and rocking their wings. The crisp beauty of morning flight envelops them. The first glimpse of sunrise from the air was the privileged realm of pilots.

For information about the artist, John Paul Jones, please see page 34.

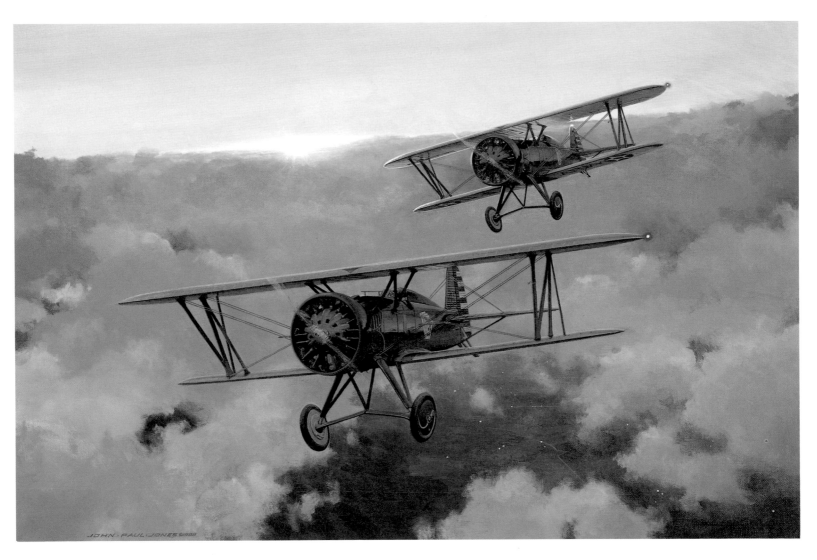

EARLY RISERS by John Paul Jones, acrylic, completed 1988, private collection.

Over Revere Beach

by Ray Crane

In June 1932, Lockheed was newly reorganized, having been resurrected from the moribund Detroit Aircraft Corporation, so that the company's viability hinged in large measure on acceptance of its new products. Lockheed's savvy chairman in the Depression years, Robert Gross, knew that the utility of the single-engined passenger airliners was giving way to the greater carrying capacity of the more economical twins that also offered the safety of a second power plant. Lockheed's 1934 entry into the commercial airline market was the Model 10A Electra, an all-metal, low-wing airplane with a pair of 450-horsepower Pratt & Whitney Wasp Junior SB engines. The Electra was easily distinguished from its two larger Boeing and Douglas competitors by its twin fin arrangement. It could carry its crew and ten passengers at a cruise speed of 190 MPH.

Numerous wind tunnel tests performed at the University of Michigan by a graduate student named Clarence L. "Kelly" Johnson showed serious flaws in the proposed Lockheed design. The testing demonstrated that installing a double vertical tail, among other modifications, would solve the problems. This design characteristic of a repeating vertical tail became a Lockheed trademark incorporated in subsequent designs for planes as diverse as the Lightning fighter and the Constellation airliner. Kelly Johnson, who almost lost his employment opportunity with Lockheed because of his outspoken advocacy of the unconventional tail design, became the company's top designer, spending his entire career with Lockheed and evolving as a legend within the aerospace industry.

In this image by artist Ray Crane, a 10A in the colors of Boston-Maine Airways (later Northeast Airlines) is depicted in 1936, the year of the airplane's acquisition, on approach to Boston from the northeast. The passengers on board are treated to a splendid view of Revere Beach, a popular amusement center that featured roller coasters, fun houses, and carrousels. It was a haven for sunbathers, a place that provided respite from the cares of the everyday world, where there were no reminders of the push of modern society except for the occasional hum of radial engines in the sky.

Raymond Crane

Ray's love of aviation dates back to his childhood when he received a round-trip flight in an airliner as a birthday gift. A graduate of the School of the Museum of Fine Arts in Boston, he frequently uses New England settings for his aviation paintings. By focusing his efforts on commercial and general aviation subjects, he attempts to chronicle flight as a form of transportation, much as earlier artists concentrated on sailing ships and the railroads. He is artist-in-residence at the Charles Hayden Planetarium at Boston's Museum of Science where he creates artwork for the planetarium's multimedia productions. He and his wife, Monica, reside in Winthrop, Massachusetts.

OVER REVERE BEACH by Ray Crane, acrylic, completed 1989, collection of the artist.

S-42B in Hong Kong Harbor

by Andrew Whyte

By the early 1930s, Pan American Airways needed a longer-range and faster flying boat than those currently in its fleet, one capable of carrying more passengers to service its expanding overseas operations. This was the only way the airline could expect to open up the Atlantic and Pacific markets and make it pay. The Sikorsky factory offered the S-42, a huge, four-engined, high-wing design that could accommodate thirty-two passengers in unequalled comfort and walnut-lined luxury. The S-42 was still not sufficiently endowed with transoceanic range, so the first model, dubbed the *Brazilian Clipper*, was installed on the Miami-to-Rio de Janeiro route on August 16, 1934.

Another S-42, outfitted with extra fuel tanks, was employed by the airline to survey a Pacific route in April 1935. On the return leg from Hawaii to San Francisco, this S-42 encountered stiff head winds. The pilot wisely throttled back to conserve fuel. Landing five hours late after a total elapsed flight time of nearly twenty-four hours, the S-42's fuel tanks were checked and found to be nearly bone dry.

The S-42 was followed by even larger commercial flying boats, the Martin M-130 and the Boeing 314, which raised the standard of elegance of long-distance flight still further. Crew lounges and passenger dining rooms that featured silver tableware made the fatiguing trips across the Pacific more agreeable. Pan American built essential way stations, providing weather and navigational information, as well as rest facilities at strategic islands that dotted the Pacific route from Hawaii to the Philippines.

After an improved version of the S-42, designated S-42B, entered service in 1937, it was placed on the Pan American connector route between Manila and Hong Kong. The first of these was appropriately named the *Hong Kong Clipper*. Here, an S-42B is seen climbing out of Hong Kong harbor while a moored S-42B services passengers at the pier. Sadly, war was to impinge upon the halcyon days of the glamorous flying boats. At the same time that Japan attacked Pearl Harbor in a devastating rampage across the Pacific, the *Hong Kong Clipper* was destroyed in its home port.

Andrew Whyte

Andy's attraction to aviation is natural, for his father served in the Royal Flying Corps and later in the Royal Air Force. Influenced by his father's example, he became a flight engineer/gunner with the U.S. Navy during World War II. He flew in the Dauntless, Catalina, and Harpoon. He studied mechanical engineering at the University of Oklahoma, eventually returning to his native Connecticut where he joined Sikorsky Aircraft as a design engineer in the Advanced Design Group. Combining his engineering and art backgrounds, he has been involved in configuration work on his company's products for forty years, producing hundreds of paintings for the Sikorsky marketing and engineering departments. He also has been active in the Air Force Art Program. He and his wife, Pat, reside in Norwalk, Connecticut.

S-42B IN HONG KONG HARBOR by Andrew Whyte, oil and acrylic, completed 1990, collection of the artist.

Beechcraft Means Business

by Craig Kodera

The year 1937 marked the introduction of an airplane that was to enjoy one of the longest and most fruitful production runs in the annals of airframe manufacturing. The Model 18, as conceived by president Walter H. Beech and company engineer Ted Wells, was a handsome and spacious twin-engined utility airplane. Its appeal was for corporate and charter users.

Wood and fabric in aircraft construction were giving way to all-metal fuselages and wings, like those of Beechcraft's Model 18. Its ruggedness made it an airplane of choice in harsh operating environments such as the outback territories of Canada. Frigid temperatures and unimproved landing strips did not seem to faze the trusty twin Beech.

Recognizing the many fine attributes of this design and with the war looming over the horizon, the U.S. Army added the Model 18 to its inventory, notably as the C-45 Expeditor (transport), the AT-7 Navigator (navigation trainer), and the AT-11 Kansan (bombardier trainer). The U.S. Navy also bought the aircraft, designating it the SNB (navigation trainer and transport).

Production continued until the last twin Beech of this pedigree rolled off the assembly line in 1969. By then almost eight thousand Model 18s had been produced, a tribute to the staying power of a simple, practical, quality product. Popular even now among regional freight haulers for its availability and relatively low operating costs, the "old" twin Beech is often an hours-building airplane for commercial pilots aspiring to become airline captains. Today when one hears the reverberating clatter of radial engines overhead, chances are that the airplane above is a Beechcraft Model 18.

For information about the artist, Craig Kodera, please see page 62.

BEECHCRAFT MEANS BUSINESS *by Craig Kodera, oil, completed 1984, collection of the National Air and Space Museum, Smithsonian Institution, Washington, D.C.*

Hawaiian Patrol

by Craig Kodera

The Golden Age of Flight is replete with intriguing airplane designs that sported colorful paint schemes. The era seemed to belong to those adventurous souls who lived a kind of exhilarating life flying the magnificent new aircraft that were rolling off the assembly lines. In particular, the military planes of the mid- and late-1930s are a memorable lot for they managed to encapsulate the progressive mood that characterized the aviation community at the time. The army and navy designs of the period showed the traits of a new-born endeavor while they incorporated experimental features. The end products were thus exciting combinations of new and old as the whole industry forged into uncharted territory.

The Curtiss SOC-3 Seagull was a chunky biplane designed as a scout-observation aircraft for the U.S. Navy. In an age before radar and other sophisticated detection devices, the Seagull would be catapulted from cruisers on the high seas and would act as the eyes of the fleet, ranging up to 859 miles. As a seaplane, upon return it would settle onto the waters alongside its mother ship and be hoisted aboard for reuse. These delightful oversized biplanes countered their weight and drag with a 550-horsepower Pratt & Whitney radial engine.

The Seagull shown here during a routine patrol of the Hawaiian coast in the late 1930s is from the USS *Portland*. While the cruiser is anchored in Hawaiian waters, the Seagull is attached to VCS-5. In the carefree years between the world wars, flying was often like this—low, relatively slow, with canopies open for pilots to inhale the fresh air, banking gently over sparkling seas or unspoiled landscapes.

For information about the artist, Craig Kodera, please see page 62.

HAWAIIAN PATROL by Craig Kodera, oil, completed 1989, private collection.

The Great Silver Fleet

by Ray Crane

The legendary DC-3 had its birth in a lengthy telephone conversation in 1934 between Cyrus R. Smith, president of American Airlines, and Donald W. Douglas, the founder and head of the company bearing his name. Smith exhorted Douglas to come up with an enlarged and longer-range version of the DC-2s his airline was then flying. Though skeptical that such a design could be achieved and equally skeptical about the airline company's ability to pay for the bigger airplanes, Douglas worked with his trusty team of designers and engineers. By the end of the following year, an airplane that seemed to be in the right proportion took to the skies for the first time. It would dominate domestic airline service for years thereafter.

Known at first as DST, for Douglas Sleeper Transport, because of American's intention to use them on long routes that called for sleeping berths, the airplanes that would soon roll out of Douglas's Santa Monica, California, factory without provisions for sleeping berths were designated DC-3s. With its capacity for twenty-one passengers and its ability to hop across the country in an unprecedented 17 ½ hours with only three stops, there was nothing flying like this new DC-3. For the first time, airlines could be profitable transporting passengers alone and not have to rely on hauling the mail under contract. When the United States entered World War II, 80 percent of the airplanes operated by the nation's airlines were DC-3s. In the twelve-year production run, over ten thousand DC-3s and its variants were built.

In war the DC-3 took on new designations, chiefly the U.S. Army Air Force's C-47. By whatever designation, it performed amazingly well under the most extreme conditions. General Dwight D. Eisenhower went so far as to list the Douglas C-47 as one of the five pieces of equipment essential to victory in World War II.

The DC-3 in this image is flying to a destination somewhere in New England in the 1940s. It sports the colorful Eastern Air Lines paint scheme with a red peregrine falcon decorating the tail. Eddie Rickenbacker, who ran Eastern, envisaged the company's metal airplanes as "The Great Silver Fleet" and advertised his airline under that catchy phrase. This depiction of a DC-3 skirting weather is not unlike scenes occurring even today as DC-3s, though in less distinctive markings, lumber on, faithfully transporting freight throughout the world and providing living proof of the legend that transformed aviation.

For information about the artist, Ray Crane, please see page 78.

THE GREAT SILVER FLEET by Ray Crane, acrylic, completed 1988, collection of the artist.

FIGHTERS AT PORT MORESBY by Jack Fellows.

World War II

World War II hastened advances in aviation. Production lines began churning out combat aircraft with capabilities only dreamed of a few years before. Mass-produced piston-powered airplanes attained their performance zenith. As the internal-combustion engine, driving a propeller, reached its physical limitations, a whole new technology, jet propulsion, fostered an enduring revolution.

Both Axis and Allied nations mobilized their manufacturing resources. From their factories came a steady stream of airplanes. At the same time, efforts were undertaken to train thousands of young men to fly the new fighters, bombers, and transports. In an incredible feat of organization, the U.S. Army and Navy, using civilian flight schools, imparted a solid curriculum and good flying skills to droves of cadets.

Even before the United States' official entry into World War II, American fliers were fighting in the skies over Europe and Asia. Following the Royal Air Force's pivotal defense of Britain against the Nazi aerial assault in the summer of 1940, American pilots joined the RAF in special units known as the "Eagle Squadrons," seeking to assist the British in their attempt to repulse the forces of tyranny. On the other side of the globe, still more volunteer American pilots were banded together as the famous "Flying Tigers" to thwart Japanese imperialism.

Although America was caught off guard during the surprise attack on Pearl Harbor, it was not long before the "sleeping giant" stirred. On April 18, 1942, Jimmy Doolittle led a formation of sixteen B-25 medium bombers from the deck of the carrier *Hornet*, striking Tokyo for the first time. About six weeks later, a significant blow was inflicted against the Japanese fleet at Midway. The navy's Dauntless dive bombers wreaked havoc, contributing to the destruction of four Japanese aircraft carriers. This victory signaled a shift in the tide of war in the Pacific theater.

In Europe the 8th Air Force was conducting an unprecedented build-up for precision daylight bombardment raids as the RAF proceeded with heavy area bombardment at night. Huge formations of American B-17 and B-24 long-range heavy bombers began attacking targets in Germany in early 1943. But the Luftwaffe's fighters often caused devastating losses to the U.S. bomber force.

A partial solution emerged when World War II's ultimate fighter aircraft, the P-51 Mustang, outfitted with the legendary Rolls-Royce Merlin engine and two external 110-gallon fuel tanks, entered service with the 8th Air Force. Now, a year after the first U.S. raids over Germany, the heavy bombers could go all the way with fighter escort. Day-and-night pounding from above eroded the German military's fuel supplies. The Allied forces had set the stage for air superiority in Europe.

The war produced a variety of unusual planes, not the least of which was the Me 163 Komet, a tailless rocket-propelled interceptor with swept wings. Unlike the Komet, which was plagued with numerous drawbacks, another of Nazi Germany's wonder weapons, the Me 262, proved to be a menacing addition to the Luftwaffe's arsenal toward war's end. The Me 262, the world's first operational jet fighter, was aerodynamically sculpted, sporting a swept wing, and could attain a top speed of over 500 MPH. This aircraft was more advanced than anything the Allies possessed at the time. While its arrival late in the war prevented it from having great impact, its design was clearly the shape of things to come.

89

Gloster Gladiator

by Jo Kotula

A mid-1930s product of the Gloster Aircraft Company's Hucclecote factory, the Gladiator was the last of Britain's biplane fighters. Like other airplanes of the period, the Gladiator combined old-fashioned features with forward-looking ones. The production Gladiators featured an enclosed cockpit with a sliding canopy and not merely nose-mounted machine guns but also a pair under the lower wings. The Gladiator was surprisingly fast with its powerful Bristol Mercury engine, able to reach a top speed of over 250 MPH. Its rate of climb was spectacular for a biplane.

Despite being superseded by newly introduced Hurricanes and Spitfires almost from the day it became operational, the Gladiator saw action throughout Europe and the Middle and Near East during the early years of World War II. When Italian aircraft attacked the strategic central Mediterranean island of Malta in June 1940, the slim British force was outnumbered. Among the defending fighters were three Sea Gladiators, Royal Navy variants. These were nicknamed *Faith*, *Hope*, and *Charity*. These outmoded biplanes performed admirably, helping to fend off the attacker until more modern fighters arrived. Also, Gladiators successfully defended Aden in a dramatic display of fighter pilot aggressiveness. A Gladiator pilot even forced an enemy submarine into surrender. And one of Britain's leading aces, Flight Lieutenant M. T. St. J. Pattle, scored a large number of his over thirty victories flying the Gladiator. As modern fighters began reaching the front, the feisty Gladiator was withdrawn from combat.

Jo Kotula

From childhood, Jo was inspired by the masterful World War I aircraft paintings of Henri Farré, an impressionist with his sights on the sky. Without so much as a high school diploma, Jo traveled nationwide, settling as a free-lance artist in New York. Starting in the 1930s when he earned his pilot's license, he would use his small airplane to deliver his paintings. His work has appeared in publications as diverse as *The Saturday Evening Post* and *Model Airplane News*. He was one of the five founding members of the American Society of Aviation Artists. He and his wife, Charlene, live in Asbury, New Jersey.

GLOSTER GLADIATOR
by Jo Kotula, *opaque gouache,*
completed 1961, collection
of the artist.

Lady of the Lakes

by James Dietz

As storm clouds gathered over Europe, the Norwegian government ordered two dozen floatplanes for offshore patrol duty from Northrop Aircraft. These airplanes were designated the N-3PB (for Northrop Patrol Bomber), but Norwegians called them simply "the Northrops."

Outfitted with two bulbous Edo floats, the N-3PB had a cumbersome appearance. Yet, powered by the twelve-hundred-horsepower Wright Cyclone GR-1820-G200 engine, it could attain an astounding maximum speed of 257 MPH, thereby earning for itself the title of the world's fastest military seaplane to date. Its cantilevered low-wing configuration was a hallmark of John K. "Jack" Northrop's designs.

By the time the first production models were ready for delivery, Norway had been occupied by the Nazis. The twenty-four N-3PBs were, however, delivered to the 330th Squadron of the Royal Norwegian Naval Air Force stationed in Iceland and operated as a unit of the British Royal Air Force. The heavy armament of the N-3PBs included four forward wing-mounted .50-caliber machine guns, a .30-caliber machine gun for the rear top gunner-observer, a .30-caliber machine gun for the lower rear gunner-bombardier, and a bomb or torpedo load of up to two thousand pounds.

Based at coastal positions without benefit of hangar facilities, the N-3PBs labored as convoy escorts and on submarine patrols. None was ever lost to enemy fire, but weather conditions were so atrocious that during the early deployment of the N-3PBs nine were claimed in landing accidents. The N-3PBs were still able to accumulate a commendable combat record that included a hand in the sinking of the *Bismarck*.

Flight testing of the N-3PBs commenced on November 1, 1940, at Lake Elsinore in southern California. Artist James Dietz has captured the early flight trials of the N-3PBs on these placid waters far removed from the hostile conditions awaiting the Northrop floatplanes.

For information about the artist, James Dietz, please see page 14.

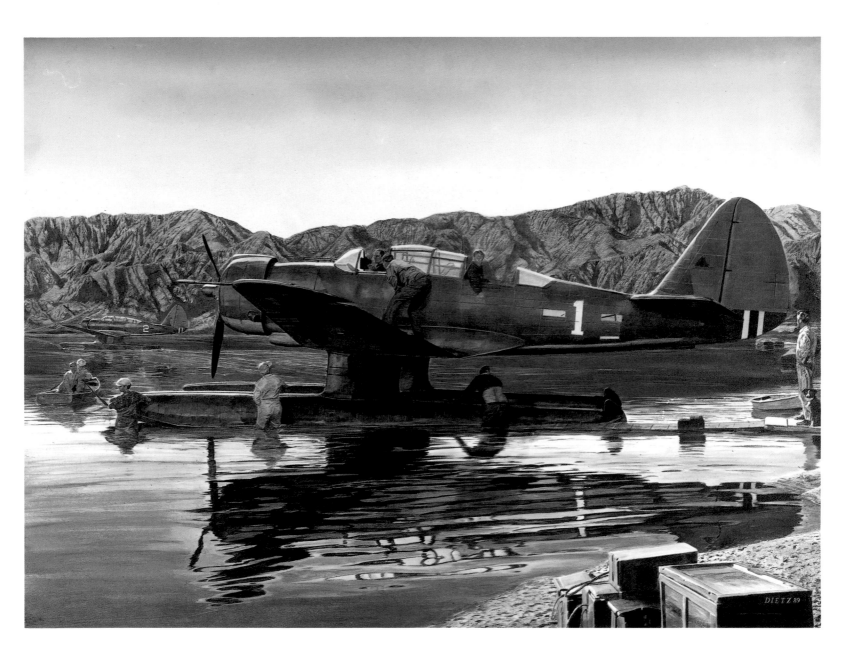

LADY OF THE LAKES by James Dietz, oil, completed 1989, private collection.

A Time of Eagles

by William Phillips

When the whole of Europe except for Great Britain came under Nazi domination, well before the surprise attack on Pearl Harbor that drew the United States into World War II, 240 American fliers volunteered to fight the Luftwaffe alongside the gallant pilots of the British Royal Air Force. The volunteers were attracted variously by the nobility of the cause and the adventure of the flying.

The idealistic Americans were formed into three distinct RAF squadrons—71, 121, and 133—which were called the "Eagle Squadrons." Untested in combat, they entered the fray alongside the seasoned pilots of RAF Fighter Command and soon made a mark that would be hailed not only by the British citizenry but by their fellow countrymen as well. From this group of young volunteer pilots who were among the first Americans to fight the Third Reich came many aces and outstanding commanding officers.

A member of No. 71 Squadron, Oscar Coen, a North Dakotan who had been a schoolteacher, participated in the Eagles' first successful air-to-air encounter with the enemy on July 2, 1941. Nearly four months later, while attacking ground targets over France, he was shot down. Evading capture in France and Spain, he was ferried back to reunite with his squadron. In William Phillips's painting, Oscar Coen is at the controls of the preeminent British fighter, the Spitfire.

After the United States entered the war, the Eagle Squadrons were transferred to American command. At a ceremony marking the end of the eighteen-month Eagle Squadron experience, Air Chief Marshal Sir Sholto Douglas lamented the parting and made note of the 73 ½ Luftwaffe aircraft the American pilots had destroyed. Today in London's Grosvenor Square, in the shadow of the American Embassy and across from the Franklin Roosevelt statue, is a simple monument to those Americans who flew with the Eagle Squadrons in the struggle for freedom.

For information about the artist, William Phillips, *please see page 40.*

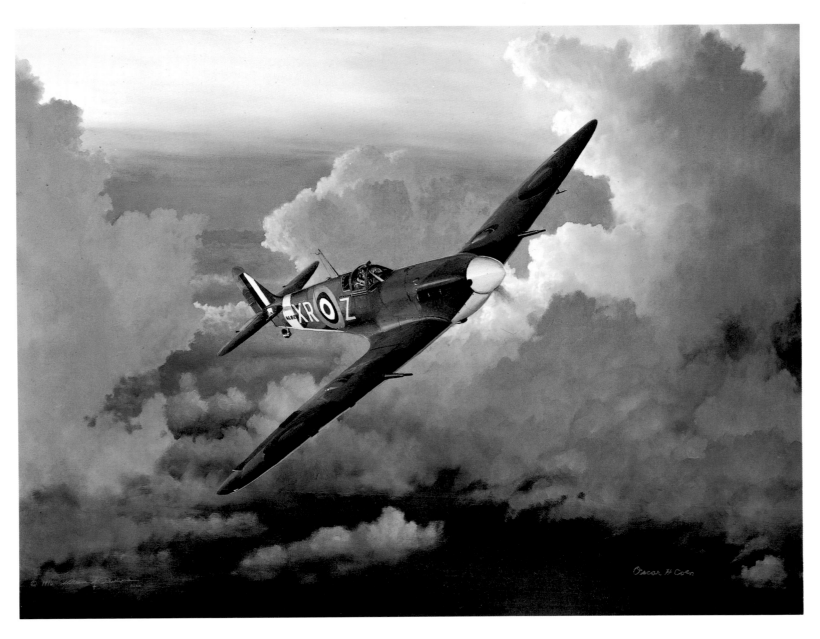

A TIME OF EAGLES *by William Phillips, oil, completed 1990, collection of the artist.*

Sikorsky's First Helicopter

by Andrew Whyte

Vertical flight entered a new era on December 8, 1941, when after decades of dreaming and a few years of concentrated research, Igor Sikorsky personally piloted the greatly refined final version of his VS-300. Sikorsky's first delvings into the world of helicopters occurred some thirty years earlier in Russia. War, then revolution, followed by emigration, and the ever-present realities of the marketplace, forced a lengthy postponement of his pursuit of practical vertical flight. Ironically, the failure of his flying boat enterprise to turn a profit by the late 1930s prompted Sikorsky's employer, United Aircraft and Transport Corporation, to relegate the talented inventor to the research area of his choice—helicopters. While saddened by the demise of the flying boats business, Sikorsky was elated over his new assignment.

Since the invention of the autogiro, European experimenters had made strides in the pursuit of vertical flight. One concept called for a pair of horizontal counter-rotating rotors to share a single shaft, while another envisioned two horizontal rotors mounted on separate shafts with sufficient spacing to create a kind of eggbeater effect. Sikorsky, working with aides in his Connecticut shop, tinkered with the notion, tempered through trial and error, that a helicopter would fly best if it had a main overhead rotor and a smaller tail rotor to balance torque. In the course of developing the VS-300, he struggled with the problem of control. The answer came when, after extensive testing, he removed the horizontal tail rotor and restored cyclic pitch control to the main rotor exclusively. With only the vertical anti-torque rotor retained on the tail boom and with cyclic pitch changes now possible in the main rotor, the enigma of the helicopter's longitudinal and lateral control was solved.

The U.S. Army recognized the value in such a flying machine and soon placed orders for hundreds of helicopters based on Sikorsky's design. In its most dramatic early application the helicopter was an angel of mercy, rescuing those in need of medical attention, a role it still fulfills. As time wore on, the helicopter's uses expanded—from assault missions in war to rush hour traffic reporting in major cities. Vertical flight is an accepted part of everyday life.

For information about the artist, Andrew Whyte, please see page 80.

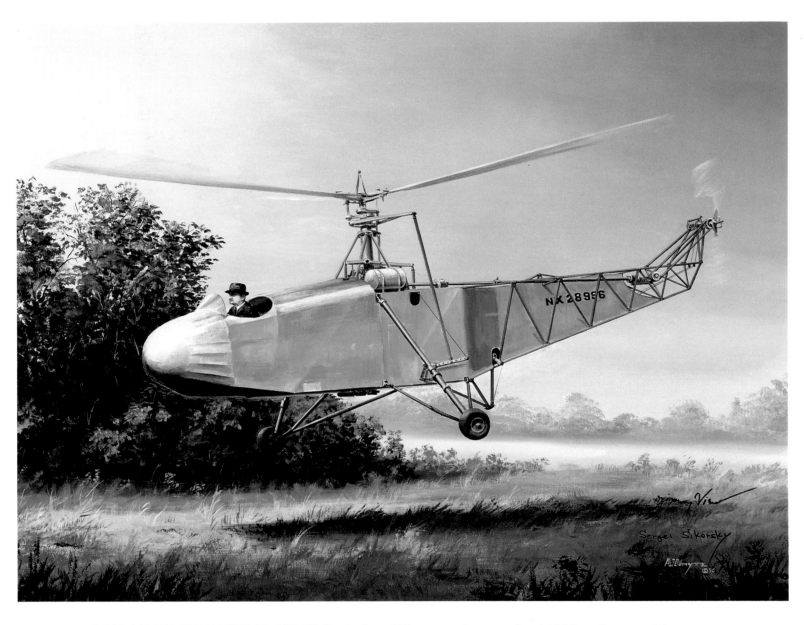

SIKORSKY'S FIRST HELICOPTER by Andrew Whyte, acrylic, completed 1990, collection of the artist.

Doolittle's B-25

by John Paul Jones

At 08:20 hours on the morning of April 18, 1942, sixteen North American B-25 Mitchells, named for the upstart army flier who had years earlier forecast a surprise attack by the Japanese on U.S. forces, launched into a low overcast from the USS *Hornet*. The army medium bombers under the command of Lt. Col. James H. "Jimmy" Doolittle were a rarity on an aircraft carrier flight deck, but this was a special mission, America's first raid on the Japanese mainland—a long-awaited answer to the bombing of Pearl Harbor. Stripes were painted down the *Hornet's* flight deck to guide the army pilots on their takeoffs. There was a mere six-foot clearance between the B-25's wing tips and the carrier's island superstructure as the Mitchells roared off into the sky.

The Doolittle raiders, all volunteers, were forced to embark on their mission a day ahead of schedule because of a Japanese picket boat's discovery of their naval task force. This meant that their distance to the target was about 650 miles as opposed to the desired 400 miles and raised doubts about their ability to reach the planned landing site in China.

The raiders hit predetermined military and industrial targets in and around Tokyo, having broken through the Japanese home defense. But as they finished their successful low-level bombing runs and veered toward the distant Chinese coast, the real test had just begun. Depicted here is the lead ship, Jimmy Doolittle's B-25, as it turns away from the Japanese shoreline toward more hospitable territory. Approximately thirteen hours after leaving the *Hornet,* Doolittle's fuel was almost depleted. Not knowing his exact position and unable to reach friendly forces by radio, Doolittle ordered his crew to bail out.

Luckily, Doolittle and his crew came down uninjured in friendly territory. At the time, of course, he was unaware of the condition of the other fifteen crews and feared the worst. Most of the other crews did survive after either bailing out or crash landing.

In terms of damage inflicted, this first Tokyo raid would be vastly overshadowed by the destructive power of waves of heavy B-29s from island bases later in the war. But Japan knew from that point that it was no longer immune to the sleeping giant it had stirred. Also, when prospects in the struggle for democracy looked bleak, the Doolittle raiders provided the American public and its friends with a glimmer of hope.

For information about the artist, John Paul Jones, please see page 34.

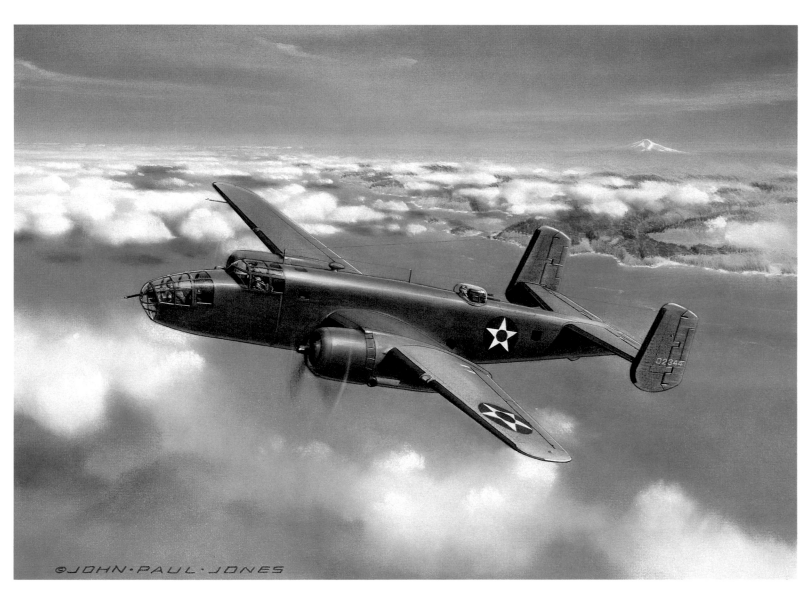

DOOLITTLE'S B-25 by John Paul Jones, pastel, completed 1977, collection of the artist.

Unsung

by James Dietz

Commissioned to celebrate the seventy-fifth anniversary of U.S. naval aviation, this portrait depicts the essential yet unheralded aviation machinist's mates below the flight deck who, for long periods of time, did not see the light of day as they toiled away on critical aspects of the aircraft carrier's airplanes. Aboard a flattop somewhere on the high seas in 1942, a Douglas SBD Dauntless has been lowered into a cavernous hangar bay for minor engine repairs.

While the attention of the mechanics (and their mascot) has been momentarily distracted from the tedious work, the long hours will wear on as the carrier air group commander urgently needs his dive bombers prepared for an impending mission. Without fanfare, the maintenance crew will commit the necessary time and effort to ensure that the airplanes under their responsibility will be ready for combat when the call comes. These nearly anonymous souls are the key to what kept U.S. Navy aircraft flying off the navy's carrier decks in World War II.

Adm. Arthur Radford, when speaking of his duty aboard the revered USS *Enterprise* during World War II, described the aircraft carrier as "an almost mystical blending of men and metal into one of the most efficient fighting machines in the history of war at sea." The indomitable spirit of the two thousand men on such a ship, assigned mostly to unglamorous jobs, explains much of the success of naval aviation.

Stories abound of seamen, shipfitters, and petty officers jeopardizing their own safety in battle to save shipmates. In a specific instance, while a carrier was taking hits during an attack in the Pacific, a group of sailors organized themselves into a human chain to remove explosives from a burning compartment. Others waded into compartments billowing with smoke, treading over a slippery and odd mixture of blood, foam, water, and oil to search for unconscious compatriots whom they rescued by pulling out. Diligence and heroism have always been integral parts of the operation of the navy's aircraft carriers.

For information about the artist, James Dietz, please see page 14.

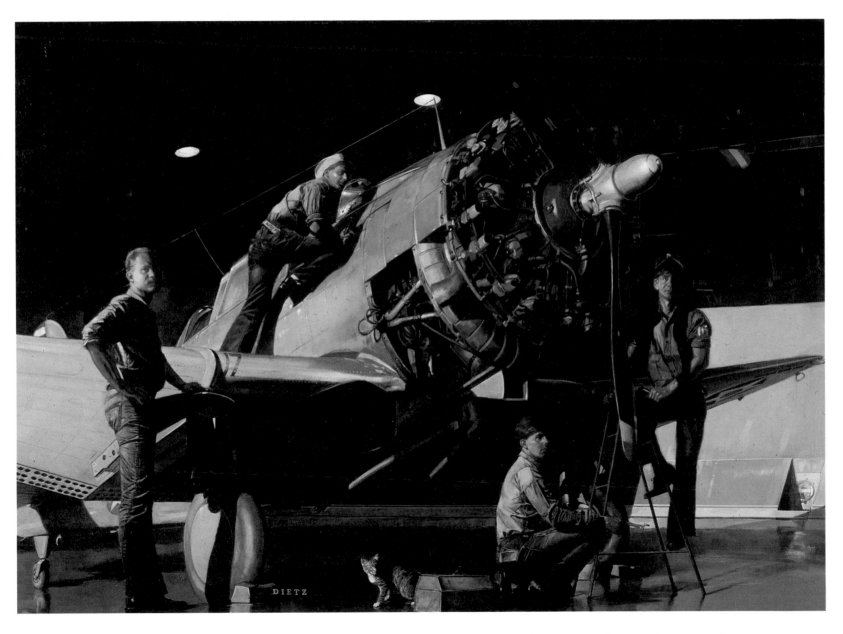

UNSUNG by James Dietz, oil, completed 1987, collection of the Secretary of the Navy, on loan to the National Museum of Naval Aviation, Pensacola, Florida.

Best on Deck

by James Dietz

During the bleak early days of the war, as the free world faced an uncertain future, the outcome of the great carrier battle of Midway ultimately would be decided by the extraordinarily courageous acts of dedicated men with a fighting spirit.

On June 4, 1942, on the distant waters of the Pacific, more than one thousand miles west-north-west of Pearl Harbor, young naval aviators embarked on an array of flights against the Japanese fleet. Their attacks were not without tragic losses. The obsolete Douglas Devastator torpedo bombers were ripped apart. But the newer SBD (for Scout Bomber Douglas) Dauntless dive bombers were deployed and had a considerably different impact. Under the able leadership of Rear Adm. Raymond A. Spruance, the U.S. carrier task force's airplanes sank the Japanese carriers *Kaga, Akagi, Hiryu,* and *Soryu.* Although the U.S. Navy's loss of the *Yorktown* hurt, the battle was a decisive victory for the United States and contributed to the establishment of the aircraft carrier as a dominant vessel in warfare.

This painting depicts a scene from that crucial battle, as navy Lt. Dick Best prepares to launch in his Dauntless from the deck of the USS *Enterprise.* A carrier flight deck is a dangerous place and all the more so as crews scramble to launch aircraft. As can be seen, the deck crewmen wear color-coded tunics, each representing a different function. Reflecting the elementary communications systems available in those days, a last-minute mes-sage is conveyed by blackboard to Lieutenant Best just before he releases brakes for the catapult.

For information about the artist, James Dietz, please see page 14.

102

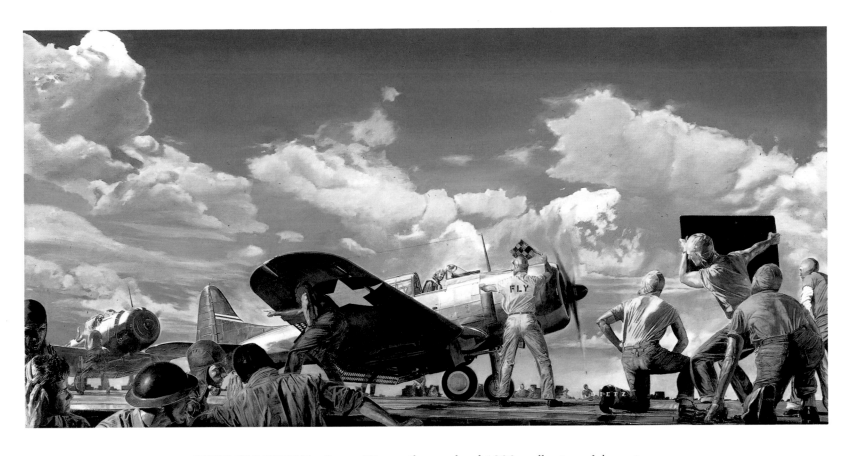

BEST ON DECK by James Dietz, oil, completed 1990, collection of the artist.

First American Raid on Europe

by R. G. Smith

During a strafing run at DeKooy Airfield in Holland, a Douglas DB-7 Boston borrowed from the British Royal Air Force and piloted by Capt. Charles C. Kegelman of the U.S. Army Air Force's 15th Bombardment Squadron encountered heavy enemy ground fire, causing the starboard engine to erupt in flames and the propeller to detach. The attack aircraft, known in U.S. government nomenclature as the A-20 Havoc, sank to the ground, its tail and right wing-tip dragging along the surface, but with more power applied to the left engine the sturdy ship bounced up into the air again. Captain Kegelman was so infuriated that he made another pass at the antiaircraft position that was generating the damaging flak and succeeded in knocking it out. The DB-7 managed to limp home.

This first air strike in Europe during World War II by an operational American unit involved twelve of the borrowed aircraft and occurred, propitiously, on July 4, 1942. For his valor on this mission, Captain Kegelman was awarded the Distinguished Service Cross. He was also promoted to major and later received command of his squadron.

Douglas began design work on the DB-7 (for Douglas Bomber) in the 1930s to satisfy the army's requirement for a light bomber. The Boston/Havoc emerged as an effective attack aircraft with a ruggedness appreciated dearly by the crews of the many Allied air forces that flew the plane. These aircraft will be remembered for their capacity both to absorb and to dish out punishment. A total of 7,478 Bostons and Havocs were produced.

Another twin-engine Douglas attack aircraft, the A-26 Invader, was developed as a successor to the DB-7/A-20 series. Based on the lessons learned in the development of the earlier light bomber, the A-26 enjoyed improved performance and benefitted from heavier armament.

Robert G. Smith

Known affectionately in aviation art circles as "R.G.," this pioneering painter of airplanes got his initial inspiration from Lindbergh's epic flight across the Atlantic. After graduating from the Polytechnic College in Oakland, California, with a degree in engineering, he joined one of the predecessor companies to what is now McDonnell Douglas Corporation. His work soon came under the admiring eye of the legendary Douglas Aircraft designer Edward Heinemann. He served as a configuration engineer and illustrator as part of the prolific design team that produced such remarkable naval aircraft as the SBD Dauntless and the A-4 Skyhawk. He spent sixty days in Vietnam during the late 1960s as a navy combat artist, depicting the realism of carrier life in war. Reflective of his close association with naval aviation was his being named an honorary member of the Blue Angels. He was among the founders of the American Society of Aviation Artists. He has received virtually every accolade that can be bestowed upon an aviation artist, but perhaps the greatest tribute is that several of the other artists represented in this book enjoyed his kind and caring mentorship at McDonnell Douglas. He and his wife, Betty, live in Palm Desert, California.

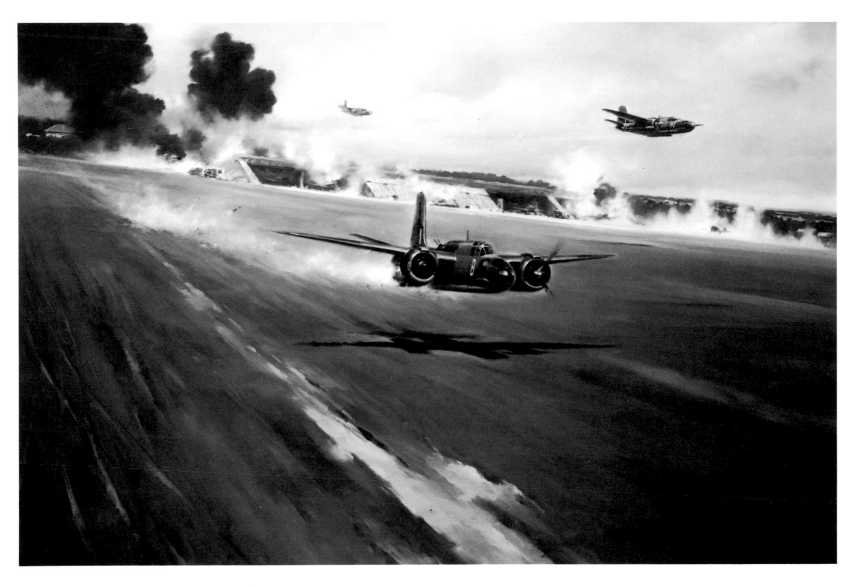

FIRST AMERICAN RAID ON EUROPE by R. G. Smith, oil, completed 1975, collection of McDonnell Douglas Corporation.

Tigers in the Valley

by Jack Fellows

For the American air crews operating in Alaska during World War II the weather was said to be the greatest enemy. Blizzards, frigid temperatures, and poor visibility were everyday realities for the men who had to fly on missions against the Japanese forces. At the time of the Battle of Midway, the Japanese invaded two islands in the Aleutian chain, Attu and Kiska, thinking them strategically important. Fearful of potential Japanese leapfrogging from island to island until they reached the North American continent, the United States believed the enemy must be driven from the remote islands. In the ensuing year, elements of the American 11th Air Force attacked the Japanese positions despite the most unfavorable weather imaginable.

One of the officers with the 11th Fighter Squadron, 343rd Fighter Group which was coping with these hostile conditions in the Aleutians was John S. "Jack" Chennault, eldest son of the famed Gen. Claire Lee Chennault. Claire Chennault had commanded the American Volunteer Group in China, a ragtag bunch of volunteer pilots who, flying antiquated Curtiss P-40B Tomahawks, had downed 286 Japanese aircraft before being absorbed into the U.S. Army Air Force. Popularly known as the "Flying Tigers," apparently because of the Chinese press's use of the term in reaction to the upstart unit's spectacular accumulation of aerial victories, the A.V.G. used a shark-teeth paint scheme on the noses of their airplanes, an idea inspired by a British squadron flying in North Africa.

Not surprisingly, in tribute to his father and the highly successful A.V.G. that he so ably led, the P-40E Warhawks in Jack Chennault's squadron, the "Aleutian Tigers," were emblazoned with stylized tigers accentuated by a growl that exposed big pointy teeth.

By May 1943 it was thought that the aerial attacks on Attu had softened the Japanese forces to the point where an invasion by the army's 7th Infantry Division was attempted. A bloody but successful battle ensued. Not wishing to endure the same fate, the Japanese troops on Kiska were evacuated under cover of fog.

Jack Fellows

From his studio Jack produces a diversity of realist paintings with, in recent years, a primary output of aviation art. His current focus is the Cactus Air Force Project that in a series of thoroughly researched paintings seeks to memorialize the U.S. military pilots who flew combat missions in the Pacific theater during World War II. Following in his father's footsteps, he worked for Boeing. He also ran a general aviation service facility at Renton Field in Seattle. Further adding to his understanding of aviation subjects, he served in the navy as a helicopter air crewman. He and his wife, Louise, reside in Seattle.

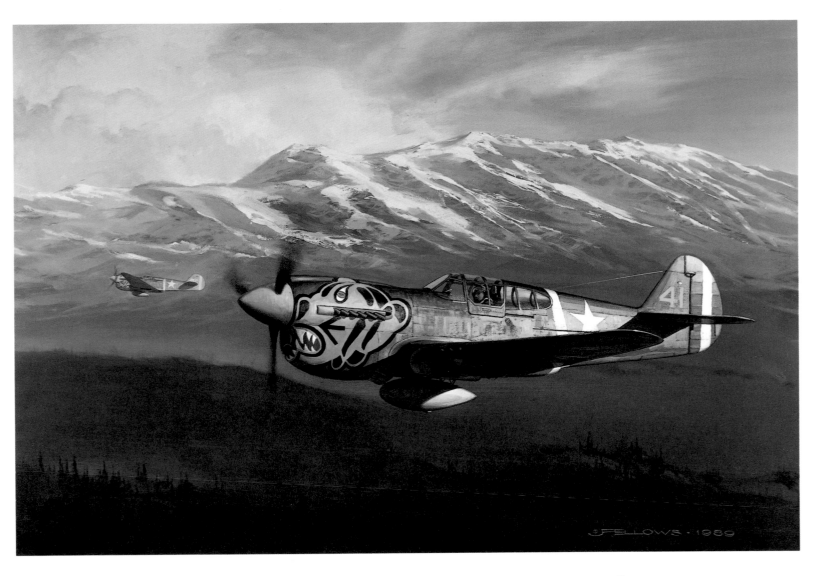

TIGERS IN THE VALLEY by Jack Fellows, oil, completed 1989, private collection.

The Circus Outbound

by Keith Ferris

The strange majesty of heavy bombers crossing the tranquil eastern English coast shortly after dawn is captured in this image by artist Keith Ferris. Rumbling Pratt & Whitney fourteen-cylinder twin Wasp engines power these eighteen mighty B-24D Liberators as they draw ever closer to the Vegesack submarine port in Germany on March 18, 1943. Led by Col. Edward Timberlake, this contingent from the 93rd Bomb Group, in conjunction with many other bombers, will make its first raid on a German target, attempting to confirm the as yet unproven and still controversial theory that massive daylight bombings can be efficacious.

The 93rd Bomb Group had been dubbed "Ted's Traveling Circus" because while commanded by Colonel Timberlake it served in widely distant parts of the European and African continents. Through their dogged determination these bombardment crews scored on their targets, showing the feasibility of daylight bombing missions.

Over eighteen thousand B-24s were built during World War II, which was more than any other American aircraft in wartime. The production demand was so great that the assembly lines of the aircraft's originator, Consolidated, had to be augmented by the factories of Douglas, North American, and Ford. The Liberator was a giant of an airplane whose bomb load capacity was substantial. It had significant range in large part because of the use of a new airfoil design. Despite the enormous number of Liberators built during World War II, only a handful are flying today as special attractions at air shows.

For information about the artist, Keith Ferris, please see page 26.

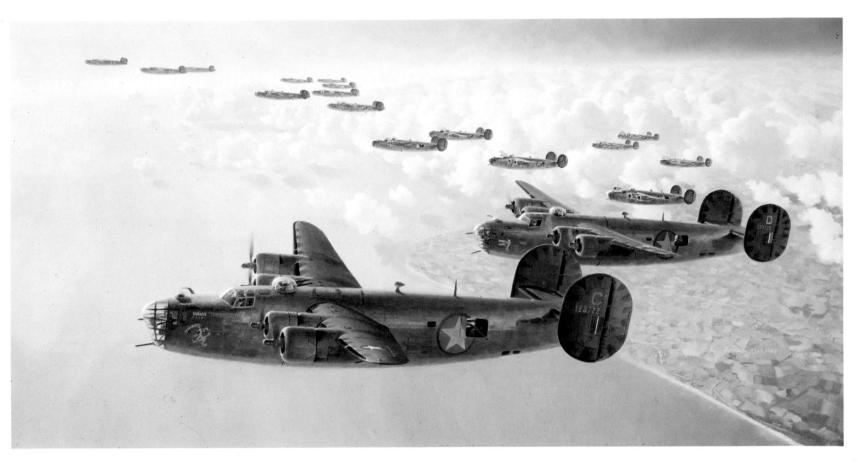

THE CIRCUS OUTBOUND by Keith Ferris, oil, completed 1989, collection of the artist.

Coming Home/England 1943

by Gil Cohen

This scene, at an East Anglian airfield on a typically cloudy and misty day, depicts American 8th Air Force crews returning from precision daylight bombing raids and was often repeated in 1943. Of course, these were the fortunate fliers who survived the onslaught of the enemy's massive firepower as they tread their way through hostile airspace in high formations to wreak unprecedented destruction. It was a relief to come home from another trip through hell.

Precision daylight bombing was a bold idea, shunned by the British and Germans but pursued by the U.S. Army Air Force. The American heavy bombers were designed with more defensive gun positions than the heavy bombers of other nations. Also, as part of the overall strategy, long-range fighters were used to escort the bombers on their far-reaching missions to destroy the enemy's industrial infrastructure. However, the large bomber formations, with their concentration of .50-caliber machine guns, were hardly invincible, and an adequate supply of long-range escort fighters took some time in coming. The 8th Air Force's strategic bombardment campaign proved to be an arduous endeavor.

By creating an imaginary *Kayo Katy*, artist Gil Cohen seeks to express the universal mood of the dedicated though weary 8th Air Force bomb crews returning from the fire of battle. The crewmen are shown as ordinary men from all walks of life who find themselves caught up in extraordinary circumstances.

Their ship is a Boeing B-17F Flying Fortress, which on this day's mission has absorbed fistfuls of 20-mm shells. Yet the durable Fort has endured the punishment to bring the crew safely back so they can pound the enemy on another mission. While a mechanic points out cowling damage to the copilot, the captain, a somewhat older and more experienced pilot who heads the squadron, lights up a cigarette. The trench-coated officer, his aide standing nearby, is the group commander. Other B-17s, just starting to break formation for the landing pattern, can be seen in the background, carrying yet more crews glad to be coming home.

Gil Cohen

Gil has practiced his craft as a free-lance artist for more than thirty years. He has produced commissions for an impressive list of corporate and governmental clients. A graduate of the Philadelphia College of Art, he later served as a faculty member at that institution as well as the chairman of its Illustration Program. He also participates in the Air Force Art Program and is a member of the New York Society of Illustrators. He and his wife, Alice, reside in Doylestown, Pennsylvania.

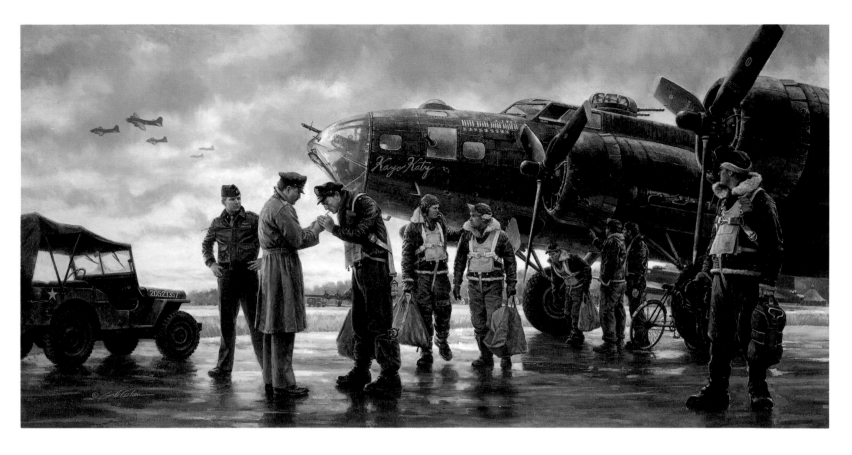

COMING HOME/ENGLAND 1943 by Gil Cohen, *oil, completed 1990, collection of the artist.*

Hathi to the Rescue

by Charles Thompson

British Royal Air Force operations in India and Burma during World War II had to cope with extraordinary indigenous conditions. In this image set in 1943, a Hurricane IIC of the RAF's No. 136 Squadron at Chittagong is stuck in the soft soil. It is being pulled away from the makeshift landing strip to a nearby shelter by a *hathi* (the Indian word for elephant) native to the area and accustomed to hauling logs of teak. The Hurricane has been lightened and correspondingly has had its range extended by the removal of two of its wing-mounted 20-mm cannons.

The Hurricane IIC represented an improved version of the fighter that so ably defended the British homeland in the Battle of Britain. The plane's manufacturer, Hawker, recognizing the weakness of the armament of the first Hurricanes, decided to beef up the plane's firepower by installing four 20-mm cannons in the wings. While giving the Hurricane devastating punch, the modification made the plane heavy and slow with a reduced operational radius, especially when bombs were carried in a close support role.

The British airmen and soldiers who served in India and Burma refer to themselves as the "forgotten army" since so little was reported about their operations. The artist, having grown up in India during the war where he witnessed firsthand much of what went on, has attempted to remedy the omissions of the past.

For information about the artist, Charles Thompson, please see page 58.

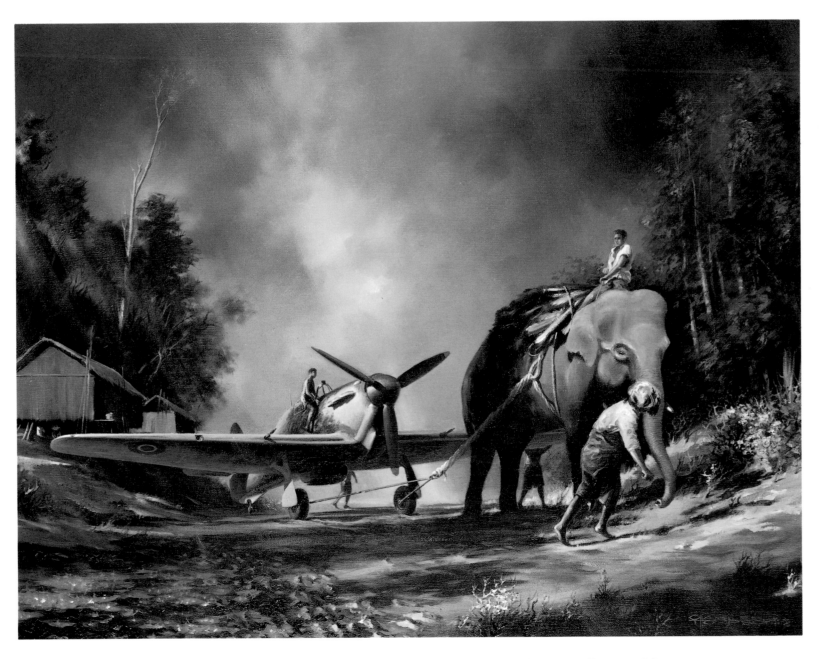

HATHI TO THE RESCUE *by Charles Thompson, oil, completed 1990, collection of the artist.*

Big Hog

by Jerry Crandall

On the morning of November 11, 1943, flying cover for a U.S. Navy task force sailing for Rabaul, two Chance Vought F4U-1A Corsairs were alerted by radio to the presence of a possible enemy aircraft near their position. Acknowledging the transmission was Lt. Comdr. John Thomas "Tommy" Blackburn, call sign "Big Hog." Blackburn raced in the direction of the reported bogey. Shortly, a plane came into sight, as advised. Gaining on it, Blackburn positively identified it as a Kawasaki Ki-61, a Japanese fighter, nicknamed "Tony" by the Allies.

The Tony's pilot, by now cognizant of the navy fighters on his tail, made a dash for a cloud bank. Blackburn and his trusty wingman pressed the attack, diving hard. In this image, the moment preceding Blackburn's trigger pull is depicted. With a short burst, the Tony was splashed, becoming one of Blackburn's eleven confirmed wartime victories.

Blackburn brilliantly commanded the men of VF-17, whose emblem was the skull and crossbones and who were known as the "Jolly Rogers." In about five months of frontline combat, Blackburn's squadron downed 154 Japanese planes. During that time a dozen of his men became aces, and he earned his service's highest award, the Navy Cross. The squadron's record of accomplishment helped to set the standard for subsequent navy fighting squadrons.

Jerry Crandall

Born in La Junta, Colorado, Jerry has retained a deep sense of his roots and has developed an expertise in the history of the American West. His fascination with frontier lore is combined with an equally fervent interest in the history of aerial combat. A stickler for detail, he immerses himself in comprehensive research of his subject matter, referring to his collection of archival photographs and, where possible, conducting interviews with the actual pilots of his subject aircraft. Prior to devoting himself to the full-time painting of historic scenes from the American West and World War II aviation, he worked for McDonnell Douglas Corporation as an aviation artist. He and his wife, Judy, now reside in Sedona, Arizona.

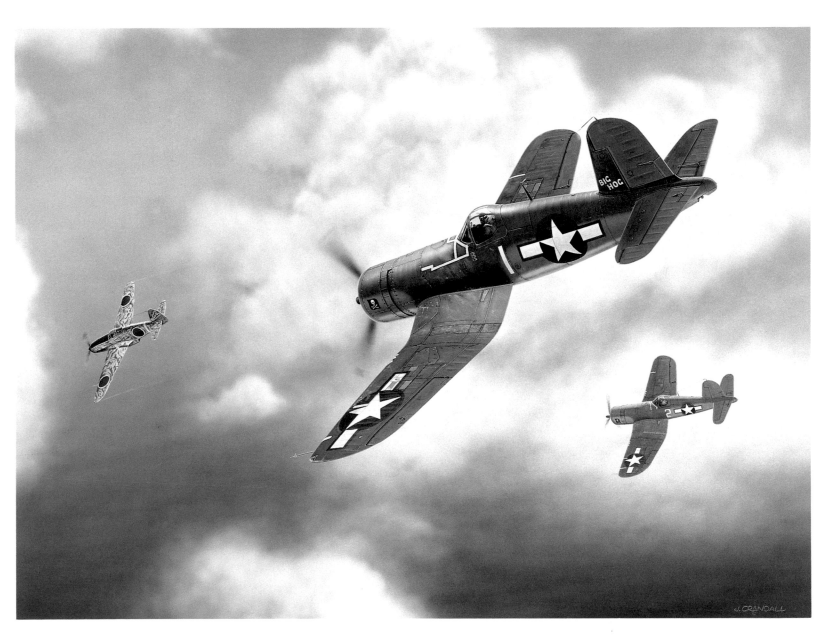

BIG HOG by Jerry Crandall, acrylic, completed 1988, private collection.

Flying Fortress

by R. G. Smith

The Boeing Airplane Company had achieved commercial success with the introduction in 1932 of its Model 247 twin-engined airliner. This aircraft was destined to be superseded in popularity by the entry into the marketplace of the legendary Douglas DC-3. However, the design of the Boeing airliner served as the foundation for an exciting new four-engined long-range bomber, dubbed the Model 299.

When the Model 299, a gleaming giant of an airplane festooned with gun blisters, was rolled out on July 27, 1935, an attending reporter referred to it as the "Flying Fortress." During the development period the designation changed to B-17, but the nickname remained. Not all went well at the beginning; the first model crashed about three months after roll-out, killing two of the crew, and another early test model tumbled on landing, causing extensive damage but no injuries. Though political pressure to cancel the program intensified, cooler heads prevailed.

The Fort was highly regarded for its survivability. At bomber bases spread across England, 8th Air Force B-17s would be seen returning from massive daylight raids on places like Wilhelmshaven, Schweinfurt, Regensburg, and Berlin, where the intense enemy fire made gaping holes in fuselages or shot away engines. Using the closely guarded Norden bombsight, the Fort relentlessly pounded enemy targets in Europe. Along with their heavy-bomber brethren, the American Liberators and the British Lancasters, they wrought widespread devastation and most importantly, deprived the enemy of vital fuel resources. Maj. Gen. Carl A. "Tooey" Spaatz, commander of the U.S. Army Air Forces in the European theater of operations, was to remark later, "Without the B-17, we might have lost the war."

Depicted here is a B-17G belonging to the 614th Bomb Squadron, 401st Bomb Group, known as *Maiden U.S.A.* The G model was distinguished from earlier model B-17s because of the installation of a chin turret. Many modifications were made during the B-17 program, but the engines remained the one-thousand-horsepower Wright Cyclones. Through the end of the war, 12,731 Flying Fortresses were built. By far, the most numerous model was the B-17G, with a total produced of 8,680.

For information about the artist, R. G. Smith, please see page 104.

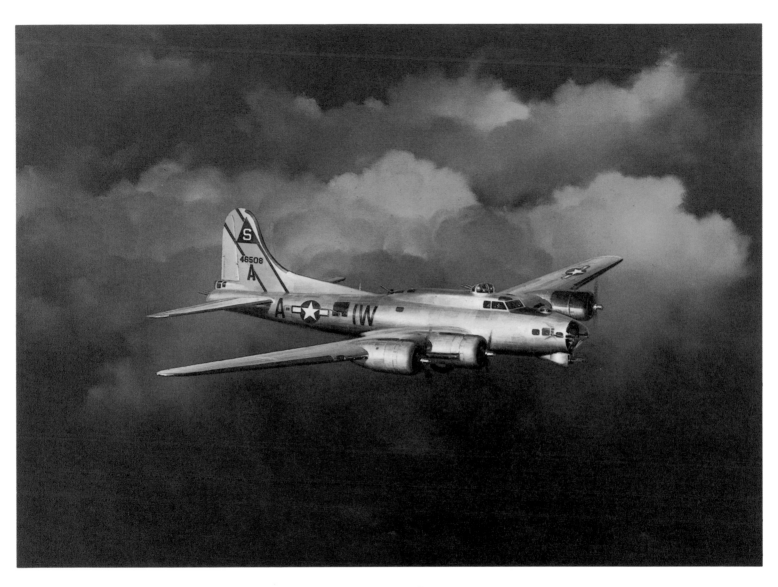

FLYING FORTRESS by R. G. Smith, oil, completed 1981, collection of U.S. Air Force Museum.

Rudel's Stuka

by Jerry Crandall

For the Third Reich, the Spanish Civil War was a kind of proving ground, allowing the German military a test of equipment and tactics for the big war yet to come. The Luftwaffe sent three new Stuka dive bombers to support the Nationalist forces. Flight crews were extensively rotated to give as many pilots as possible a chance to experience actual combat. With the overwhelmed Republican side unable effectively to challenge the Fascists' air superiority, the Stukas succeeded in destroying their targets in precision attacks. Adding to the psychological impact of this terror weapon, particularly in target areas with civilian populations, was the activation of a shrieking siren during the high-speed dive.

The Stuka's success was repeated in the Blitzkrieg against Poland and again against France. It was not until the Battle of Britain that the Stuka's weak spot was discovered. When the Luftwaffe failed to achieve command of the skies the mid-1930s-vintage Stuka, being relatively slow in cruise flight and lacking in self-protection with a single rear-firing gun, was exceptionally vulnerable to Allied fighters. The Luftwaffe still found utility for the Stukas on the Russian front.

A young Stuka pilot who had not yet seen action, Hans-Ulrich Rudel, was thrown into the Russian campaign. He soon erased the reservations of his superior officers when he attacked the Soviet battleship *Marat*, not wavering in the face of considerable flak, and released his sole twenty-two-hundred-pound bomb at an altitude of nine hundred feet. The bomb exploded, igniting the on-board munitions which demolished the ship.

From that point, Rudel, who continued to fly the Stuka, compiled an incredible combat record. In 2,530 sorties, he sank, in addition to the *Marat*, a cruiser and a destroyer. He is credited with destroying hundreds of trains, landing craft, and assorted vehicles, as well as 519 tanks. He became known as "the Eagle of the Eastern Front" and was the only Luftwaffe pilot to be awarded the Knight's Cross with Golden Oak Leaves. Rudel's Stuka, a Junkers Ju 87B-2, is shown here on the Russian front in late 1941, when Rudel was attached to Gruppe Stab III/Stuka Geschwader 2.

For information about the artist, Jerry Crandall, please see page 114.

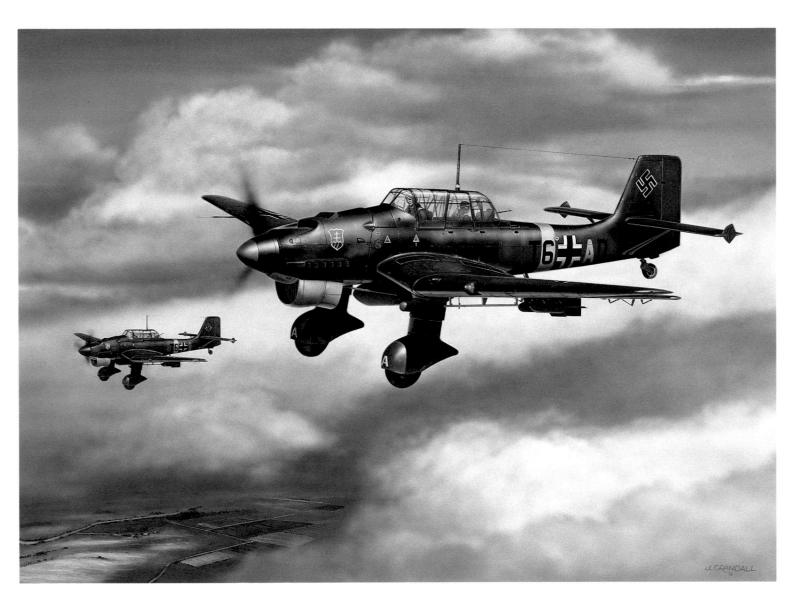

RUDEL'S STUKA by Jerry Crandall, acrylic, completed 1990, private collection.

Green Light—Jump

by Craig Kodera

The Douglas DC-3, in its U.S. military designations C-47 and R4D, was indispensable to the Allied victory of World War II. Indicative of its contribution is this image depicting a pair of Skytrains, or, as the aircraft were popularly called, "Gooney Birds," making a paratrooper drop inland from the Normandy beachheads during the early morning hours of the D-Day invasion on June 6, 1944. These aircraft of the 89th Troop Carrier Squadron, 438th Troop Carrier Group are part of a larger force of 850 Army C-47s hauling more than fifteen thousand air assault troops on this momentous day. Like all Allied aircraft participating in the D-Day invasion, the C-47s are painted with the alternating black and white stripes that identify them as friendlies.

A full moon peeks through openings in the cloud decks, providing some light for the transport flight crews. At the same time, searchlights scan the sky, attempting to illuminate the intruders. Meanwhile the soldiers on board, hooked to parachute static lines, exit the relative safety of the steady C-47s as they leap into an uninviting cauldron.

The C-47, being primarily a cargo hauler and troop transport, differed from its civilian counterpart. On the port side, the C-47 had a large cargo door to accommodate easy access or egress as the case warranted. A glass dome aft of the cockpit was added for the navigator. The military version of this great plane also had a slightly longer wingspan.

During the war, the renowned Gooney Bird carried just about anything that could fit through its cargo door. It often performed beyond its design limitations, reliably hauling excessive loads over treacherous terrain. More than ten thousand were delivered under contract to the military.

For information about the artist, Craig Kodera, please see page 62.

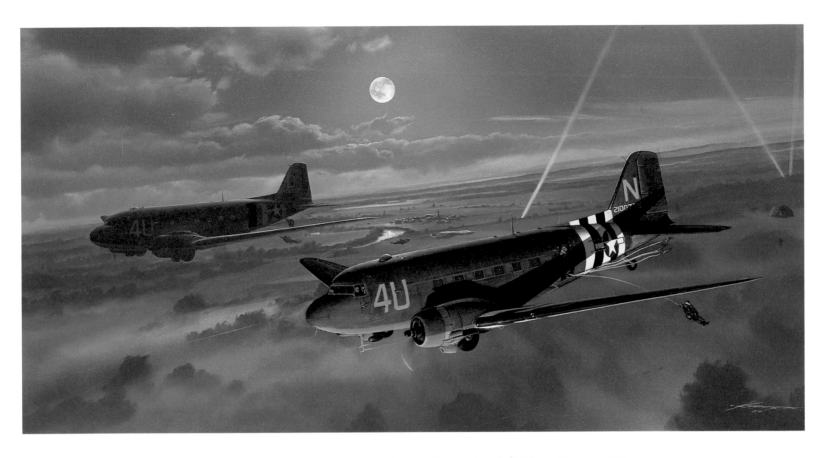

GREEN LIGHT—JUMP by Craig Kodera, oil, completed 1989, collection of the artist.

Two Down and One to Go

by William Phillips

Prior to the outbreak of war, the Army Air Corps, which would not allow blacks to fly at all, came under pressure from black leaders and concerned citizens who argued that blacks should have a chance to fly as military pilots. The Army Air Corps relented and established a flying school for blacks only at the renowned Tuskegee Institute in Alabama. With the doors open to blacks aspiring to fly, the ablest of young American black men entered the stereotype-shattering program. The school's graduates became known, appropriately enough, as the "Tuskegee Airmen." They debunked the absurd myth that blacks were incapable of piloting military airplanes.

Artist William Phillips has captured the moment at which Tuskegee Airman Clarence D. "Lucky" Lester has bagged his second of three Me 109s in a single day, over Italy in 1944. The German pilot can be seen bailing out of his damaged and smoking Messerschmitt fighter. The North American P-51 Mustang flown by Lieutenant Lester sports a brightly painted red tail, the distinctive trademark of the all-black 332nd Fighter Group, which called itself the "Red Tails."

Lucky Lester pursued a successful twenty-eight-year career with the air force, retiring as a colonel. The Tuskegee Airmen who comprised the four squadrons of the 332nd distinguished themselves as remarkably good fighter pilots given the segregated environment in which they gained their footing and in which they daily operated. Although they valiantly fought for liberty abroad, they were tragically denied its fruits at home. Still, their unflinching efforts paved the way for today's black pilots in the military, the airlines, and the astronaut corps. The success of the Tuskegee Airmen serves as an affirmation of the power of the human spirit and as an inspiration to all people.

For information about the artist, William Phillips, please see page 40.

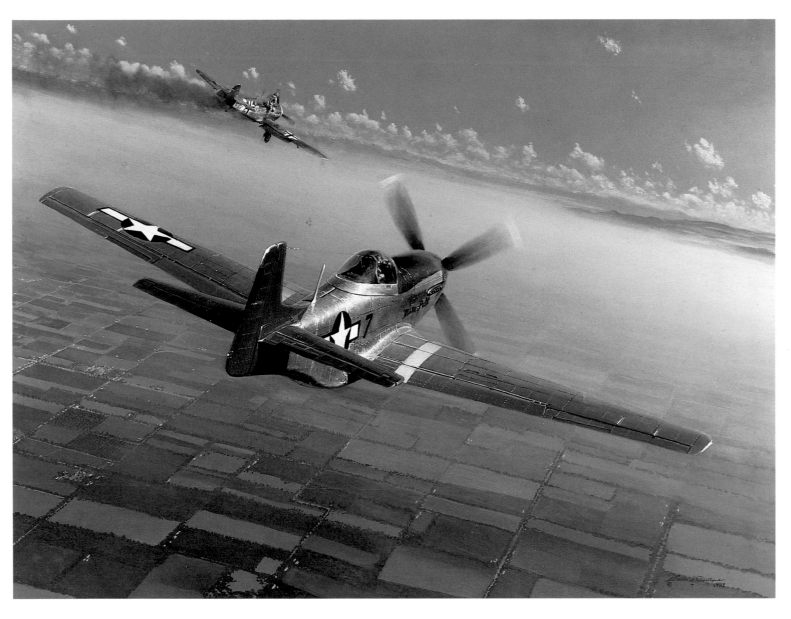

TWO DOWN AND ONE TO GO, by William Phillips, oil, completed 1982,
collection of Tuskegee University, Tuskegee, Alabama.

The Long Ride Home

by William Phillips

On the return to their bases in England amid the splendor of a golden sunset in a sky that has turned to a welcome calm, these B-17 Flying Fortresses of the 8th Air Force are escorted by Mustang fighters. In the foreground is a P-51D, nicknamed *Betty* by its pilot, Lt. Col. Wayne Blickenstaff of the 350th Fighter Squadron, 353rd Fighter Group.

The Mustang, when outfitted with external fuel tanks, acquired the range to accompany the heavy bombers on their long missions. When enemy interceptors engaged the bomber formations, the Mustangs would jettison their "drop tanks" and counter unhindered by the weight and drag of the tanks. Having long-range fighter escorts later in the war was a substantial plus for the waves of strategic bombers that sometimes faced swarms of unfriendly aircraft.

The flights to home base were frequently filled with their own drama. Wounded crewmen were sometimes in desperate need of medical attention. Mechanical systems would malfunction or control surfaces would be shaky from battle damage. Pilots would nurse their shot-up mounts as best they could, but bailing out or ditching became the only alternatives for many.

For information about the artist, William Phillips, please see page 40.

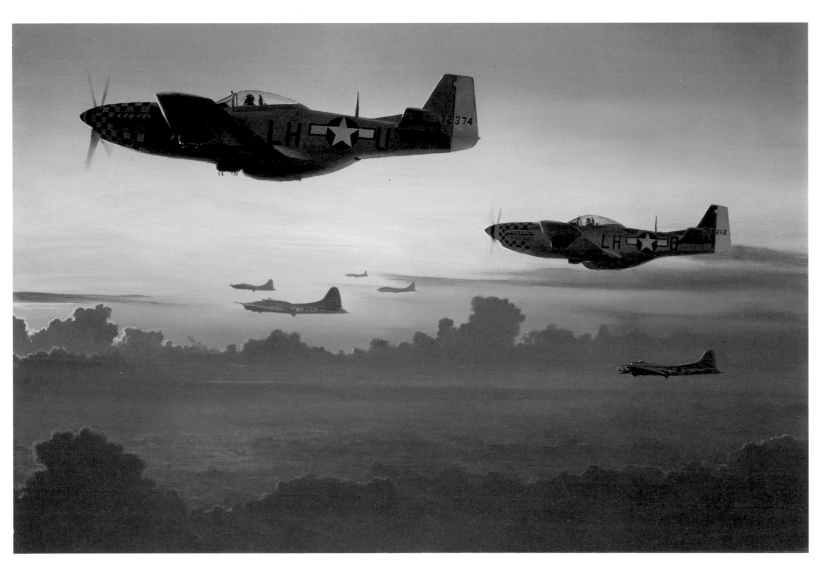

THE LONG RIDE HOME by William Phillips, oil, completed 1990, collection of the artist.

Dumbo

by Jack Fellows

The Consolidated PBY Catalina, conceived as a patrol bomber and employed in a number of roles, was one of the U.S. Navy's stalwart flying boats. The Catalina saw service under various insignia and in both the Atlantic and Pacific theaters. It was reliable and offered an impressive range of well over two thousand miles. Though the Catalina's capacity for ordnance was respectable, it could cruise at little more than 110 MPH. The aircraft's protruding side blisters enhanced observation.

In this image a PBY-5A, an amphibious version of the Catalina, is banking low over the coastal waters of a remote island on an air-sea rescue mission. Awkward in appearance, the Catalina was given the nickname "Dumbo" after the friendly flying elephant in Walt Disney cartoons. But to downed American aviators bobbing in the high seas after bailing out, or floating on a raft after ditching, the bulky flying boats were a lovely sight. On many occasions, these pilots owed their lives to the Dumbo crews that scoured for hours in search patterns over large bodies of water to find them.

For information about the artist, Jack Fellows, please see page 106.

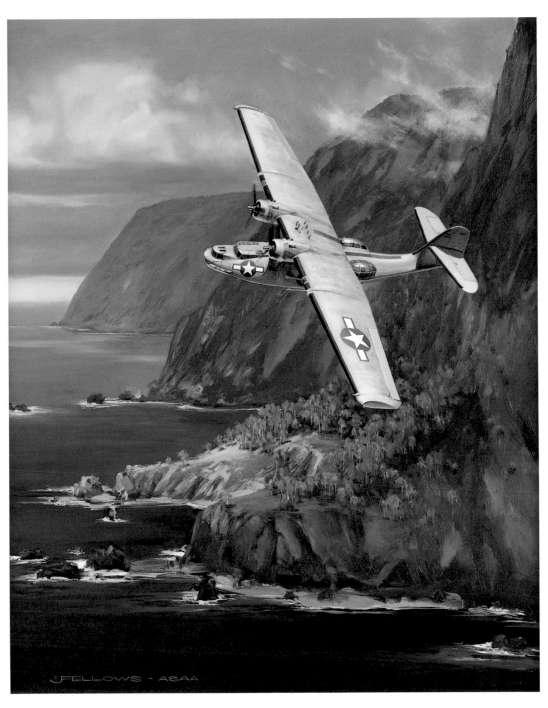

DUMBO
by Jack Fellows,
oil, completed 1989,
private collection.

127

Welcome Home Yank

by William Phillips

The American heavy bombers that conducted the devastating daylight raids over Europe in World War II were subjected to the most intense antiaircraft barrages ever seen up to that time. Compounding the danger would be hordes of enemy interceptors trying to maul the massive bomber formations. After unloading their bombs on fiercely defended targets, the bombers would try to hightail it out of harm's way. Many, unfortunately, did not leave the combat unscathed.

Legendary are the stories of the mammoth planes returning from battle with dead engines and shot-up control surfaces. Here we see a Consolidated B-24 Liberator trying to maintain altitude as it descends perilously low over the English Channel on its way back to base. The starboard wing's outboard engine is dead and the port wing's outboard engine is losing oil as can be seen from the trailing smoke. With the white cliffs of Dover now in view, it appears that home is in reach and that the Lib, after some extensive repairs, should be able to fly another mission.

Having rendezvoused with the crippled bomber over dangerous airspace, a British Royal Air Force Spitfire has provided a welcome escort. Now that the bomber is safely within England's protective perimeter, the Spit's pilot, realizing his job is accomplished, pulls up and away. This scene exudes a sense of the strong British-American friendship forged in World War II.

For information about the artist, William Phillips, please see page 40.

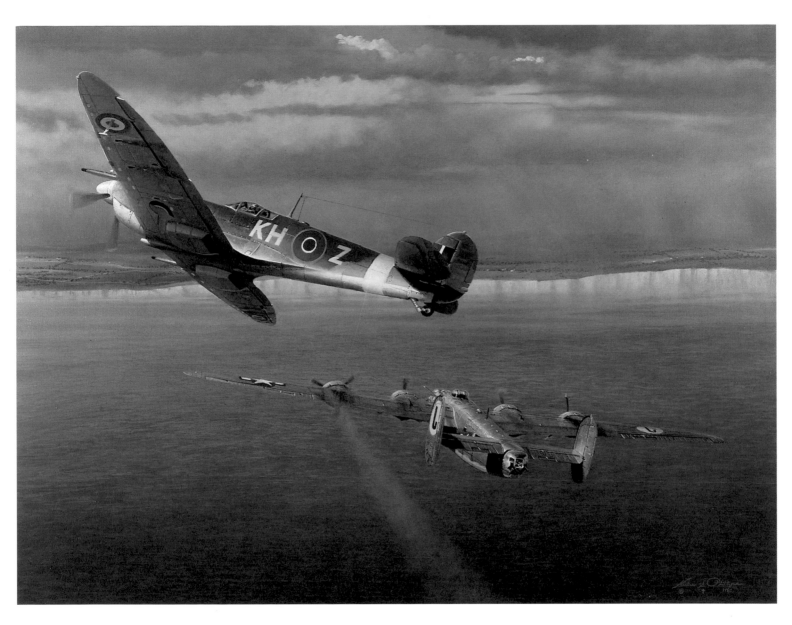

WELCOME HOME YANK by William Phillips, oil, completed 1982, private collection.

Dangerous Skies

by Jack Fellows

Remarkably aesthetic for a combat airplane, the Lockheed P-38 Lightning's unconventional configuration, classic lines, and technological innovations combined to make it a standout fighter. The twin-boom design allowed the nose to be dedicated to armament carriage. Accordingly, standard nose-mounted weaponry was one 20-mm cannon and four .50-caliber machine guns. The pair of twelve-cylinder liquid-cooled Allison engines powered counter-rotating propellers, eliminating the effects of propeller torque. The P-38 was, for this reason, an unusually stable gun platform. The pilot had line-of-sight firepower concentrated in the nose which he could unleash without having to compensate for the tendency of the nose to yaw to the left. The P-38's bubble canopy offered the pilot 360-degree visibility. Built with tricycle landing gear, the P-38 would not be prone to ground-looping. It is no coincidence that the two top-scoring American aces of World War II, Majors Richard I. Bong and Thomas B. McGuire, Jr., flew the P-38 exclusively.

The P-38 fell short of perfection, however. It was among the first airplanes to encounter the phenomenon of compressibility as it gained high speed in steep dives. Some early models would break-up in flight because of this, and in some circles the airplane became known as a "pilot killer." But the problem was solved on later models by the installation of dive brakes. There were also problems with the turbo superchargers, but these too in time were corrected, and the P-38 was able to perform well at higher altitudes. Importantly, the presence of a second engine provided life-saving redundancy if in encounters with the enemy one of the P-38's engines was shot up.

In this image, 5th Air Force P-38s outfitted with long-range drop tanks are approaching an island in the southwest Pacific. It is 1944 and the tide of the war has turned clearly in favor of the Allies. Where once fighters of the Rising Sun were free to roam the Pacific skies, now the superior U.S. forces hold sway.

For information about the artist, Jack Fellows, please see page 106.

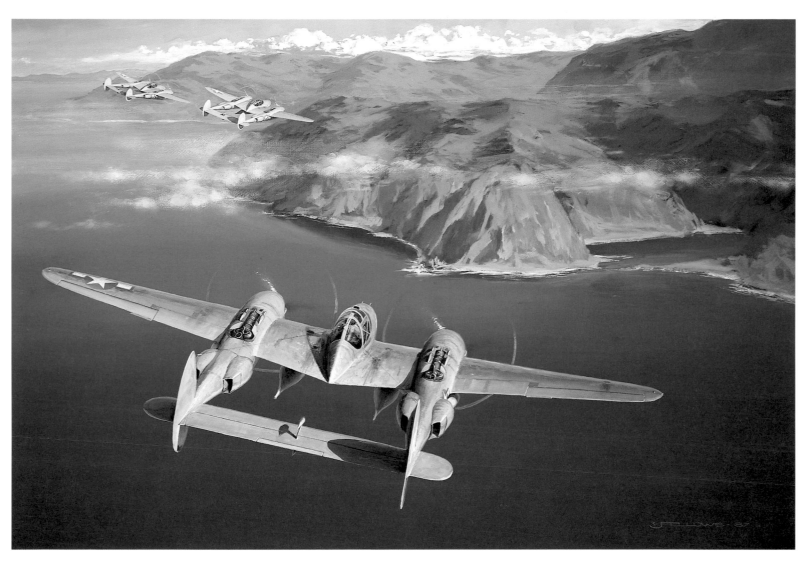

DANGEROUS SKIES by Jack Fellows, oil, completed 1987, collection of the artist.

Wie Ein Floh — Aber Oho!

by Mike Machat

Among the German *wunderwaffen* (wonder weapons) of World War II was the midget-sized, swept-winged, tailless, rocket-powered interceptor, the Messerschmitt Me 163 Komet, developed amid great secrecy in wartime Germany. Two of the leading test pilots on this revolutionary project at Peenemunde-West, Wolfgang Spate and Rudolf Opitz, would later join in flying the Komet in its one operational unit, Jagdgeschwader 400.

A liquid-fueled rocket engine would boost the Komet into flight, at which time the narrow wheel undercarriage would fall away. The rocket plane had only eight minutes worth of fuel packed into its tiny shell, giving it a range of a mere fifty miles. Upon disengagement from combat with its fuel expended, the Me 163 would revert to a glider and land on a lowered skid.

As a fighting machine the Me 163 was plagued with shortcomings. Its fuel handling was complicated and hazardous. When diving on Allied bombers it could suffer compressibility problems and go out of control. Its two wing-root mounted 30-mm cannons were notoriously unreliable. The takeoffs and landings were rife with danger. Komets were built in small numbers and came late in the war. Their immediate impact was minimal, scoring a total of just seven confirmed victories. But the Me 163 represented dramatic advances in the theory of flight technology that after years of refinements would appear in the X-15 and the Space Shuttle.

In the foreground of this image, a Komet ascends quickly as other Me 163s streak steeply upward and arc over to attack incoming formations of Allied bombers whose contrails mark their position. One of the interceptor unit's emblems is shown. The image's title roughly translated means, "Small like a flea, but Oh Wow!" which reflects the rapid acceleration common to the petite rocket plane's takeoff and climb out.

Mike Machat

While growing up, Mike fell under the influence of his uncle, a leading designer at the Republic Aircraft factory in Farmingdale, New York. He studied art at Pratt Institute and California State University at Long Beach. After a stint as a technical illustrator in the air force, he joined McDonnell Douglas Corporation as a staff illustrator. Now as a free-lance aviation artist, he is integrally involved in the Air Force Art Program. He has flown in more than 160 aircraft types, including gliders and jet fighters, and is widely known for his thoroughly researched depictions of airliners and flight test scenes. His artwork has been exhibited at the Air Force Museum and the Experimental Aircraft Association's Air Adventure Museum. Mike served as the first president of the American Society of Aviation Artists. He and his wife, Sheri, reside in Woodland Hills, California.

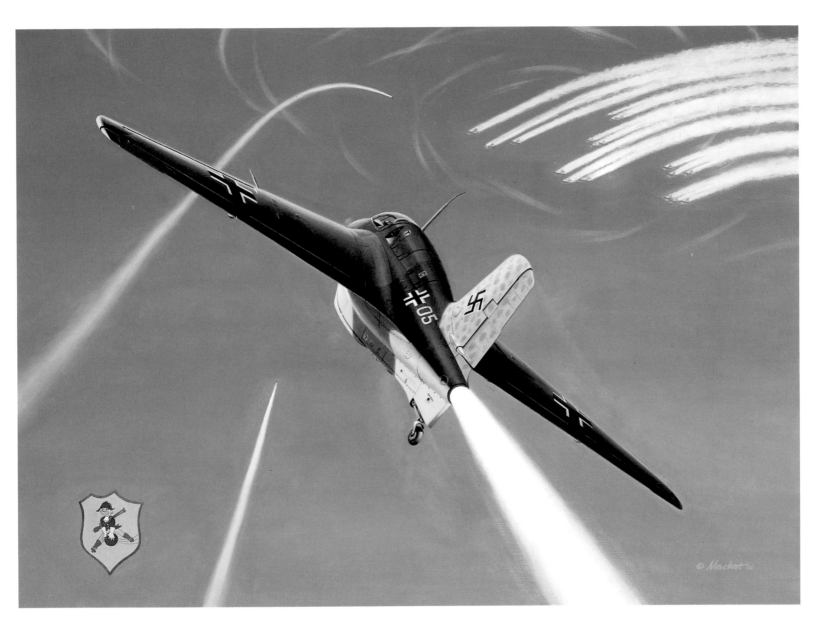

WIE EIN FLOH — ABER OHO! by Mike Machat, oil, completed 1986, private collection.

Incident over Villafrance

by Nixon Galloway

Every night at around nine o'clock for several weeks during the winter of 1945, a German Ju 188 reconnaissance aircraft would fly over the American air base in Pontedera, Italy. Because of the regularity of these overflights, the intruder was nicknamed "Recon Charley."

Since the base had few night fighters it was a problem coordinating an intercept. On the night of February 28, however, a de Havilland Mosquito was readied with USAAF Capt. Larry Englert at the controls and Lt. Earl Dickey working the radar. When the Ju 188 reappeared on the scene like clockwork, the Mosquito took off in pursuit.

The Mosquito, known as a fast and effective night fighter, located Recon Charley and pursued as the Ju 188 retreated toward the Dolomite Alps. Because of the Mosquito's rapid closure rate it was in dangerous proximity to the target at the time the pilot opened fire. The Ju 188, caught unaware of the Mosquito's presence on its tail, began to disintegrate. Some of the debris struck the Mosquito, harming the engines and causing hydraulic damage. The flaps and landing gear became locked in the "up" positions.

Upon return to Pontedera, the limping aircraft was greeted by a fog blanketing the base. Able to spot the glow of the runway lights, Captain Englert maneuvered the Mosquito over the faint landmarks, and then, with Lieutenant Dickey, bailed out. These two members of the 416th Night Fighter Squadron not only survived, but became the only Americans to achieve a confirmed victory flying a Mosquito during World War II.

The de Havilland Mosquito, sometimes called the "Wooden Wonder" because of the extensive use of wood in its construction, was conceived by Geoffrey de Havilland as a light bomber whose attributes of high maneuverability and great speed would protect it from enemy fighters. In fact, the Mosquito was a superb all-around performer, showing more versatility than any other military aircraft of the time.

For information about the artist, Nixon Galloway, please see page 22.

134

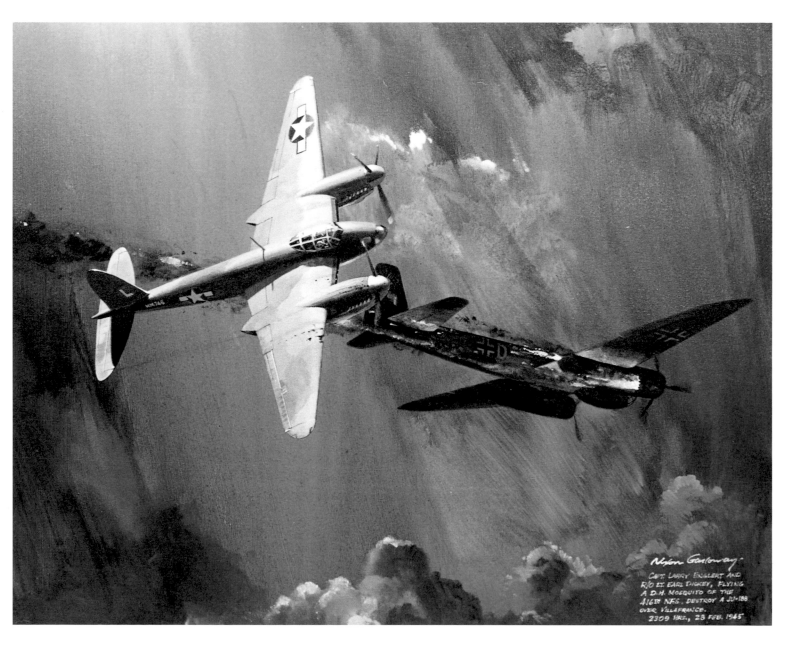

INCIDENT OVER VILLAFRANCE by Nixon Galloway, oil, completed 1979, U.S. Air Force Art Collection.

Ivan and the Lavochkin

by Jerry Crandall

About to duel in the skies north of Frankfurt on February 19, 1945, are two new fighters, the best that Germany and the Soviet Union can field. The streamlined Lavochkin La-7 in winter-white paint scheme, piloted by the legendary Ivan Kozhedub, will be cranked in hot pursuit of a distant Messerschmitt Me 262, the first operational German jet fighter. In the ensuing air battle, Kozhedub got the best of the enemy jet, becoming the first and only Soviet fighter pilot to down an Me 262.

Kozhedub chalked up another two kills after his German jet encounter, bringing his total victory count by the end of World War II to sixty-two, which made him the war's highest scoring ace, not only of the Soviet Union but among all the Allies. He was the three-time recipient of the Gold Star of a Hero of the Soviet Union, the country's most prestigious military award. He eventually retired from the Soviet Air Force with the rank of General Major but holds the honorary title of Air Marshal.

Because his skills were needed first instructing student pilots, he did not enter combat until March 26, 1943. The three fighter types he flew during the war were all from the Lavochkin factory. Kozhedub's favorite was the last of the three, his La-7, which with its fourteen-cylinder, 1,850-horsepower Shvetson M-82FNV radial engine vastly outperformed the earlier LaG-5 and La-5FN models. Kozhedub was assigned his La-7 in July 1944 and flew it in combat for the next ten months, scoring seventeen victories with the aircraft. His beloved

Lavochkin today rests in the Soviet Union's National Air Museum at Monino.

For information about the artist, Jerry Crandall, please see page 114.

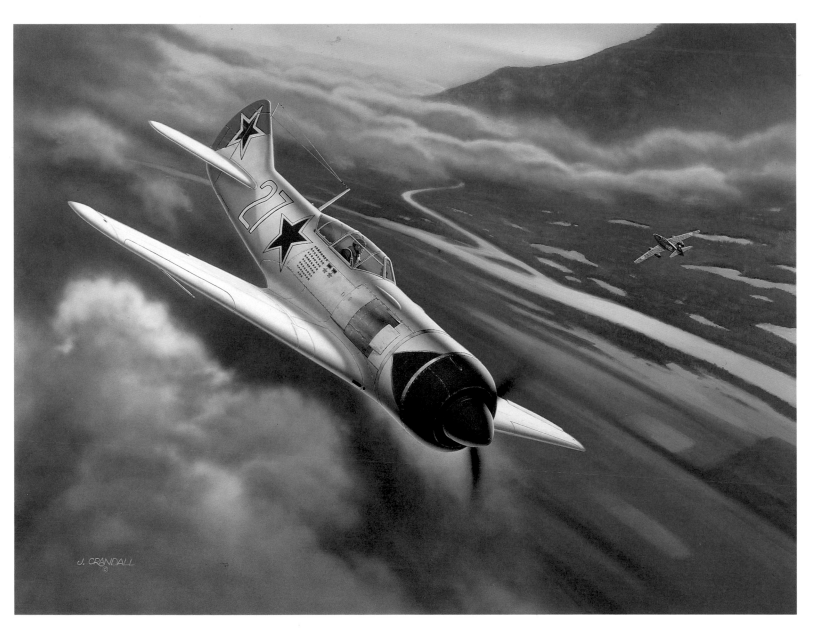

IVAN AND THE LAVOCHKIN by Jerry Crandall, oil, completed 1990, private collection.

Last Flight of Yellow Ten

by Jack Fellows

By early 1945 the imminent collapse of Nazi Germany and the consequent end of the war in Europe were becoming increasingly apparent. Some Luftwaffe pilots, not wishing to leave their fate up for grabs and fearful of being captured by the advancing Russians, decided to surrender to the western Allies. In this image, a steeply banked Focke-Wulf Fw 190 D-12 ground attack fighter is signaling with landing gear and flaps down that the pilot intends to give himself up. It is April and the British have already taken control of this former Luftwaffe airfield in Flensburg, Germany.

The angular simplicity of the Fw 190 reflects the design philosophy that sought to mate an aerodynamically clean shape to a particular engine—a compact BMW radial. When the Fw 190 entered operational service in the summer of 1941, the Royal Air Force, which by then had gained a deserved confidence with its superb Spitfire, was taken off guard by this fast and sleek new Luftwaffe fighter. The Fw 190 as an all around fighter, in fact, far surpassed the more common Me 109. In the hands of a capable Luftwaffe pilot, the Fw 190 was a match for anything in the Allied inventory.

As the Fw 190 underwent refinement during the war, the D or "Dora" model emerged. Its main difference from existing models was the use of a twelve-cylinder liquid-cooled Junkers Jumo engine in place of the radial engine. The rounded cowling was retained, however, and the fuselage was elongated for proper weight and balance. Because of the new engine, the D model had a longer nose.

Four "long nose" Fw 190s from Flensburg, including *Yellow Ten*, were transported to the United States. Once the air force had finished evaluating the plane, it was given to a university. From there it changed hands several times, eventually being acquired by the Champlin Fighter Museum, where after extensive restoration it was put on static display.

For information about the artist, Jack Fellows, please see page 106.

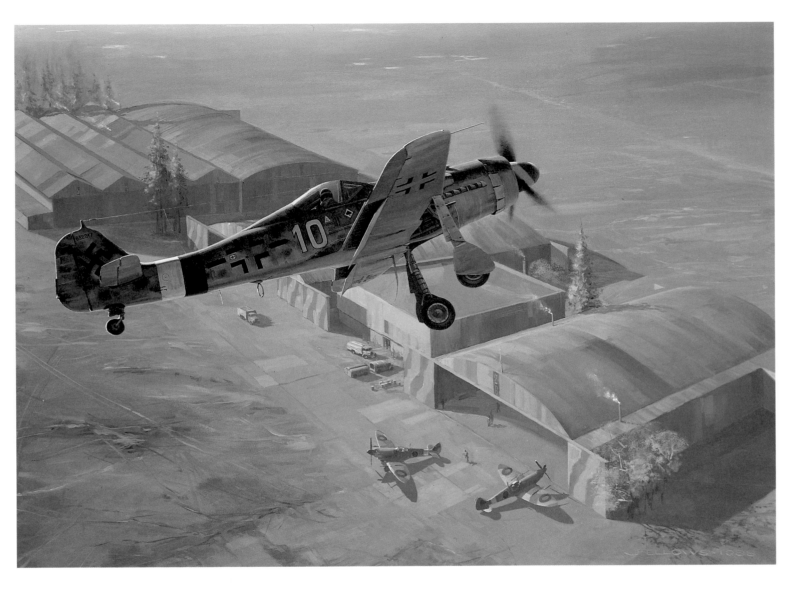

LAST FLIGHT OF YELLOW TEN by Jack Fellows, oil, completed 1989, collection of Champlin Fighter Museum.

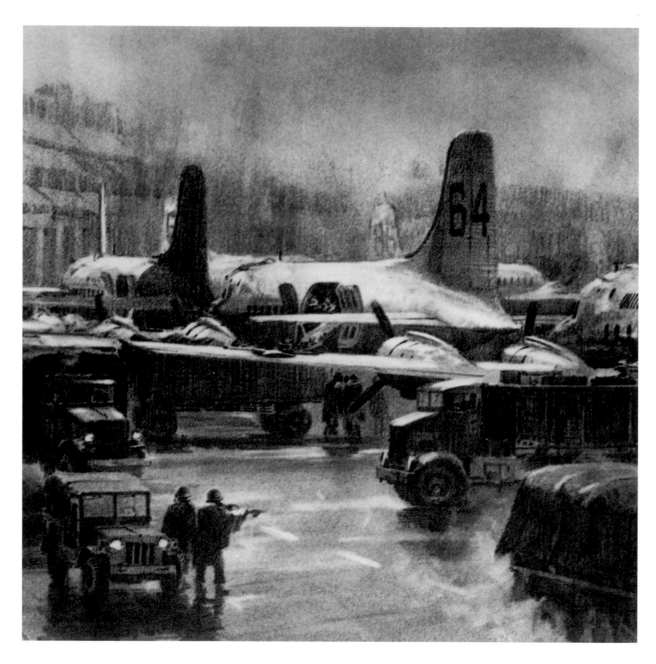

Detail from BERLIN AIRLIFT by R.G. Smith.

The Post-War Era

The peace that followed World War II was filled with infinite possibilities for aviation. At a sprawling airfield encompassing the world's largest natural dry lake in the remote stretches of the Mojave Desert, all sorts of peculiar shapes were taking to the sky under a cloak of secrecy. The challenge of the sound barrier, described as impenetrable by some, loomed before man and machine.

Without fanfare, a young fighter ace from the recent war, nursing broken ribs from a riding accident, slipped into the cockpit of a research plane shaped like a bullet. When the vehicle was released by its mother ship, a converted bomber, the self-confident test pilot throttled forward, the rocket engine's thrust propelling him faster and faster until he pushed the envelope farther than ever before. It was October 14, 1947, and Captain Charles "Chuck" Yeager, flying the Bell X-1, had exceeded Mach 1, the speed of sound. His achievement inaugurated the heyday of flight test.

Like the racing pilots at Cleveland a generation earlier, the test pilots at Muroc Army Air Field (later, Edwards Air Force Base) strove to attain ever greater speeds, but under more controlled circumstances that included scientific monitoring. The X-planes, many with unforgettable configurations, were unique aircraft built expressly for research.

Embodying the soul and the success of this period of pure research flight was the X-15 program. A sleek rocket plane launched from a B-52 mother ship, the X-15 climbed to the fringes of space and set new speed records, opening a glorious window on a new frontier.

Meanwhile, Piper's reintroduced Cub, an inexpensive airplane to buy and a forgiving airplane to fly, made the weekend pilot a reality. Across the land, the little yellow tail draggers afforded their owners the opportunity to visit friends in a neighboring county, make business trips, view the scenery from above, or simply enjoy the cherished moments of freedom in a splendidly serene sky known only to pilots. The growing number of private pilots sprouted a viable industry to service demand.

The period was not without military conflict. The Korean War brought the latest combat aircraft of the world's two superpowers against each other in deadly dogfights. The light and highly maneuverable MiG-15 was pitted against the fast and rugged F-86 Sabre. For the first time the U.S. Navy committed jets, like the carrier-based F9F Panther, to combat. With the development of the helicopter in a medical evacuation role, casualties among ground forces could be moved swiftly to field hospitals for life-saving care.

The jet engine was utilized not only in military aircraft but also in airline aircraft. In the 1950s the major commercial carriers embarked on comprehensive fleet transitions, junking their old props for new jets. Because of the jetliners' faster speeds, travel times were drastically reduced. Airline travel improved appreciably in terms of passenger convenience and aircraft reliability.

The First Phantom

by Keith Ferris

Naval aviation entered a new era when on July 21, 1946, a turbine-powered American aircraft successfully operated off the flight deck of an aircraft carrier for the first time. This image depicts that day when U.S. Navy Lt. Comdr. James Davidson, flying the McDonnell XFD-1 Phantom I prototype, took off from and landed aboard the USS *Franklin D. Roosevelt*. The Phantom I, later designated FH-1, proved suitable as a carrier-based fighter, and VF-17A became the first unit to adopt it.

Because World War II had ended during the Phantom I's development, the original navy order for one hundred was cut back to sixty. The production aircraft were powered by two sixteen-hundred-pound thrust Westinghouse J30-WE-20 turbojet engines situated in the wing roots. Armament came in the form of four nose-mounted .50-caliber machine guns.

The Phantom I's success demonstrated the advantages of having a young company, McDonnell Aircraft Corporation, charged with its development. As a relative newcomer to the world of airframe manufacturing and defense contracting in 1939, by the middle of World War II McDonnell was not burdened by huge contract obligations nor was it locked into preconceived design notions. McDonnell then had the fresh approach necessary for devising a radically new naval fighter. The Phantom I soon reached obsolescence due to the introduction of better performing naval jet fighters, but it neverthe-less represented a critical breakthrough in the advancement of naval air superiority capabilities.

For information about the artist, Keith Ferris, please see page 26.

142

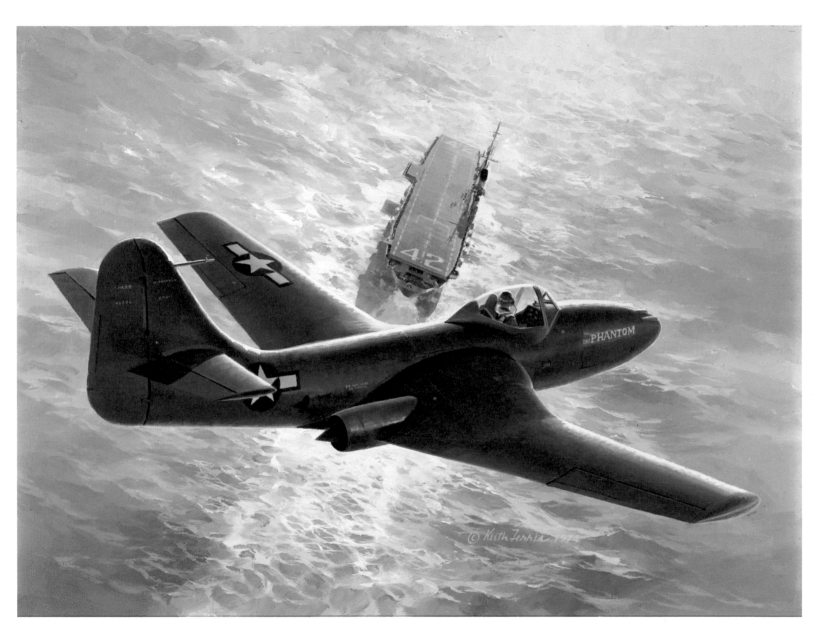

*THE FIRST PHANTOM by Keith Ferris, oil, completed 1974,
collection of Keith Ferris/Aviation Week & Space Technology.*

J-3 Cub—Introduction to Flight

by Keith Ferris

Though diminutive in appearance, the Piper J-3 Cub is a giant in its contribution to the lifeblood of aviation. The Cub's simplicity, ease of maintenance, and economy of operation combined to make it the most popular airplane in general aviation. Virtually everyone in the flying fraternity has at some point been around a Piper Cub. On the one hand, it initiated many a student pilot in the nuances of flying while at the same time it reacquainted experienced airline captains with the basic stick-and-rudder skills at the heart of all flying. The Cub, more than anything else, made flying accessible to the ordinary citizen and thus gave birth to the weekend pilot.

The J-3 Cub, based on a design by C. Gilbert Taylor, was introduced in 1938. (The "J" designation derives from Walter C. Jamouneau, the Piper Aircraft Corporation's chief engineer at the time, who influenced the design of the Cub as well as other early Piper models.) The airplane was quickly recognized as a practical and inexpensive trainer. During the war, the Cub provided the first hours of primary flight instruction to many aspiring military aviators. A military version of the Cub, designated the L-4, served as an artillery spotter, provided VIP transportation, and fulfilled other liaison duties. The Cub's short takeoff and landing capabilities made it ideal for its missions in army service.

Immediately following the war, William T. Piper's factory in Lock Haven, Pennsylvania, churned out the affordable little airplane in amazing quantities. In 1946 alone, over six thousand rolled off the assembly line. The Cub's fuselage was a tubular steel frame covered in fabric. The wings, also covered in fabric, had wooden spars. The standard paint scheme for the airplane was yellow with black trim. When the bottom suddenly fell out from under the lightplane industry in 1947, Piper had to retrench, but the widely hailed Cub remained ubiquitous.

Powered by a sixty-five-horsepower Continental engine, the Cub, weighing merely 1,220 pounds when fully loaded, could climb at 450 feet per minute and cruise at 75 MPH. It retained its position as the leading trainer in the civilian world until the late 1950s when a competing design that featured all-metal construction and tricycle landing gear came on the market. Today's flyable J-3 Cubs remain not only a treat for their owners, but they have become collector's items as well. Because of the preponderance of Piper's quintessential lightplane for more than a half a century, many people have grown accustomed to referring to all lightplanes as "those Pipers."

For information about the artist, Keith Ferris, please see page 26.

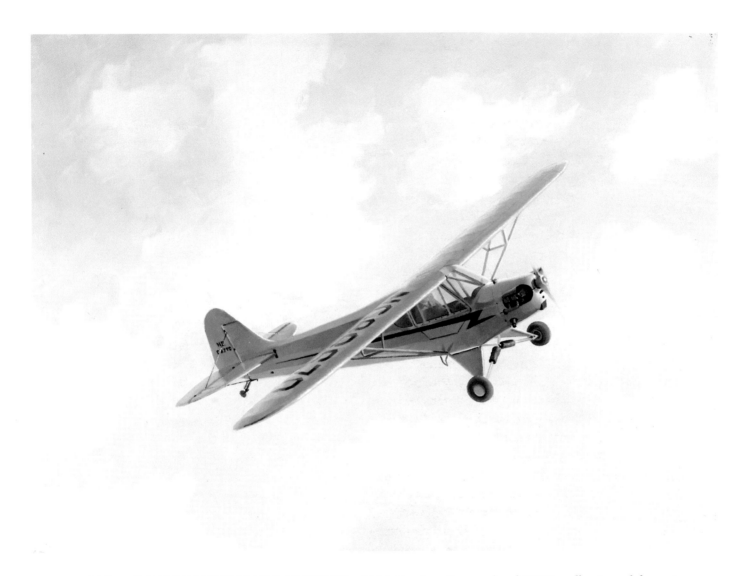

J-3 CUB—INTRODUCTION TO FLIGHT by Keith Ferris, oil, completed 1989, collection of the artist.

Seabee on the Step

by Mike Machat

The Republic Aircraft Corporation hoped the fame of its renowned World War II fighter, the P-47 Thunderbolt, would rub off on its post-war entry into the general aviation market and at first called it the Thunderbolt Amphibian. As a large defense contractor, the company could see the Pentagon's budget substantially diminishing at war's end. Moreover, the company theorized that with all the returning military pilots there would surely be a lot of potential buyers of small, inexpensive airplanes for personal use.

Renamed the Seabee as a tribute to the navy's can-do construction battalions, the airplane grew out of an idea by design impresario, Percival Spencer. Republic's George Hildebrand and a team of company engineers distilled that raw concept into a rugged yet simple airplane that could be mass produced. The Seabee was a practical airplane all around. It could take off and land in reasonable distances and cruise at 105 MPH. The cockpit was roomy, and when the airplane was anchored, owners were known to relax in the comfort of the cabin with a fishing rod and reel.

But the post-war economy suffered a recession and the anticipated orders for the Seabee—a relatively expensive airplane—did not materialize. In all, 1,076 Seabees were built before Republic, which was losing money on the line, halted production. The RC-3, as the Seabee was officially known, did make an indelible impression on the aviation community, and the fact that many are still flying has proven the underlying soundness of the design.

In this image by artist Mike Machat, Republic's demo ship, the *Red Dragon*, is seen at sunset in the late summer of 1947 taking off from Lake Tahoe. The Seabee has always been a favorite of the artist, for he is the late George Hildebrand's nephew.

For information about the artist, Mike Machat, please see page 132.

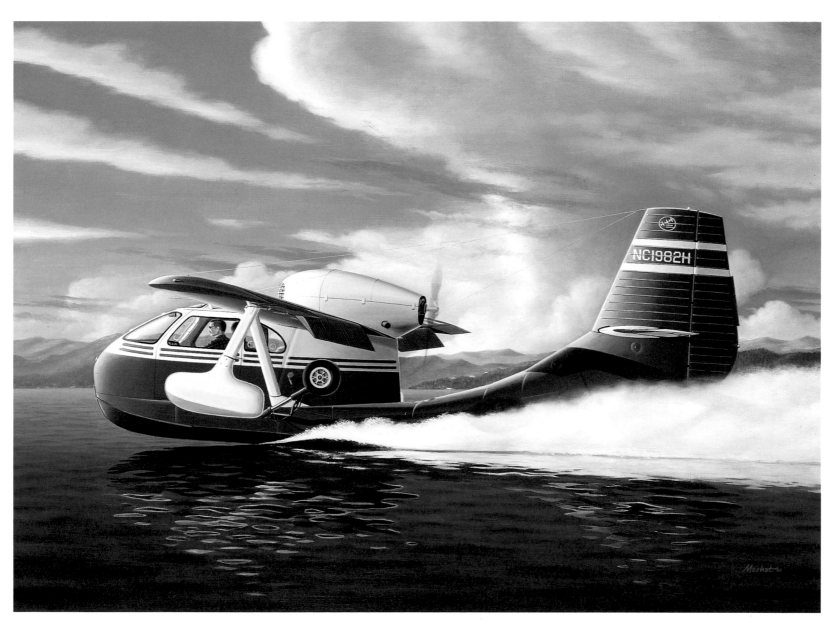

SEABEE ON THE STEP *by Mike Machat, oil, completed 1986, collection of the artist.*

Berlin Airlift

by R. G. Smith

The humanitarian use of the airplane was amply demonstrated from June 1948 to May 1949, during the Soviet land blockade of West Berlin. Cut off from the outside world, West Berliners became dependent upon a hurriedly arranged airlift of vital supplies. Hard-charging Gen. Curtis LeMay, a seasoned veteran of bomber missions later to become head of Strategic Air Command and Air Force Chief of Staff, put the disparate elements of the British-French-American effort together in a successful aerial supply line that became known as the Berlin Airlift.

Depicted here are the marginal weather conditions and limited ramp space that characterized the situation at Tempelhof Airport. The U.S. Air Force's C-54 and the U.S. Navy's R5D, military versions of the popular, early 1940s-vintage Douglas DC-4 airliner, were the workhorses of the airlift. At the peak of the effort the military transports arrived in three-minute intervals, allowing for just a forty-nine-minute unloading cycle per aircraft. From its initiation to the lifting of the blockade, the Berlin Airlift succeeded in providing 1,588,293 tons of supplies in 196,031 flights.

Overcoming the logistical obstacles of this massive supply effort was in itself a major accomplishment. The Berlin Airlift proved the resolve of the western democracies when tested in the emerging Cold War world. The airplane, feared by the German populace only a few years earlier as an instrument of mass destruction, was now the bridge that provided the beleaguered West Berliners their daily sustenance.

For information about the artist, R. G. Smith, please see page 104.

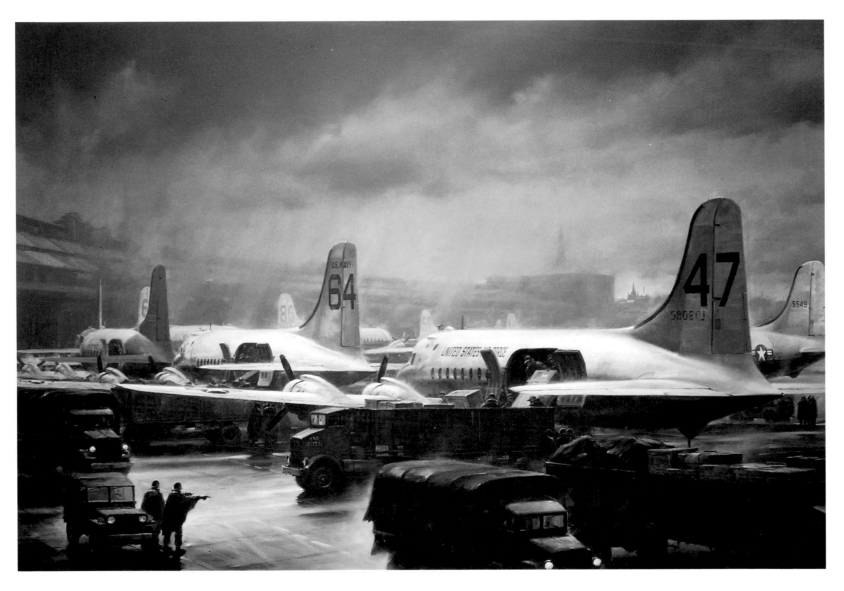

BERLIN AIRLIFT by R. G. Smith, oil, completed 1973, collection of McDonnell Douglas Corporation.

Gasin' Up

by Sam Lyons, Jr.

The Aeronautical Corporation of America's wartime trainer, the Defender, was the basis for the popular tandem-seat 7AC Champion, introduced in 1945. The sixty-five-horsepower Aeronca Champ satisfied a large part of the demand in the post-war period for a simple and economical lightplane. It could take off over a fifty-foot obstacle in just 650 feet and its engine burned only 4.4 gallons per hour. More than seventy-two hundred of this model were sold in the first few years after the war. Artist Sam Lyons, Jr., has pieced real-life ingredients into an imaginary scene. Although there is no record of this having happened, it is possible that on a sunny Saturday in aviation's laissez-faire days of the late 1940s or early 1950s, a Champ could have plunked down on Highway 41 in suburban Atlanta and taxied up to a country store for some gas and conversation.

The store belonged to and was run by a Mr. Johnson, who raised his family in an adjoining home. The airplane is Robert Armstrong's 1947 Aeronca Champ, which in 1983 won a prestigious restoration award. As these two objects, the store and the airplane, come charmingly together in a less complicated time with the locals standing around taking a look, there is a sense of old-style general aviation flying.

The same warmth of this earlier era can still be found at grass airstrips and country airports, where tail wheel puddle jumpers like the old Champ are greeted with big smiles. These little, fragile-looking airplanes that can only go low and slow are really at the core of American aviation; without them we would not have the rest.

Sam Lyons, Jr.

A Georgia native, Sam developed an interest in aviation at an early age because of the World War II flying stories related by his father, an Army Air Force B-24 pilot. He grew up with a passion for building airplane models, which led to his founding a hobby shop in Atlanta. By 1985 he decided to devote full time to aviation painting, specializing in the photo-realism style. He is a director of the Georgia Air Show Group, which restores World War II vintage airplanes to flying condition. He also served as secretary of the American Society of Aviation Artists. He and his wife, Vickie, live in Kennesaw, Georgia.

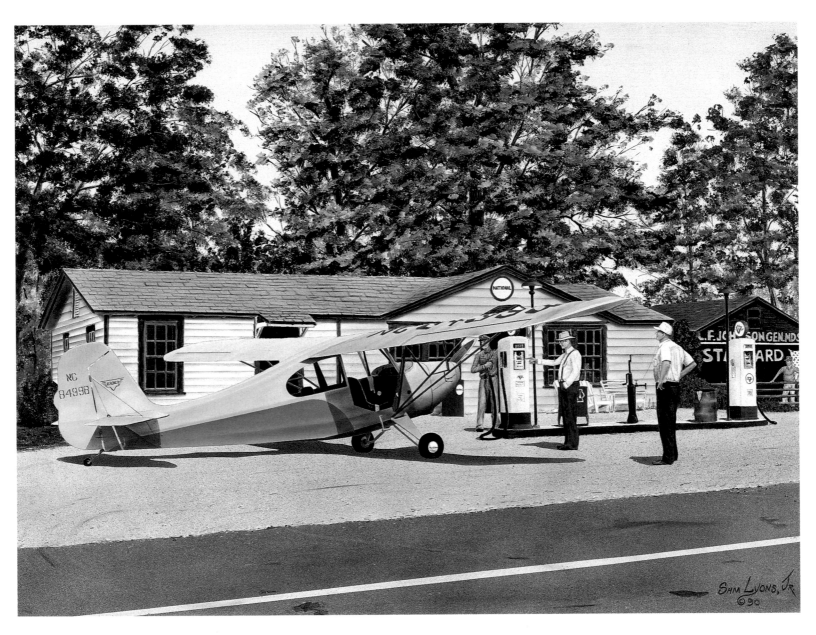

GASIN' UP by Sam Lyons, Jr., acrylic, completed 1990, private collection.

151

Barnstorming

by Nixon Galloway

Artist Nixon Galloway has captured the allure of aviation in this depiction of a war surplus Stearman trainer, converted for agricultural applications, pulling up over a cultivated field ever so close to a barn and silo. Noting that the crop duster is nearing completion on this morning's job and that his last pass will take him by the barn, the farmer's two boys have rushed up to the hayloft for a closer look at the biplane.

The Boeing Model 75 Stearman served admirably as the U.S. military's leading primary trainer during World War II. It was an "honest" airplane, but if the cadet did not exercise constant vigilance, the Stearman could retaliate, particularly on landing, where ground-looping tendencies were quite pronounced due to the plane's closely coupled landing gear and its lack of forward visibility. Because the Stearman was a rugged design and was produced in massive quantities, it became a popular plane after World War II. With the introduction of more efficient aerial sprayers, the Stearman's fortunes declined for a time. In recent years it has experienced a resurgence as an aerobatic and sport airplane. As a result, many examples of beautifully restored Stearmans can be seen at air shows today.

For information about the artist, Nixon Galloway, please see page 22.

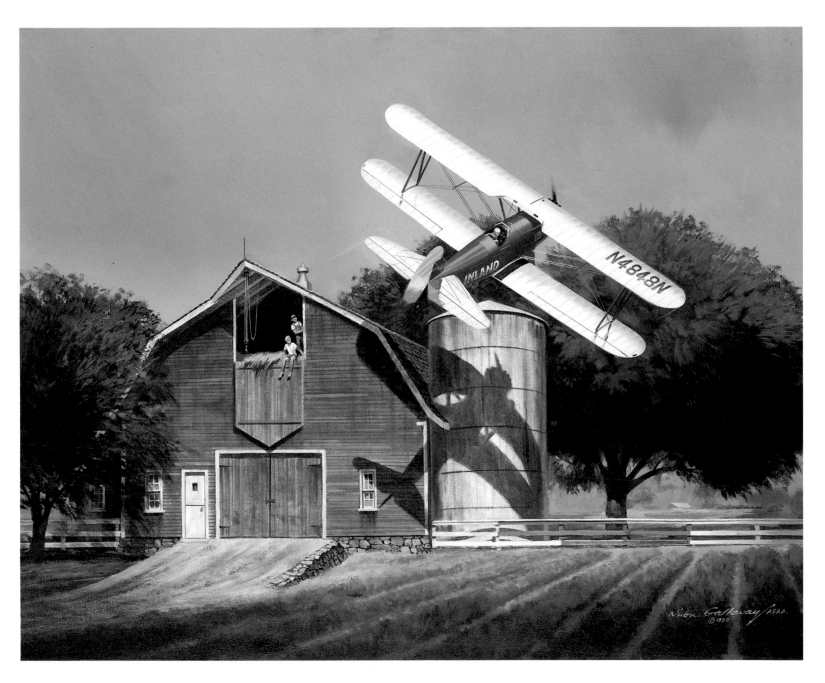

BARNSTORMING by Nixon Galloway, oil, completed 1990, private collection.

Check Six

by Jack Fellows

From the time he was a boy reading the comic strips *G-8 and His Battle Aces* and *Tailspin Tommy*, Frederick C. "Boots" Blesse had a burning desire to become a fighter pilot. He graduated from West Point and completed army flight training just as World War II was coming to a close. Undeterred, he pursued an air force career, accumulating flight time in fighters, including the first operational American jet fighter, the P-80 Shooting Star. When the Korean War broke out, he spent his first one hundred missions flying the World War II-vintage Mustang, which had been redesignated the F-51.

Blesse's second Korean tour was spent flying the outstanding North American F-86 Sabre with the 334th Fighter Squadron, 4th Fighter Wing. His missions frequently took him into the notorious MiG Alley in northwestern North Korea. There, his years of preparation came to bear in short bursts of life-or-death air-to-air combat maneuvering.

As Blesse knew, the fighter pilot must always remember to "check six," meaning to keep a vigilant lookout on what is going on to the rear, where the enemy in air combat traditionally tries to gain the advantage. In harrowing encounters, he would violently roll his Sabre, trying to shake a MiG gaining on him from behind, as depicted in this image. Blesse had the knack and the drive for fighting in the air. When he had completed his second tour of one hundred missions, he had scored four victories. Unwilling to leave before achieving his fifth victory to qualify as an ace, he volunteered for an additional twenty-five missions. Before his extended tour was completed, he had become a double ace credited with ten victories.

After his return home he served at Nellis Air Force Base in Nevada. As a fighter pilot instructor, he was frustrated with the lack of adequate texts on practical principles and tactics, so he authored a primer entitled *No Guts, No Glory*, which soon became mandatory reading for air force fighter pilots. Blesse believed that success in air combat requires thinking through maneuvers, anticipating the enemy's action and, of course, never forgetting to check six.

For information about the artist, Jack Fellows, please see page 106.

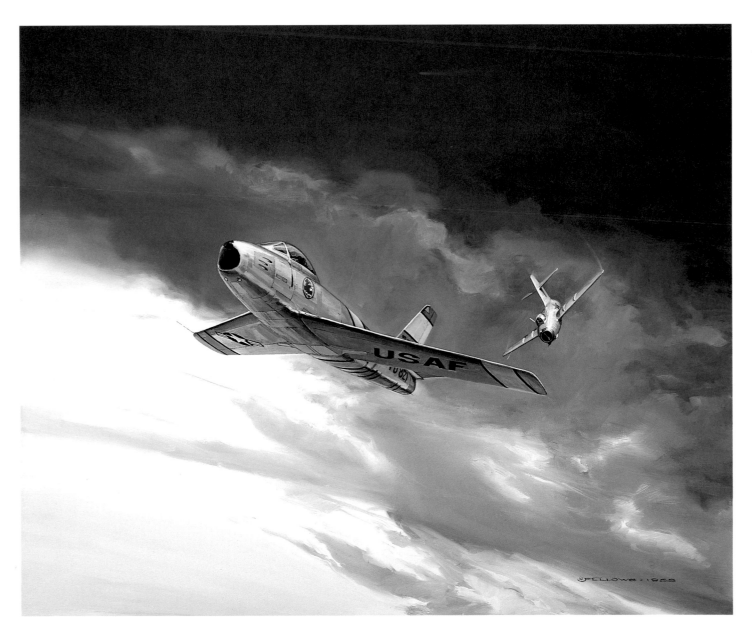

CHECK SIX by Jack Fellows, oil, completed 1988, collection of Champlin Fighter Museum.

Lake Bed Liftoff

by Mike Machat

If ever there was an airplane whose look belied its performance, it was the sharp and sleek Douglas X-3 Stiletto. The earlier X-planes had been unable to sustain supersonic flight for more than brief periods, but the X-3 was conceived to fly at high Mach numbers for prolonged duration. Unfortunately, delays in producing the desired Westinghouse J46 engines required substituting J34 turbojets, which left the X-3 seriously underpowered. Indeed, the fastest the X-3 ever flew was early in the flight-test program when in a thirty-degree dive it reached just over Mach 1.2, far short of expectations.

This exotic-looking research vehicle of the early and mid-1950s is shown here piloted by experienced test pilot USAF Lt. Col. Frank K. "Pete" Everest, Jr., as it rises from the sun-baked surface of Rogers Dry Lake at Edwards Air Force Base. Oil was used to etch runway markings along the great expanse of the desert floor. The X-3, due to its short wings and low thrust, required a takeoff roll of three miles. Incredibly, this deceptively beautiful airplane did not lift off until it reached a speed of 260 MPH. In the upper left, the artist has provided a glimpse of some of the hangars of the old South Base at Edwards, home to the early flight-test programs.

The golden age of flight test, extending from the first post-World War II supersonic experiments with the X-1 to the early 1960s record-breaking X-15 flights, was highlighted by aeronautical breakthroughs that frequently entailed enormous risks. Even the ill-fated X-3 contributed to the advancement of flight. Flown by civilian test pilot Joseph Walker in 1954, the X-3 became briefly uncontrollable at the outset of an abrupt roll. From this unexpected problem, designers and engineers gained knowledge of a phenomenon known as inertia coupling. As a result, the design community was able to perfect new configurations for sustained high-speed flight. The X-3 also helped prove the viability of titanium as a practical heat-resistant material for aircraft use. Despite a number of close calls, the only X-3 ever built survived four years of flight test and is now displayed at the U.S. Air Force Museum at Wright-Patterson Air Force Base in Dayton, Ohio.

For information about the artist, Mike Machat, please see page 132.

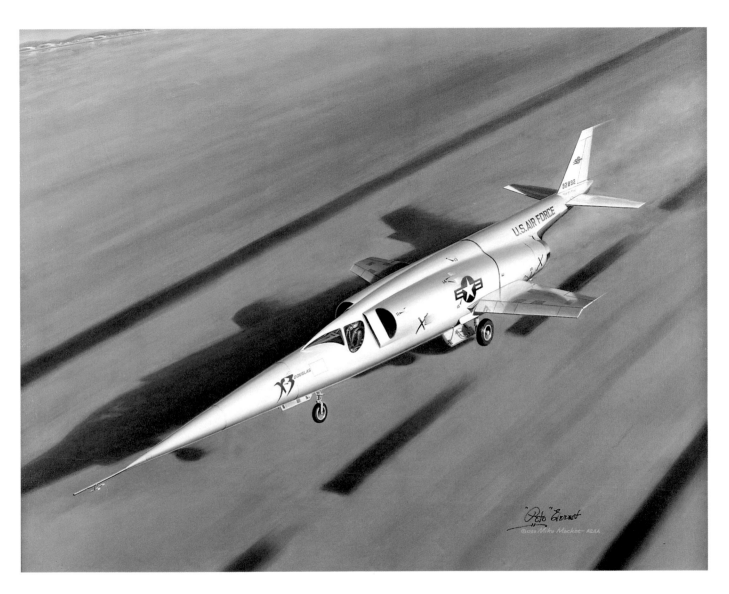

LAKE BED LIFTOFF by Mike Machat, oil, completed 1989, private collection.

Gold Cup Roll

by Mike Machat

On the sunny morning of August 7, 1955, an audience of more than a quarter of a million ringing Lake Washington was treated to an air show before the first heats of Seattle's Gold Cup hydroplane speedboat races. The Boeing Company was hosting airline executives from around the world and sought to take advantage of the moment by asking its test pilot, Alvin M. "Tex" Johnston, to make a low-altitude, high-speed pass over the race course in the company's spanking new 707 jetliner prototype, known as the "Dash 80." Upon completing a scheduled flight test over the Olympic Peninsula, the Dash 80 maneuvered in for its pass. As it accelerated to five hundred knots at just five hundred feet above the lake, Johnston pulled the nose up to the left and swung the big four-engined jet into a barrel roll. Before the disbelieving audience, Tex Johnston then turned for a second pass and executed another barrel roll in the opposite direction.

Boeing's earlier experience with the B-47 Stratojet program proved of immeasurable value in its pursuit of the development of a jet airliner. The Boeing 707 entered airline service with Pan American Airways on October 26, 1958, becoming the first operational American-built jet airliner. Its commercial prospects were given a boost when the U.S. Air Force ordered a refueling tanker version of the 707, designated as the KC-135. Introduction of the Boeing 707 elevated the expectations of passenger airline service and fostered the conversion from piston to jet-powered airliners flying the longer national and international routes.

Tex Johnston, the Boeing test pilot who for years had distinguished himself as a skillful aviator flying exotic designs and setting speed records, went on to several Boeing projects and later became head of the company's flight-test division.

For information about the artist, Mike Machat, please see page 132.

158

GOLD CUP ROLL by Mike Machat, oil, completed 1990, collection of the artist.

Tupolev Takeoff

by Tom Morgan

In the early 1950s, the Soviet airline Aeroflot recognized the need to update its fleet, which comprised relatively slow, piston-powered aircraft. In response, the Tupolev Design Bureau offered an airliner version of its turbojet-powered Tu-16 bomber. The advantages to this approach were that the airliner would be a proven design and that it could be manufactured in a reasonable amount of time. The first model, designated the Tu-104, entered the Aeroflot route system on September 15, 1956. Because of the de Havilland Comet's temporary withdrawal from the market due to safety concerns, the Tupolev was, at the time, the only jet in the world providing regularly scheduled airline service.

Reflecting the airliner's bomber heritage, the Tu-104 had a glass nose. In Aeroflot operations the nose position was occupied by the navigator. The wing was swept and had a noticeable downward slant, known as anhedral. The engines fit in bulging rounded nacelles at the wing roots.

The first airliner model was uneconomical because cabin capacity was limited to fifty passengers. A new model with seventy passenger seats, the Tu-104A, was introduced in July of the following year. The seating configuration of this model was divided into two distinct arrangements—sixteen club-style in first class and fifty-four line-abreast-style in the aft section.

The introduction of the Tu-104A into commercial service, with its success in elevating airline standards and in substantially reducing travel time, represented major improvements. Depicted in this image by artist Tom Morgan is a Tu-104A

making a night departure as passenger travel by jet becomes routine. Tupolev produced approximately two hundred of the airliners in various versions and seating capacities. The only exported models, of which there were six, went to Czechoslovakia.

Tom Morgan

Tom is one of the "old hands" in the aviation art movement, having established himself as an illustrator of model box tops. At the behest of his clients, the plastic model companies, he frequently emphasized brightness of color and high drama in his paintings. Today, some of his model-box-top paintings for the likes of Lindberg, Hawk, Comet, and Monogram are collector's items. He remains active in the Air Force Art Program. He and his wife, Shirley, reside in Park Ridge, Illinois.

TUPOLEV TAKEOFF by Tom Morgan, opaque gouache, completed 1967, collection of Lindberg Model Company.

Vulcans

by Tom Morgan

One of the most eye-catching shapes of the jet era, the Avro Vulcan, a component of the British Royal Air Force's new "V" bomber force, entered service on February 22, 1957. The aircraft's massive delta wing housed four Bristol Olympus turbojet engines, which over the years were upgraded to provide maximum thrust of twenty thousand pounds each. Because of Cold War tensions, the Vulcan was utilized in the nuclear deterrent role. In the 1960s, the Vulcan was equipped with the Blue Steel nuclear warhead cruise missile, an early standoff weapon that would allow the bomber to deliver its destructive load without having to overfly the target.

Two Vulcans in the RAF's green and gray camouflage are shown here in an imaginary combat scene. The surrealism evident here, with the bright, almost antiseptic exhaust streams and a clearly delineated, tipped horizon, was typical of the illustration that decorated plastic model box tops of the 1950s and 1960s at the height of the Cold War. The box-top artwork did not strive for historical accuracy, but was characterized by a naive flashiness that would appeal to a wide audience of young modelers.

Vulcans had gradually been phasing out of service and were scheduled to be completely withdrawn in 1982. But the Falkland Islands dispute between Argentina and Britain erupted and ironically the Vulcan, for the first time in its twenty-five years of operational life, was pressed into combat. Britain's first strike in the Falklands War, code named "Black Buck I," came on May 1, when an RAF Vulcan operating from Ascension Island attacked the runway at Stanley Airport with twenty-one 1,000-pound bombs. The runway cratering was successful, precluding its use by high-performance Argentine aircraft. Further long-range missions were performed by the old Vulcans with generally good results. With the cessation of hostilities, the Vulcans returned to their home base at RAF Waddington where their postponed retirement soon took place.

For information about the artist, Tom Morgan, please see page 160.

VULCANS by Tom Morgan, opaque gouache, completed 1967, collection of Lindberg Model Company.

Solo Student over the Numbers

by Keith Ferris

For a few generations of U.S. Air Force pilots, including most of those on flight duty today, the Cessna T-37B Tweet is the airplane that introduced them to the hands-on world of military flying. Since 1961 the air force has had an all-jet pilot training program. Primary flight instruction consists of eighty-seven hours in the Tweet; the advanced phase entails 109 hours in the supersonic Northrop T-38 Talon. Altogether, the course for aspiring student pilots runs fifty-two weeks, during which the second lieutenants are also inundated with demanding academics covering everything from meteorology to navigation.

This scene shows a student practicing landings shortly after his first solo in 1963 at Webb Air Force Base in West Texas, now deactivated. The Tweet's distinctive clamshell canopy provides a wide cockpit with side-by-side seats, allowing students and instructors to establish eye-to-eye contact—a valuable asset in training. It is not hard to imagine the screech of the tires as they strike the runway or the constant high-pitched whine of the Tweet's Continental J69 engines.

The sturdy Tweet, in service for over three decades, has remained operational through a fastidious maintenance program, but even so the end of its operational usefulness is in sight. Its replacement has not yet been chosen, and there promises to be a lively competition. The air force will insist that any successor have the same aerobatic capabilities, as it is deemed essential that anyone wearing air force silver wings be able to fly in unusual attitudes achieved through aerobatic maneuvers, including spins. The air force is also in the midst of significantly revamp-ing the training syllabus so that students, following an elaborate screening process, will be steered onto the appropriate track. Those destined for tankers and transports will go directly from their primary phase into a modified business jet for the advanced portion of their course.

For information about the artist, Keith Ferris, please see page 26.

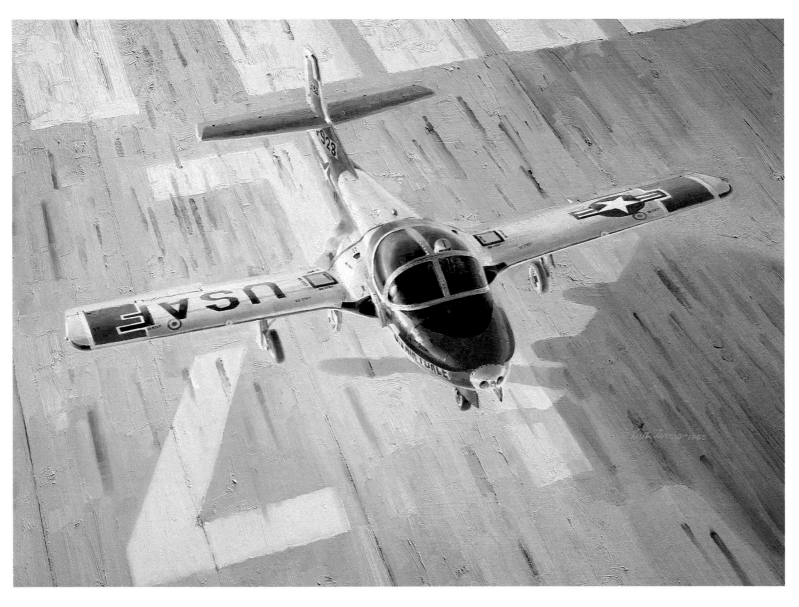

SOLO STUDENT OVER THE NUMBERS by Keith Ferris, oil, completed 1980, U.S. Air Force Art Collection.

Before the Ax Fell

by Charles Thompson

Forward-thinking military planners, concerned about the proliferation of supersonic interceptors and the development of radar-guided surface-to-air missiles in the 1950s, questioned the wisdom of conventional attack doctrine that relied on high-altitude, relatively slow bombers to destroy ground targets. In the emerging battlefield of the skies, the new high-tech threats would presumably decimate old-style bombers. With this in mind, the British conceived a high-speed, low-level tactical strike aircraft that would also serve in the reconnaissance role. The low-level approach to knocking out ground targets was predicated on the belief that the lower an aircraft flies the harder it is for radar to detect it.

Before the end of the decade, the newly formed British Aircraft Corporation received a contract for the development of the TSR 2 (for Tactical Strike Reconnaissance). The TSR 2, powered by two Bristol Olympus 22R engines, was to be the Royal Air Force's new aircraft for a new kind of air warfare. It was to race to its designated target at well over Mach 1, swoop to just two hundred feet above the surface before entering hostile airspace at a speed modestly under Mach 1, deliver its substantial bomb-load with pinpoint accuracy, and then dash to safety. It was also designed to have a nuclear strike capability. Top speed was to exceed Mach 2.

The TSR 2 was a large aircraft, measuring eighty-nine feet in length but with a crew of only two, seated in tandem in the tapered forward cockpit. All systems were to be fully integrated into the aircraft design, not fitted on afterwards. The electronics on board would derive from the latest technology. The delta wing's tips were angled down a full thirty degrees for lateral stability.

The first prototype TSR 2, designated XR 219, flew on September 27, 1964, and is depicted here. Five months later the test version went supersonic. The flight- test program was proceeding in an orderly way, but the TSR 2 never flew after March 3, 1965. Rising project costs, a belief in the superiority of competing American technology, interservice rivalry, and most of all, a meddling governmental bureaucracy, all contributed to the cancellation of the TSR 2 program. Nineteen TSR 2s were in various stages of production, but the entire lot was ordered destroyed. The ax had fallen.

For information about the artist, Charles Thompson, please see page 58.

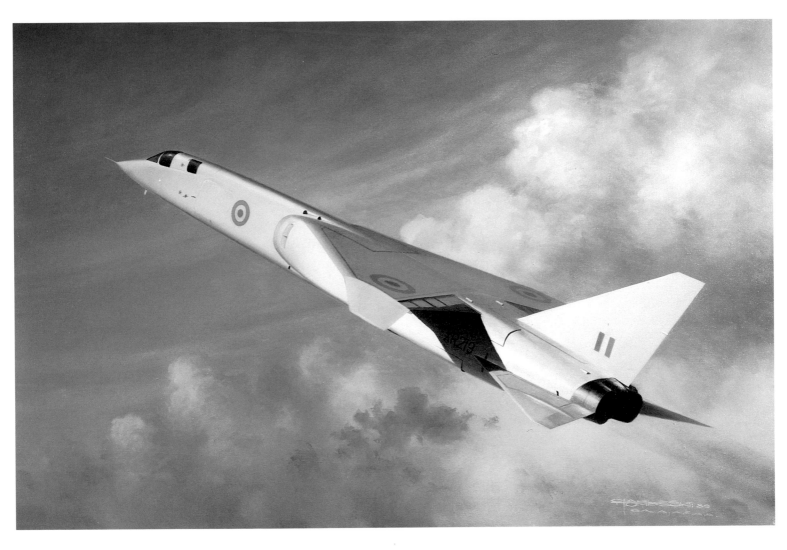

BEFORE THE AX FELL by Charles Thompson, oil, completed 1989, private collection.

Dance of the Valkyrie

by Mike Machat

Designed to replace the 1950s-vintage B-52 long-range heavy bomber, the North American XB-70A Valkyrie, a leviathan of the sky, achieved speeds in excess of Mach 3 and altitudes of over seventy thousand feet. The Valkyrie's huge delta wing's outer panels could fold downward a full sixty-five degrees, providing stability at high speeds. This speed demon sported the forward control surfaces known as canards. Movable engine inlets regulated airflow intake pressures. An on-board fuel capacity representing more than half of the aircraft's takeoff weight would permit the six General Electric YJ-93-GE-3 engines to carry it a distance of over seven thousand miles.

The Valkyrie was conceived as a strategic bomber whose sustained supersonic cruise altitude at fourteen miles above sea level would protect it from enemy intercept. However, prior to the first flight in 1964, Washington had already decided against full-scale production because of the program's mounting costs, the perceived threat of a new generation of Soviet surface-to-air missiles, and the introduction of intercontinental ballistic missiles. The XB-70A was relegated to the role of research aircraft and only two were built.

Artist Mike Machat depicts one of the XB-70As on an April 8, 1966, flight test high over the California desert. Puffy cumulus clouds form from the rising heat of late morning as test pilots Fitzhugh "Fitz" Fulton and Al White leave a TB-58 Hustler chase plane in their wake, accelerating to beyond Mach 3. Two months later, Fitz Fulton was scheduled to give an indoctrination ride in the XB-70A, but because of a scheduling conflict, the task fell to Al White. Tragically, during a photo pass that followed a scheduled flight test, a mid-air collision with an F-104 chase plane occurred in which Al White narrowly escaped with his life, but two others were fatally injured and both aircraft were lost. The remaining XB-70A continued in a research flight program until 1969 when it joined the Air Force Museum's collection.

For information about the artist, Mike Machat, please see page 132.

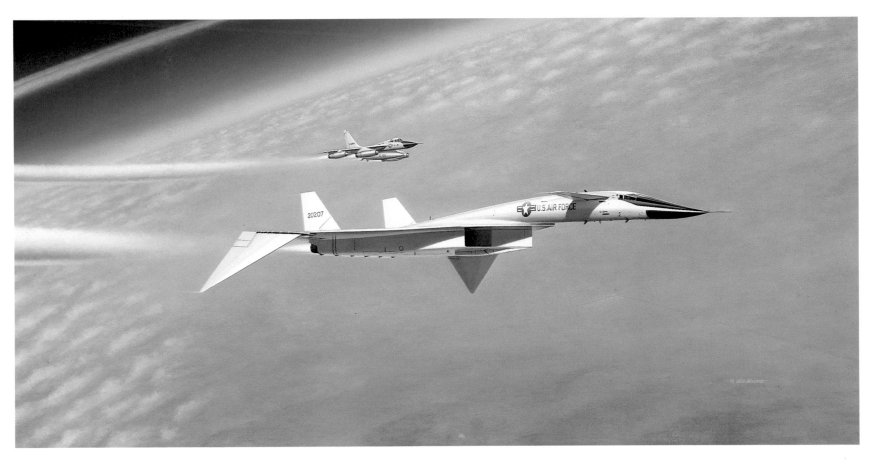

DANCE OF THE VALKYRIE by Mike Machat, oil, completed 1990, private collection.

SR-71 BLACKBIRD by Keith Ferris.

The Modern Era

The Vietnam War, so controversial and divisive at home, was pursued in an agonizingly bureaucratic manner that, especially in the view of many of the American pilots fighting there, produced an unavoidably nightmarish result. Air force and navy combat pilots were governed by burdensome rules of engagement that interfered with common sense and at times needlessly jeopardized their safety. This micromanagement of the air war by politicians far removed from the heat of battle diminished the effectiveness of the American air power deployed in Southeast Asia.

Compounding the lack of progress in the air war were the deficient air-to-air combat skills of the American fighter pilots. Before the Vietnam build-up, the prevailing wisdom among strategists was that time-tested dogfighting abilities would no longer be necessary in the modern world of air-to-air missiles. So customary fighter pilot tactics were de-emphasized with disastrous consequences as unacceptable kill/loss ratios were recorded. The navy was first to redress this serious flaw by providing new training in the old skills of air combat maneuvering. Once this program got under way at the navy's Top Gun school, the kill/loss ratios improved dramatically.

The American manned space program, at first catching up to Soviet successes, moved forward at a dizzying pace envisioned only by the most optimistic observers. It proved that the United States could achieve what it set out to do. From a few ballistic shots and some brief orbital flights in the early 1960s, astronauts voyaged to the moon and back before the decade was over.

Predicated in part on information from research flying at Edwards Air Force Base, the manned space program turned to the reusable shuttle concept. Blasted into orbit, the shuttle would return as a glider, its crew making a dead-stick landing at a precise, predetermined site, not haphazardly parachuting into an ocean as space capsules had done in previous years. The astronauts now command a spaceship with wings that for a critical phase of the flight regime is guided by their hands-on piloting.

In a lightning air war that was the antithesis of the Vietnam experience, the latest American technological might was used against Iraq's vast and impressive military. Among the new generation of combat aircraft employed in the Persian Gulf War were sophisticated drones that provided crucial intelligence and F-117A Stealth Fighters that returned unscathed from highly successful attacks against the highest priority targets in the capital city of Baghdad. Within days, the United States and its coalition partners established air superiority which paved the way for the subsequent decimation of Iraq's fighting capability.

In the last decade, private pilots have been clobbered by inhospitable economics. The new light-plane market is chronically depressed, as flying for the weekend pilot has become increasingly difficult to afford. Happily, the air show circuit continues to buck the trend with thousands of beautifully restored antiques and warbirds exhibited at hundreds of aviation events each year. These events are a tribute to the enthusiasts dedicated to preserving aviation's heritage and it represents an important link to understanding aviation's present. Perhaps in a small way the unabashed adoration for the airplane that radiates at these gatherings contributes to the foundation of aviation's future.

Blackbird

by Keith Ferris

A product of Lockheed's legendary Skunk Works, the SR-71 Blackbird, with its radical configuration and amazing performance characteristics, stunned people when its existence was first disclosed on February 29, 1964. This revolutionary aircraft, whose design dates back to theories developed in the late 1950s, still holds the world's speed record of well over 2,000 MPH. For years, in fulfillment of its daily assignments as a strategic reconnaissance plane, the Blackbird, powered by two Pratt & Whitney J58 turbojet engines, flew at speeds in excess of Mach 3.

Under the long-time expert guidance of one of the world's greatest airplane designers, Clarence L. "Kelly" Johnson, the Skunk Works (officially known at Lockheed as the Advanced Development Projects unit) crowned an already impressive record of achievements with its secret development of the SR-71, planned to succeed the earlier U-2 spy plane. From its cruise altitude of fifteen miles, the SR-71 could survey over 100,000 square miles in an hour. In order to withstand the temperature extremes of high-speed flight, the titanium wing surface was corrugated and dimpled. The aircraft's nickname derives from the high-emissivity black paint used on the skin that reduces surface temperatures.

In a monumental engineering effort, the engine air inlets were designed to handle the airflow in drastically varying flight regimes. Tires retracted into the fuel tanks where they would be cooled so as to be better able to withstand the friction and the heat of landing. Pilots of this remarkable machine, which flies at altitudes above eighty thousand feet, must wear pressure suits much like those worn by astronauts. Because of the redundancy built into the aircraft's systems, the SR-71 has enjoyed an incredibly good safety record.

A marvel of aircraft design and of engineering prowess, the SR-71 was retired from active air force service in 1990, ostensibly for budget reasons. Ironically, its "older brother," the U-2, in its improved version known as the TR-1, continues on its high altitude spy missions.

For information about the artist, Keith Ferris, please see page 26.

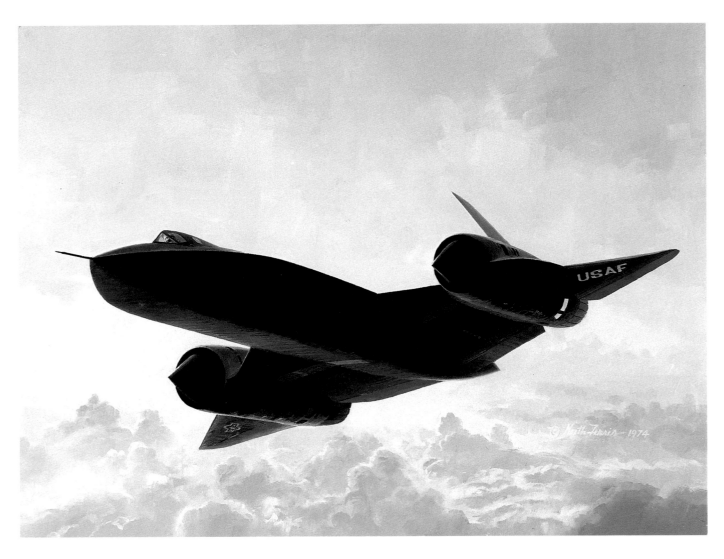

*BLACKBIRD by Keith Ferris, oil, completed 1974,
collection of Keith Ferris/Aviation Week & Space Technology.*

Flameout!

by Mike Machat

Over Hanoi (known in combat circles as "downtown") in the spring of 1967, Col. Jack Broughton, a seasoned wing commander, led his men in an attack during which a friend and fellow pilot was downed by enemy fire. The downed flier's emergency beeper was activated and contact was established. Rescue efforts during the day were frantic but unsuccessful as the missing pilot continued to dodge North Vietnamese ground forces.

Following another attack on positions in Hanoi on May 3, Broughton again went looking for his comrade, knowing that with the passage of time the odds of an evacuation were becoming increasingly slim. Contact was once again established, but an effort to arrange the necessary rescue helicopters and close air support planes proved difficult. Hanging on for all the elements to come together, Broughton's fuel and that of his wingman, Ken Bell, became distressingly low.

Believing that U.S. radar controllers had coordinated the necessary in-flight refueling for his long return flight, Broughton instead learned no such provisions were made. Desperate for fuel, Broughton repeatedly called for help. Just as the situation looked hopeless, a KC-135 tanker crew that had been monitoring Broughton's radio frequency broke in and offered to refuel the two Republic F-105 Thunderchief fighter-bombers, nicknamed "Thuds," even though the tanker had already passed on fuel to other aircraft and was below regulation minimums for further refueling.

The tanker came into sight over the Plaine Des Jarres of northern Laos. Before a link-up could be accomplished, Bell's fuel-starved Thud flamed out. Undeterred, the KC-135 pilot shoved the nose of his airplane down into a steep dive to match that of the rapidly descending Thud. The tanker's boom operator was able to plug into the Thud's receptacle, giving life to a silent engine. Broughton, his own tanks nearly dry, also angled into position for a drink. Joyous for their reprieve from an ugly fate, the two fighter-bomber pilots performed a roll for their new-found friends aboard the tanker.

Low on fuel because of its generosity, the tanker landed with Broughton and Bell at their home base at Takhli, Thailand. Sadly, subsequent attempts to recover the downed pilot were unsuccessful.

For information about the artist, Mike Machat, please see page 132.

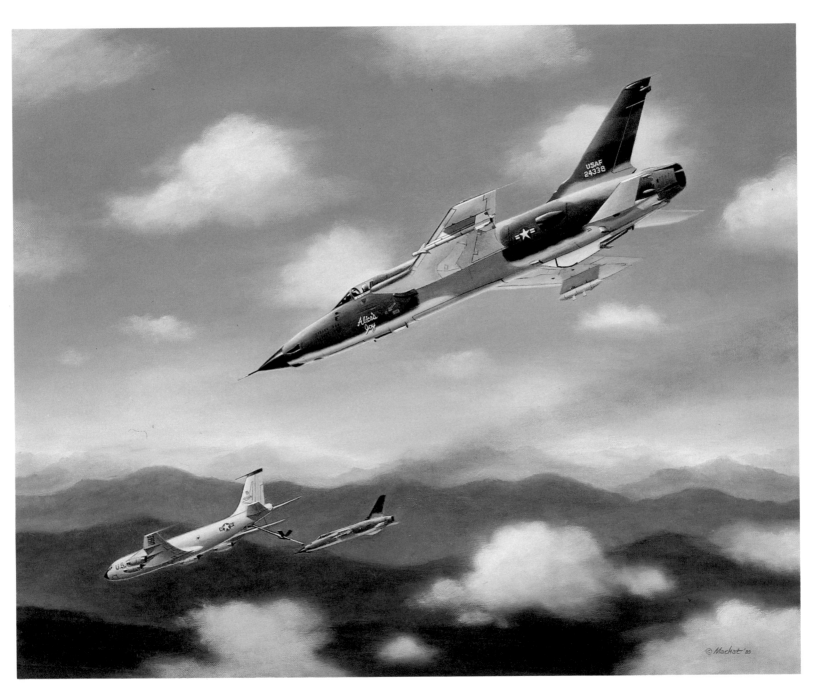

FLAMEOUT! by Mike Machat, oil, completed 1989, collection of the artist.

Launch of the A-2

by Mike Machat

This painting by artist Mike Machat shows the North American X-15A-2 momentarily after separation from its NB-52 mother ship at thirty-five thousand feet, on October 3, 1967. The rocket plane, piloted by USAF Maj. William J. "Pete" Knight, begins its dash to a new speed record. Because of the lack of oxygen at the high altitudes that were the X-15A-2's domain, the Reaction Motors' XLR99 power plant was a rocket using anhydrous ammonia as fuel and liquid oxygen as oxidizer. In this view, the engine's hot exhaust is partially obscured by fuel vapor streaming from the overflow tubes. Outfitted with two external propellant tanks designed to prolong the engine run by up to 70 percent, the "A-2" climbed in a thirty-five-degree ascent to 102,000 feet, reaching a speed of Mach 6.7, or 4,520 MPH. This speed record for a manned, winged vehicle has in the ensuing years been exceeded only by the Space Shuttle.

This version of the X-15 was differentiated from the earlier models by a number of modifications, notably the M-25S ablative coating applied to the rocket plane's outer skin. This experimental white coating provided protection from the extremely high temperatures encountered in the demanding flight regime. Also, the A-2 depicted here has a dummy scramjet on the stub ventral fin in order to explore the feasibility of such engines for sustained high-Mach flight.

The X-15 research program expanded the envelope of manned, winged flight to the limits of the atmosphere. The dedicated pilots, ground crews, and engineers who formed the core of Edwards Air Force Base flight operations during the Golden Age of Flight Test opened the aviation world up to horizons only dreamed of previously. The X-15, in all its variants, will be remembered as among the most successful of the famous X-plane programs. The X-15A-2, stripped of its special heat-resistant coating, today is housed at the U.S. Air Force Museum at Wright-Patterson Air Force Base in Dayton, Ohio.

For information about the artist, Mike Machat, please see page 132.

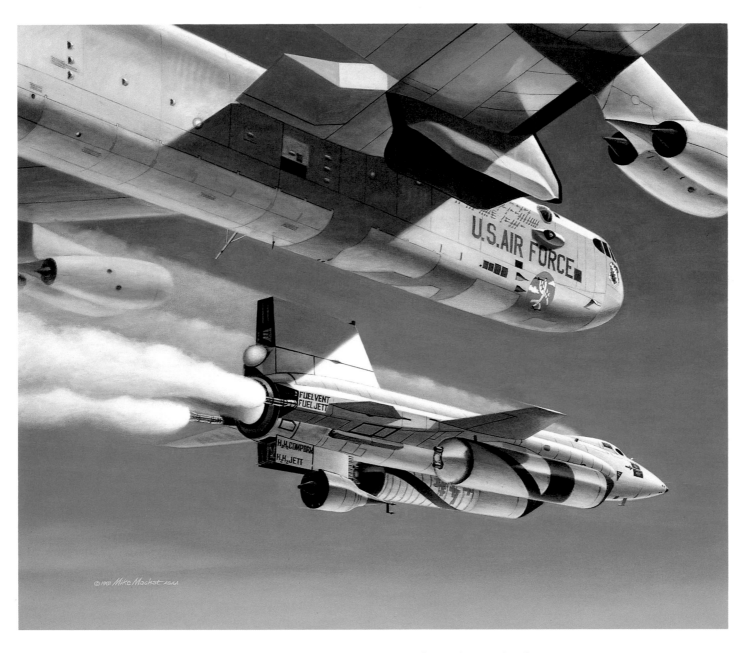

LAUNCH OF THE A-2 by Mike Machat, oil, completed 1988,
collection of the Air Force Flight Test Center Museum, Edwards Air Force Base, California.

Moonlight Intruders

by Craig Kodera

Night is the preferred cloak for an attacker, and few have been so proficient in the use of nature's veil as the Grumman A-6 Intruder during operations over Vietnam in 1968. Seen here in an image by artist Craig Kodera, two A-6As belonging to Attack Squadron VA-35, the "Black Panthers," have catapulted from the USS *Enterprise*. They are now rushing at 420 knots just four hundred feet above a winding river in the Vietnamese landscape as they approach a pre-designated target. The aircraft have recently descended beneath layers of broken clouds where slivers of moonlight illuminate the sky, allowing the pilots and bombardier/navigators to steer by visual reference.

The sophisticated radar and electronic systems of these highly capable medium-attack aircraft can lock onto their target, allowing for accurate hits with the dozen five-hundred-pound bombs carried on underwing pylons by each Intruder. Their challenge is to attack the target without attracting the attention of the formidable air defenses that range from small arms fire to advanced surface-to-air missiles. Accordingly, the aircraft's external lights have been dimmed and only the necessary avionics systems are operating.

The Intruder's distinctive features are its bulbous nose, which houses a substantial amount of electronic gear, and its in-flight refueling probe that protrudes above the nose. The Intruder first entered the fleet inventory in 1963 and has shown a remarkable ability to adapt to new and improved weapons systems. As it approaches its thirtieth year in active duty, the Intruder may be blessed with further longevity, since the cost of a replacement could be prohibitive. An updated electronic countermeasures (ECM) derivative of the attack aircraft, known as the EA-6B Prowler, is currently in service. It accommodates a four-man crew in an expanded cockpit and carries additional electronic equipment in a vertical stabilizer-mounted pod and in underwing units.

For information about the artist, Craig Kodera, please see page 62.

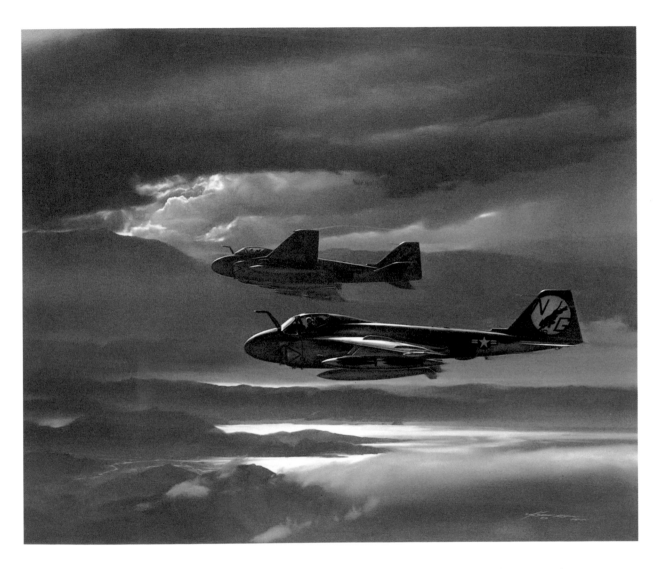

MOONLIGHT INTRUDERS *by Craig Kodera, oil, completed 1988, collection of the artist.*

One Day in a Long War

by Gary Meyer

With the initiation of the Linebacker offensive on May 10, 1972, there was a marked change in the character of the air war in Vietnam. The bombing of the north, which had been suspended three and a half years earlier, now resumed. In coordinated attacks involving both air force and navy planes, widespread damage was inflicted on enemy targets. Notable among the targets was the Paul Doumer bridge, a chief supply route for both road and rail on the northern outskirts of Hanoi.

Sixteen McDonnell Douglas F-4 Phantoms from the 8th Tactical Fighter Wing at Ubon, Thailand, streaked in flights of four toward the bridge. What had in the past been a difficult, heavily defended target, would this day be subjected to a raid employing new "smart bombs" released from higher and, it was hoped, safer altitudes. Antiaircraft gunfire, indeed, fell harmlessly short. But surface-to-air missiles were shooting up into the clear skies like popcorn. Thanks to effective electronic countermeasures and jinking techniques, the attacking pilots evaded all the SAMs.

The first seven bombs dropped were highly touted electro-optically guided devices. But they performed dismally; some even veered away from the bridge. The remaining twenty-two bombs were laser-guided and required the appropriately outfitted planes in each flight to keep their Pave Knife laser designators switched on and the beam trained on the target. As the attack ensued, bomb after bomb came extremely close to the bridge. Some even slipped through the bridge's framework but splashed into the Red River and exploded.

This image depicts the leader of Jingle Flight, Lt. Col. Rick Hilton of the 433rd Tactical Fighter Squadron, who has swung to his right immediately after passing the bridge to keep the beam locked on the target for the final element of the attacking force. Their bombs finally hit the bridge, causing a fiery explosion and breaking apart two spans at the eastern end. With bombs away, the attackers went into afterburner, hoping their sonic booms would boost the morale of their comrades imprisoned in the infamous Hanoi Hilton.

Gary Meyer

Gary graduated from the Art Center College of Design in Los Angeles and pursued further studies at Chouinard Art Institute. Since 1960 he has been involved in illustration, graphic arts, and sculpture. He served with the First Marine Air Wing in Korea and later became an illustrator for North American Aviation. A consummate commercial illustrator, he has carved a niche for himself as a consultant on the design of sets for motion pictures, including *Star Wars*. He was president of the Society of Illustrators of Los Angeles and currently serves on the faculty of his alma mater. He and his wife, Julie, reside in Woodland Hills, California.

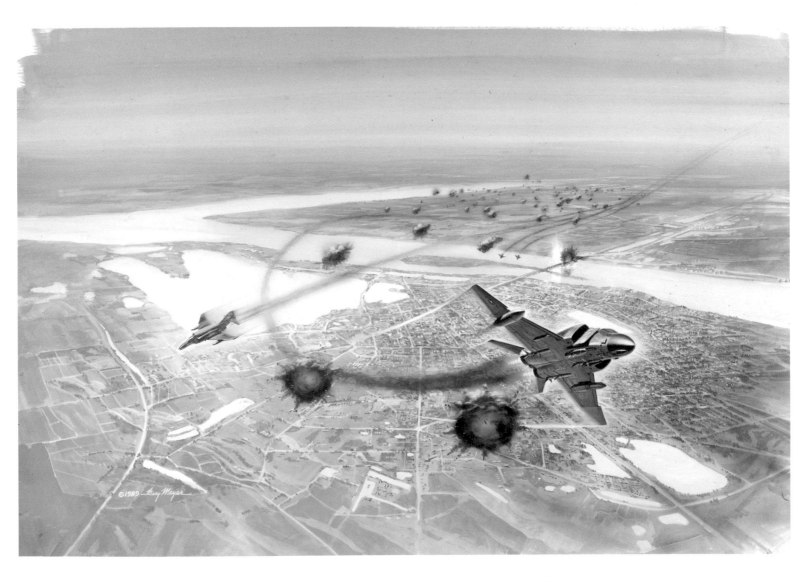

ONE DAY IN A LONG WAR *by Gary Meyer, gouache, completed 1989, collection of the artist.*

Operation Wet Wing

by R. G. Smith

Artist R. G. Smith pictures here two masterful creations of Douglas Aircraft design genius Edward H. Heinemann, with whom he worked for many years as a configuration engineer. Shown is the big Douglas EKA-3B Skywarrior refueling the humpbacked Douglas A-4F Skyhawk. During the Vietnam War hundreds of battle-damaged combat aircraft leaking fuel on return from missions were spared by the intervention of aerial tankers. This scene depicts a Skyhawk taking on desperately needed fuel from a Skywarrior at Yankee Station in the Gulf of Tonkin in 1973.

The artist was granted access to U.S. Navy flight operations in Vietnam for two months in the late 1960s and gained special insight into life-or-death situations like these. He saw close-up the daily performance of aircraft in whose design he had participated, as well as the dedication of pilots subjected to unremitting stress.

Originally conceived as a high-altitude attack aircraft, the Skywarrior, also affectionately known as the "Whale," evolved into a multimission platform—tanker, reconnaissance aircraft, electronic countermeasures plane, bomber-navigation systems trainer, and VIP transport. The air force also acquired the aircraft, designating it the B-66 Destroyer.

The Skyhawk, nicknamed "Heinemann's Hot Rod," was designed as a light attack aircraft with fighter-like handling qualities. Its success was due to its simplicity and its wisely controlled production costs. The Skyhawk's production run, from 1954 to 1979, was the longest of any tactical aircraft up to that time. It is a tribute to the basic design premise that many Skyhawks remain in service around the world to this day.

For information about the artist, R. G. Smith, please see page 104.

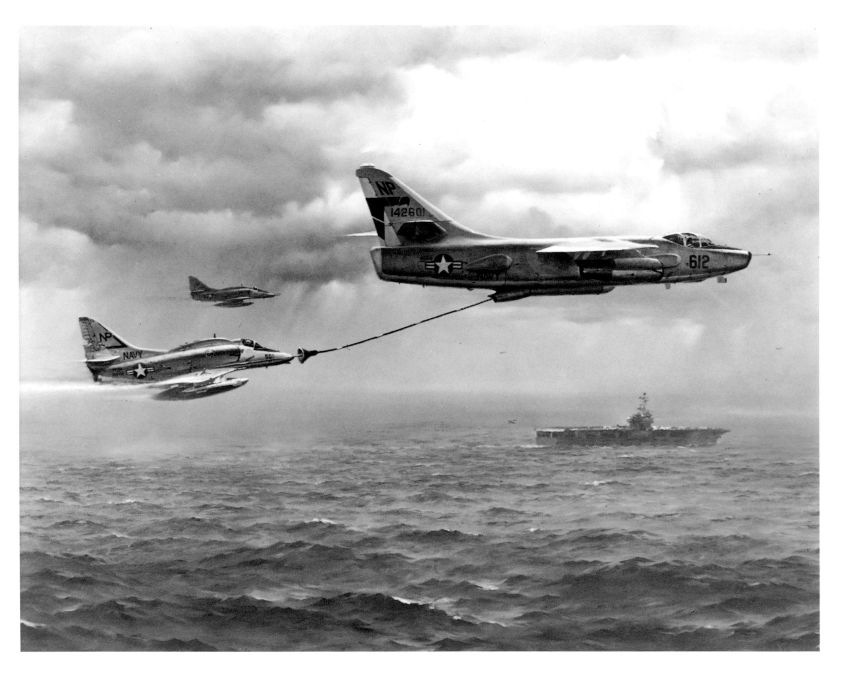

OPERATION WET WING by R. G. Smith, oil, completed 1972, collection of McDonnell Douglas Corporation.

Morning in the Rockies

by Paul Rendel

In order to take advantage of the "mountain wave" that is stronger in the early part of the day, this glider pilot, like most, prefers a morning launch from the Black Forest Airport, twenty miles from Pike's Peak. Artist Paul Rendel, a glider pilot, has depicted a typical sailplane adventure in this scene of a single-seat Concept 70 gracefully negotiating the jagged terrain of the Colorado Rockies. After release from one of the obliging tow planes, the glider, with supplemental oxygen aboard, may soar beyond the tops of the mountain range to as high as thirty thousand feet. Ambient temperatures at such altitudes are extremely low, yet the pilots will commonly leave the air vent cracked open to prevent the windshield from fogging over. The main factor limiting endurance under these conditions is the pilot's ability to withstand the freezing temperatures.

Bucking the potential discomfort of cold and turbulence, the glider pilots of the Rocky Mountains have a unique perspective of untamed and unspoiled natural beauty. The sometimes tedious tow plane climb and the hardship of freezing temperatures are thought little price to pay for the magnificent sensation of being so near to nature. As any glider pilot knows, there is nothing to surpass the view of a peaceful, motionless earth from a silent perch high in the sky.

Early experimenters in gliding such as Otto Lilienthal and Octave Chanute advanced the science but were hampered with continuing stability and control problems. It was not until the Wright Brothers' research leading to workable flight controls that sustained powerless flight in a winged vehicle was achieved. Eight years after the historic first powered flight in 1903, Orville Wright piloted a glider at Kitty Hawk, North Carolina, for nearly ten minutes, becoming the first person to soar for a sustained period. His record was not broken for another ten years.

Between world wars, gliders took on new importance. Germany, partly because of the limitations imposed by the Versailles Treaty, encouraged pilot training using gliders long before the outbreak of hostilities. The Luftwaffe had also demonstrated the utility of gliders as economical troop transports. The U.S. Army Air Forces followed the German lead and employed gliders as troop transports during the war.

For most participants today soaring is a fun sport. Refinements in gliders have been made over the years, paving the way for new altitude, distance, and duration records. Sailing motorless through an accommodating sky can be a matchless adventure.

Paul Rendel

A graduate of the Center for Creative Studies in Detroit, Paul apprenticed at a major studio in the same city. His love of flying developed from an early age when an uncle who owned a Cessna 180 and a Boeing Stearman would take him for rides. He was so fond of the airplanes that he volunteered to wash and polish them. Soon after accepting a job in Pittsburgh, he set off on his own as a free-lance artist. A significant percentage of his work stems from aviation-related commissions. He combines his interest in aviation art with his piloting of sailplanes. He and his wife, Beth, reside in Pittsburgh.

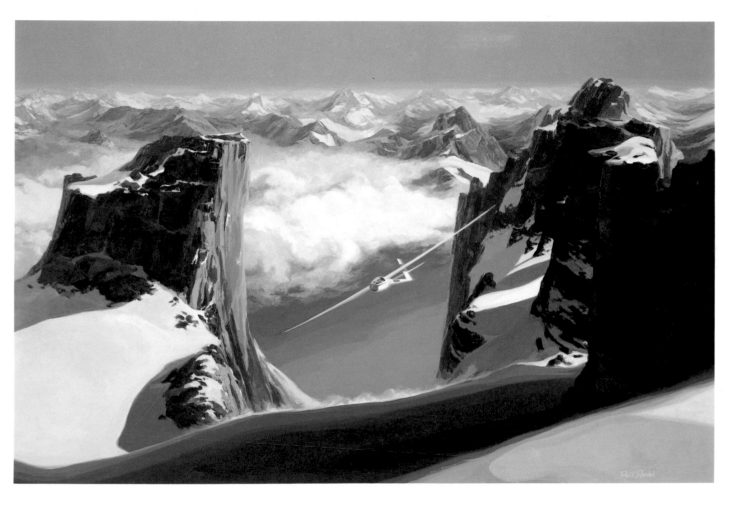

MORNING IN THE ROCKIES *by Paul Rendel, acrylic, completed 1989, collection of the artist.*

The Right Wing

by Gerald Asher

The General Dynamics F-16 Fighting Falcon serves in a multitude of deployments, but none more visible than the U.S. Air Force air demonstration team, the Thunderbirds. In American Indian lore, the power to create thunder resides with the thunderbird. The air force's team is appropriately named after this imaginary creature and has a silhouette emblazoned on the underside of each aircraft. Decorated in this distinctive paint scheme, the six-ship formation dazzles millions of onlookers at dozens of air shows in a typical season. Possessing tremendous agility, the F-16 is an ideal mount for aerobatic performances, as well as a superb air-to-air fighter.

The unusual perspective provided in this image shows an overhead close-up of the F-16A flying right wing in the team's precision formation. Slightly ahead and above is the team leader whose aircraft is reflected in the right wingman's canopy and visor.

The Fighting Falcon's cockpit is a technological gem, yet the aircraft is remarkably uncomplicated to fly. The pilot sits reclined at a thirty-degree angle to lessen the vertical distance between his heart and brain, enhancing tolerance to high G loads, inevitable in air combat. Instead of the traditional between-the-legs control stick, there is a grip on the right called a sidestick. It is very sensitive to the touch, requiring minimal input pressures. The head-up display projects essential information on a focus point in line with the forward windscreen, so that the pilot in combat does not have to dip his eyes back into the cockpit at critical moments. The instrument panel consists of a few such traditional gauges as the altitude indicator, but most data is conveyed via multifunction displays. These screens allow the pilot to call up information at his fingertips. The bubble canopy provides excellent all-around visibility. The tiny multicolored panels behind the cockpit are the flags of the many nations that have purchased the Fighting Falcon, a tribute to its enormous versatility and universal appeal.

Gerald Asher

Gerry was introduced to the world of aviation at an early age, since his father served as a corporate pilot. While he has no formal training in art, his background as a certified airframe and power plant mechanic gives him an advantage in recreating on canvas the details of aircraft with nuts and bolts accuracy. As a contributor to the Air Force Art Program he has flown in modern jet fighters. In his spare time he restores and flies warplanes of World War II vintage. He and his wife, Meg, reside in Fort Worth, Texas.

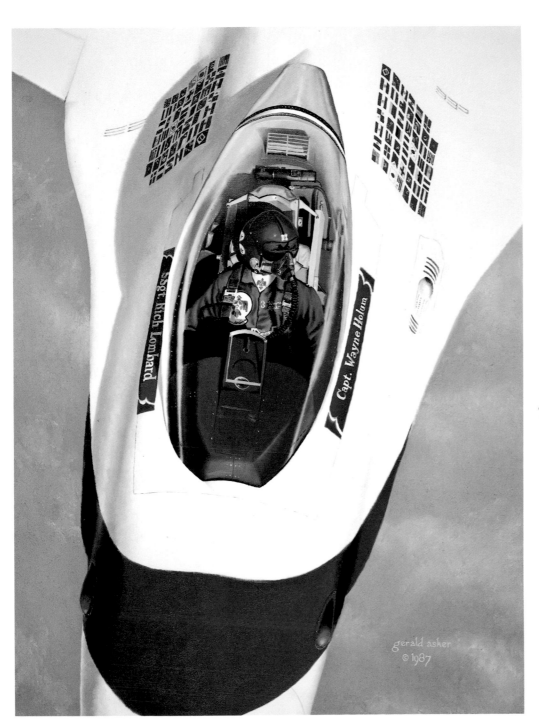

THE RIGHT WING
by Gerald Asher,
oil, completed 1987,
private collection.

One Last Look

by Charles Thompson

The gentle English countryside would hardly seem a fitting resting place for a Heinkel He 111 medium bomber, the scourge of the British populace during the Battle of Britain. The aircraft, actually built under license in Spain by CASA using the designation C.2111, found its way to England during the 1960s to be used in reenacting parts of the Battle of Britain for the motion picture of the same name. When filming was completed, this aircraft ended up as part of the outdoor exhibit at the Southend Historic Aircraft Museum in Essex, England.

The twin-engined He 111 and its Spanish variant, the C.2111, were fast bombers for their time, typically using the twelve-hundred-horsepower Junkers Jumo engine. The aircraft could achieve a top speed of 258 MPH and carry an impressive internal bomb load of over forty-four hundred pounds. It carried six machine guns and cannons for self-protection but was still vulnerable. During the daylight bombing missions over England in the summer of 1940 German fighter escort was limited, which enabled Royal Air Force Fighter Command to maul the large numbers of attacking bombers.

Sadly, the museum, facing closure in 1984, decided to auction off its collection. Shortly before the dismantling of the collection, some of the townspeople, including this lad pictured peering up from under the starboard wing, took one last look.

The artist, Charles Thompson, was himself a frequent visitor to the museum, which was near his home. He reports seeing this aircraft relic years later in another film, the British television production *Piece of Cake*. The medium bomber met an ignomini-ous end as the staged victim of the film's RAF fighters. Ironically, this twice-bloodied screen performer museum piece is thought to never have seen combat.

For information about the artist, Charles Thompson, please see page 58.

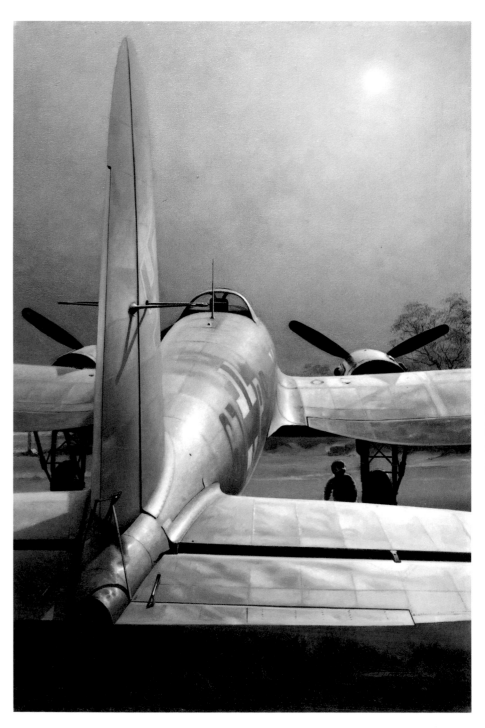

ONE LAST LOOK
by Charles Thompson,
oil, completed 1984,
collection of the artist.

Spirit of Discovery

by Terry Wofford

In this image by artist Terry Wofford, the space shuttle *Discovery* is poised for its fourth launch into space on April 12, 1985. The orbiter and its booster rockets are awash in light as scores of technicians labor intently, according to a carefully mapped sequence, to prepare this most complex of inventions for its voyage. The access arms of the huge support tower will soon be withdrawn as the countdown proceeds without interruption. Awaiting ignition, *Discovery* stands in all its grandeur on the launch pad. Within hours the massive ship will rise on a column of flames, hurtling its occupants on an incredible journey.

Aboard *Discovery* for this mission was a crew of seven, including Senator E. J. "Jake" Garn of Utah. The profile for the mission called for the launch from the shuttle's cargo bay of the Canadian Anik communications satellite. This went without a hitch, but the crew's launch of a second satellite was less successful. Called *Leasat-3*, an $85 million communications satellite, when released, was simply a dud. Thinking it could be brought to life by activating one of its switches, the flight crew in consultation with ground controllers and technical representatives rigged an impromptu fix, but in the end the problem turned out to be more than just the switch. On a subsequent shuttle mission, spacewalking astronauts were able to repair the satellite, proving once again the value of manned space flight.

Terry Wofford

Born in England and educated at the Birmingham College of Art, Terry emigrated to the American West Coast where she established herself as a commercial artist designing everything from calendars to beach towels. Fulfilling a life-long dream, in 1967 she set out on a journey around the world. Traveling to remote places, she saw firsthand the essential role of air transportation as a link to the rest of civilization. She developed a healthy respect for the pilots operating aircraft in inhospitable environments. Upon her return, she dedicated her efforts to capturing on canvas the beauty and daring of aviation. She served as the first secretary of the American Society of Aviation Artists. She and her husband, Bob, reside in Fountain Hills, Arizona.

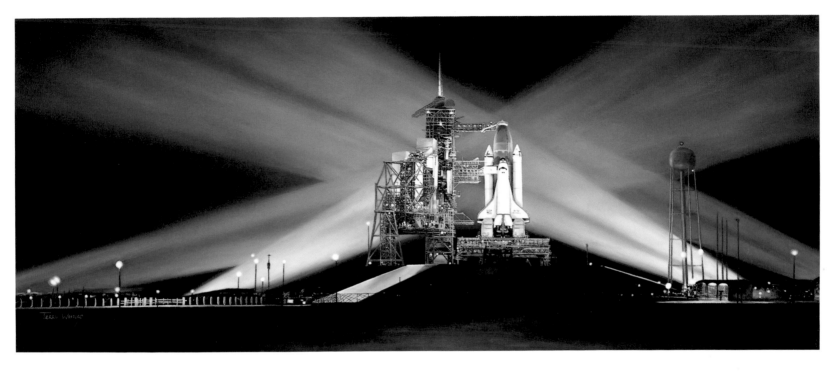

SPIRIT OF DISCOVERY by Terry Wofford, oil, completed 1985, NASA Art Collection.

Breathe Easier

by Keith Ferris

Every once in a while a revolutionary concept comes along, and through the perseverance of a few committed believers the idea gets transformed into reality. In the mid-1950s engineers at Britain's Hawker Siddeley Aviation, using a breakthrough in engine technology that allowed thrust to be directed by rotating nozzles, developed a vertical takeoff and landing jet known by the early 1960s as the Kestrel. The aircraft was refined and renamed the Harrier.

The aircraft's ability to operate off short, unimproved airfields or even country roads came to the attention not only of the British Ministry of Defense, but also of the U.S. Marine Corps, always eager to enhance air support for its ground forces. The Harrier's helicopter-like agility on takeoff and landing means that it can be deployed either on amphibious assault ships or on land near the battlefield, therefore within minutes of the field commander's urgent call for close air support. Moreover, should conventional runways at existing air bases be cratered in all-out warfare, the Harrier could continue to perform its mission. The British made effective use of the Harrier during the Falklands War.

By the mid-1980s the latest model in the Harrier line, the AV-8B Harrier II, was being delivered in quantity to the Marine Corps by a consortium of McDonnell Douglas and British Aerospace. In this image a Harrier II accelerates after a short takeoff roll necessitated by the full load of fuel and the approximately seventy-five hundred pounds of armaments. This aircraft carries two AIM-9L Sidewinder heat-seeking air-to-air missiles on out-board underwing pylons, six MK-82 high-drag bombs, and four CBV cluster bombs on inboard triple-ejection racks. Affixed to the fuselage, but not visible from this view, is a 25-mm cannon based on the GAU-12/U with three hundred rounds. The Harrier II represents a substantial advance over its predecessor in payload and range. The new type's wing is made of carbon fiber composite material which provides increased strength with less weight and greater resistance to corrosion and fatigue. The combat effectiveness of this improved aircraft gives the ground forces it protects the freedom to "breathe easier."

For information about the artist, Keith Ferris, please see page 26.

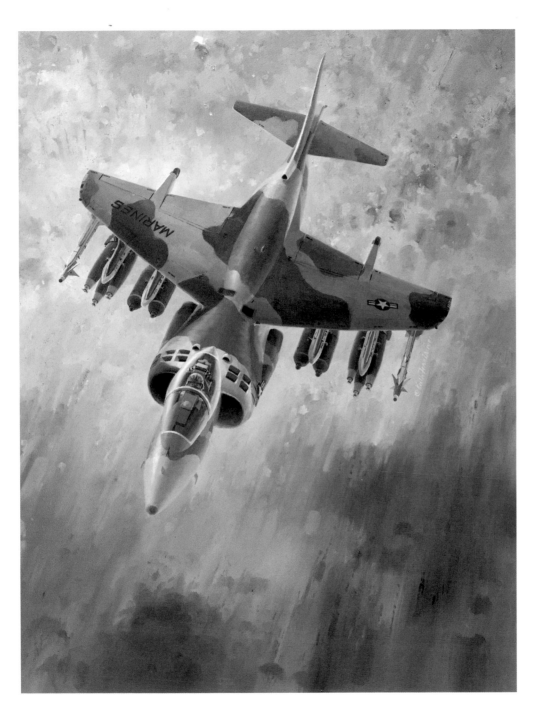

BREATHE EASIER
by Keith Ferris,
oil, completed 1981,
collection of U.S. Marine
Corps.

Blues' Hornet

by Sam Lyons, Jr.

Since the U.S. Navy's air demonstration team, the Blue Angels, was founded in 1946 nearly 250 million people at over twenty-five hundred air shows have witnessed the team's aerial artistry. The Blues, whose team always includes a Marine Corps pilot as a representative of that service, strive for perfection in their flying. They will average sixty-five appearances at about forty locations during the air show season and fly over 140,000 miles. Their performances serve as a recruiting tool and the high standards associated with the Blues provide a bench mark of excellence for all naval aviators. Each aviator considered for the team must be a volunteer who has accumulated at least fifteen hundred hours flying tactical jets and who has had a tour aboard an aircraft carrier. The rigid requirements coupled with the few openings means that only the very best, career-oriented applicants are selected.

Sam Lyons, Jr., has created a magnificently realistic depiction of one of the Blues' solos. While the six Blue Angels demonstration aircraft are usually seen in remarkably tight formations, the artist reminds us with this image of a lone vertical ascent that each jet is piloted individually and that the maneuvering, no matter how flawless the presentation, is not mechanical but very human.

The McDonnell Douglas F/A-18 Hornet, which they received for the 1987 air show season, is the newest aircraft flown by the Blue Angels. Before the public performances, though, the team got a thorough indoctrination in the Hornet, a state-of-the-art dual-mission strike fighter. Shown here is Lt. Comdr. Dave Anderson, the lead solo, wringing out his Hornet a little past straight vertical. After taking off from NAF El Centro in southern California and flying north toward the Salton Sea (visible in the background), Number 5 is put through its paces as the sun's rays glisten off the nose and canopy.

For information about the artist, Sam Lyons, Jr., please see page 150.

194

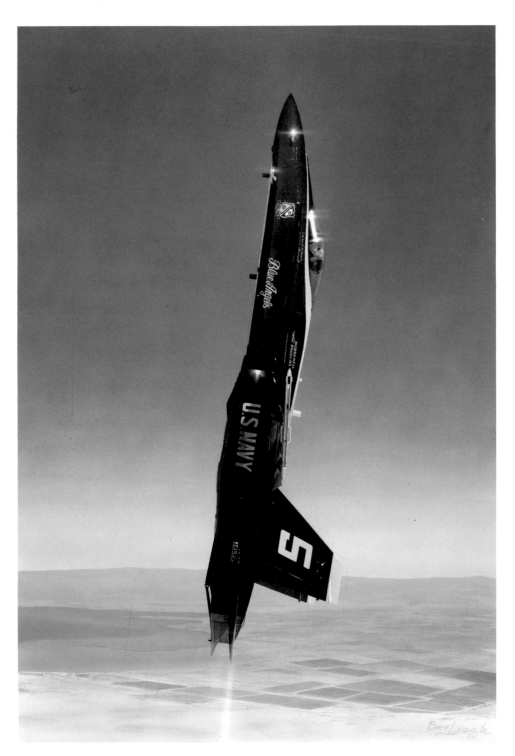

BLUES' HORNET
by Sam Lyons, Jr.,
acrylic, completed 1987,
private collection.

Catching Some Rays

by William Phillips

Aboard what is assuredly a crowded flight deck of the aircraft carrier USS *Midway* as it steams through the Gulf of Oman on maneuvers in 1988, a Grumman A-6 Intruder sits anchored to the non-skid surface with its wings folded. The aircraft's bubble canopy is cracked open to prevent heat build-up in the intensely hot Middle East climate. A deck crewman, working long hours under the unbearably high temperatures, gets a modest reprieve during a lull in the hyperactivity of the flight deck. He takes advantage of it by stretching out on the aircraft's wing, nodding off in the midday sun almost as quickly as he props his head against the fuselage.

A carrier's munitions handlers, safety officers, catapult technicians—all the people who make a flight deck come alive—labor night and day, at times under the most difficult and demanding conditions. Every moment while on the flight deck they must concentrate on their task and maintain a vigilant awareness of the goings-on around them, for an aircraft carrier flight deck is a precarious environment. The greatest hazard is fatigue, and the crew members must resist it with every ounce of willpower they can muster. Dropping their guard even for a second can be harmful if not fatal.

For information about the artist, William Phillips, please see page 40.

196

CATCHING SOME RAYS by William Phillips, oil, completed 1990, collection of the artist.

Oshkosh Aesthetics

by Charles Thompson

Every year during the first week in August the Wittman Regional Airfield in Oshkosh, Wisconsin, hosts an array of flying machines and over 800,000 aviation enthusiasts as part of the Experimental Aircraft Association's Convention and Fly-In. Acknowledged as the world's largest aviation event, Oshkosh, as the annual event is called, has developed into a kind of pilgrimage for people interested in flying.

Amidst the rows of exquisitely restored antique airplanes displayed at Oshkosh in 1989 was this exceptionally rare Curtiss-Wright Speedwing, a streamlined biplane of the 1930s. Artist Charles Thompson has captured the meticulous care bestowed upon this aeronautical beauty by showing reflections glimmering off the airplane's highly polished fabric surfaces. Such sights are common at Oshkosh.

Across the manicured grassy areas, special sections are set aside for groupings of the myriad "show-planes"—the antiques/classics, the warbirds, and the homebuilts. In all, about seventeen thousand airplanes fly in for this magical week. Oshkosh temporarily becomes the most heavily trafficked airspace in the world. A multitude of vendors sets up to exhibit aviation-related wares, and the EAA sponsors an extensive schedule of pilot and safety seminars. Attendees camp out in the open space around the airfield, and somehow the town with a year-round population of only about fifty thousand

easily accommodates the massive influx. Each afternoon the huge crowds are entertained by a spectacular air show.

For information about the artist, Charles Thompson, please see page 58.

OSHKOSH AESTHETICS
by Charles Thompson,
oil, completed 1990,
collection of the artist.

Bird in the Hand

by Craig Kodera

Helicopters as instruments of war have come a long way since their days serving medical evacuation units in Korea. During the Vietnam War, the helicopter evolved from a troop carrier into an effective gunship. Today, the essential nature of the helicopter in combat reflects its role in expanding the battlefield into the immediate overhead space. The helicopter has also introduced the element of rapid mobility.

Current combat helicopter doctrine calls for attack choppers to skim along the contour of the terrain or to get extremely low hugging the treetops, thereby making it hard to be seen by enemy troops or radar. When pursuing the attack, helos are to remain masked behind natural shelter, not popping up until ready to fire off a burst of rounds from a gun or to launch air-to-surface missiles. Once the ordnance has been expended, the helicopter is to sink back into its hiding place to avoid becoming a target itself.

The deceptively petite, egg-shaped McDonnell Douglas 530 MG, shown here zipping over the jungle with only a few feet of clearance above the lush foliage, is a new addition to a distinguished line of high-performance combat and commercial helicopters based on the old Hughes Helicopters Model 500 design from before the company's acquisition by McDonnell Douglas. The 530 MG packs a lethal wallop with a wide array of weaponry. In this depiction, the chopper is fitted with a rocket pod on the port fairing and a gun pod on the starboard fairing. There is a chin-mounted forward-looking infrared (FLIR) thermal imaging system picking up heat emissions that allows the two-man crew to see in the dark and through inclement weather. The multirole 530 MG benefits from a recent power upgrade and a modernized crew station that includes multifunction displays in place of the conventional dials and gauges.

For information about the artist, Craig Kodera, please see page 62.

200

BIRD IN THE HAND
by *Craig Kodera, oil,*
completed 1990, collection of
McDonnell Douglas Helicopters,
Mesa, Arizona.

Beechcraft Starship 1

by Douglas Nielson

The first of the futuristic Beechcraft Starship line of corporate aircraft is seen here during high-altitude cruise, flying above some of its competitors. Promoted by the energetic Beech marketing staff years in advance of its certification and delivery, the Starship promised to be the long-awaited revolutionary design that would rekindle the creative spark of general aviation innovation. Inspired by the unconventional approach of design maverick Burt Rutan, the Starship sports a movable forward canard providing pitch control with elevators, sizable tip sails for directional stability, pusher propellers, and composite construction to reduce weight and increase strength.

The Starship is a technological marvel. Such creativity has been encouraged at the Beech shop, with its tradition of setting industry bench marks. The Starship incorporates new standards in safety, comfort, and efficiency. Advancements in materials, propulsion, aerodynamics, and manufacturing processes were achieved. Economic realities, however, remain in force, and the Starship's heavy developmental expenses must be factored into each copy's price tag. Only time will tell if this example of new technology will be able to establish itself in the marketplace.

Whatever the outcome, the Starship represents an important step in general aviation manufacturing, since it offers so beautifully state-of-the-art developments in propulsion, aerodynamics, avionics, and materials.

This image is the work of artist Douglas Nielson, who was employed by a Beechcraft dealer when the 85-percent-scale demonstrator was first flown in 1983. He painted the Starship long before the Starship was produced. He worked from three-view drawings provided by the manufacturer and pictures of the Rutan proof-of-concept flying demonstrator. The artist, however, did not actually see the real-life aircraft until the summer of 1990, shortly after the official market introduction.

Douglas Nielson

With a father who was an airline pilot and a brother who flies for the airlines, Doug was a natural to pursue an aviation career. He has been a flight engineer on the Boeing 727 and currently is a mechanic for American Airlines. He enjoys restoring his family's antique airplanes. His early interest in drawing airplanes evolved several years after high school graduation to painting in oils during his spare time. He is a member of the Air Force Art Program. He and his wife, Jane, reside in Carol Stream, Illinois.

BEECHCRAFT STARSHIP 1 by Douglas Nielson, oil, completed 1983, collection of Elliott Beechcraft, Omaha, Nebraska.

Glacier Run

by Ren Wicks

The world's premier air superiority fighter, the McDonnell Douglas F-15 Eagle, has been deployed to various parts of the world but perhaps none as inhospitable as the bitterly cold and unforgiving environment of Alaska. The pilots and maintenance crews of Alaskan Air Command have no margin for error. The area's vastness and rugged terrain tolerate no sloppiness or inattention. Moreover, the mission is a demanding one—providing "top cover for North America," as the Command's motto says.

In this image by artist Ren Wicks, a loose two-ship formation of F-15Cs belonging to the 21st Tactical Fighter Wing is seen cruising over the magnificent Alaskan landscape. In a constant state of readiness, these fighters are prepared to intercept any threats that may intrude upon the vital polar air routes. In the past, it was not infrequent for Soviet Bear bombers to trigger alerts. More recently, in the summer of 1989, Elmendorf Air Force Base near Anchorage hosted, during a refueling stop, a couple of the Soviet Union's latest fighters and a cargo plane that were en route to a Canadian air show. As superpower tensions have eased, such previously unthinkable cooperation could pick up with regularity.

Ren Wicks

Ren studied at the Art Center School of Design in Los Angeles and embarked on a career as a commercial illustrator. At the outbreak of World War II he joined Lockheed as the company's publications art director. This job was followed by work at more commercial illustration and free-lancing. His commissions have come from an impressive list of corporations. He has also designed seven commemorative postage stamps, including the Igor Sikorsky airmail stamp. He is currently board chairman of Group West Inc., a company he helped to form. He is the past president of both the Society of Illustrators of Los Angeles and the National Board of Art Center Alumni. He is also a founding member of the American Society of Aviation Artists. He and his wife, Nancy, reside in Beverly Hills, California.

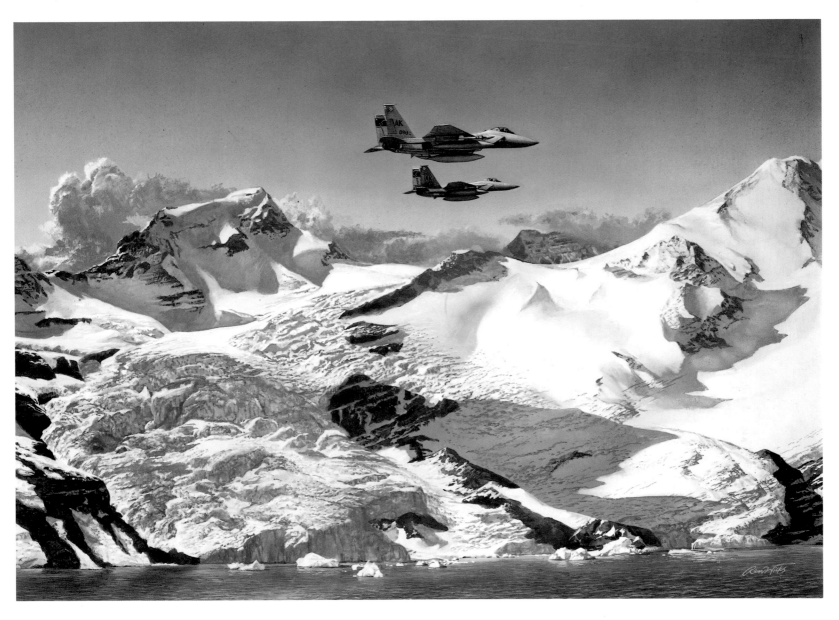

GLACIER RUN by Ren Wicks, *acrylic and gouache, completed 1990, collection of the artist.*

North American Thunder

by Rick Ruhman

Air shows and fly-ins, with the sight of antique warplanes rumbling through the sky and the sound of radial engines bellowing, have been an integral part of American culture for many years. Some of those in attendance come because, as veterans, this may be a chance to see once more the airplanes in which they trained or fought. But most people are there because of the magnetism of the special aircraft on exhibit. There are opportunities for aviation enthusiasts to get up close to the machines they have read about or seen in pictures. Pilots can exchange tidbits of information about the airplanes they fly.

Depicted in this image is an immaculately restored North American B-25 Mitchell, nicknamed *Dream Lover*, that belongs to Jim Rickett of Stockton, California. This pristine warbird with its highly polished aluminum is deceptively new-looking. If it were not for the civilian clothes and modern earphones visible through the windshield, one could easily imagine this B-25 at a World War II air base preparing for a bombing mission. Restorations such as this involve great dedication and countless man-hours of tedious labor. The painstaking effort has its reward; upon completion the owner and volunteer restorers can show off the airplane on the air show circuit. When a powerful antique like the Mitchell taxis past on the air show tarmac, the closer it gets the more deafening the engines' roar and the shakier the ground beneath.

Those who rebuild the old warhorses with such care pay an implicit tribute to those talented, devoted, and brave souls who designed, constructed, readied, repaired, and piloted these aircraft at a time when the future hinged on how they—man and machines—performed. It is a reminder of those who served and of a part of our heritage.

Rick Ruhman

Rick fell in love with airplanes at an early age when his father, a World War II combat veteran, took him to an abandoned Army Air Force training field near Miami, Florida. Growing up in Florida, with its pervasive sunny weather, gave him an opportunity to see the skies almost always occupied by flying boxcars on cargo routes or by Catalinas coming into Biscayne Bay. He moved to California to further his artistic studies and got caught up in the West Coast vintage warbird movement and related air show activity. He can be seen at the annual Reno Air Races assisting crews in the pit area. He is an aviation photographer as well as an aviation artist. He and his wife, Denise, live in Hayward, California.

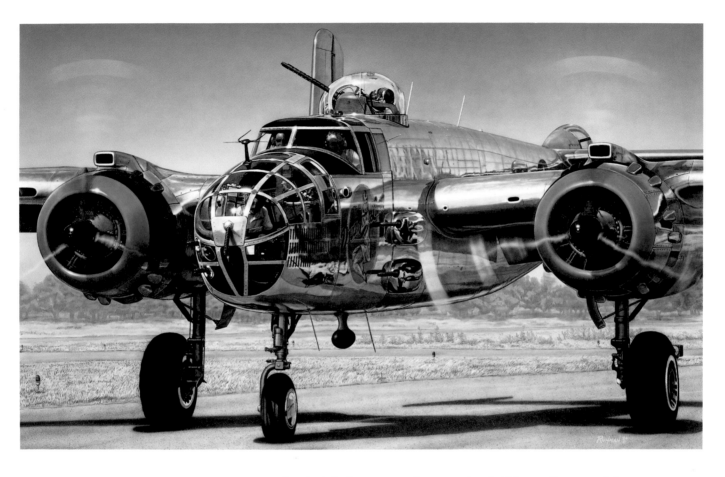

NORTH AMERICAN THUNDER by Rick Ruhman, acrylic, completed 1984, collection of the artist.

Darkness Visible

by Craig Kodera

Stealth technology became an increasing priority for aircraft designers and weapons systems planners in the 1970s as the Soviets appeared to be making significant strides in surface-to-air missile capabilities. The Lockheed F-117A Stealth Fighter's design derived from research that showed when properly aligned, numerous flat panels would scatter probing radar signals, substantially reducing the aircraft's radar cross section. Moreover, the F-117A's skin is coated with a radar-absorbent material, further reducing chances of detection. Exhaust from the twin General Electric F404-F1D2 non-afterburning engines, emitted through an exceedingly thin duct, is partially hidden by an upward swept surface, known as a platypus, that serves to reduce the infrared signature.

The F-117A is not a fighter in the classic sense because the role for which it was designed is not air-to-air combat. Its mission is ground attack, specifically, to slip through elaborate enemy air defenses and to devastate high-value targets such as radar installations, thus paving the way for the next wave of attackers. The F-117A's weapons payload is said to be only two 2,000-pound bombs, but with highly accurate delivery systems. The Stealth Fighters deployed to the Persian Gulf in the war to liberate Kuwait performed exceedingly well, destroying targets with unprecedented accuracy and without sustaining a single loss.

Maintaining the secrecy of this technologically advanced aircraft was a major undertaking that involved transporting each one from the Lockheed "Skunk Works" in Burbank in a voluminous C-5 cargo plane to a specially constructed facility at the Tonopah Test Range in Nevada. Before the public announcement, the F-117As were flown only at night. In this painting, note the markings of the 37th Tactical Fighter Wing (previously designated the 4450th Tactical Group) emblazoned on the severely swept "V" tails of two Stealth Fighters near their Tonopah base. A total of fifty-nine operational F-117As were built over eight years, with the last one delivered in 1990.

For information about the artist, Craig Kodera, please see page 62.

208

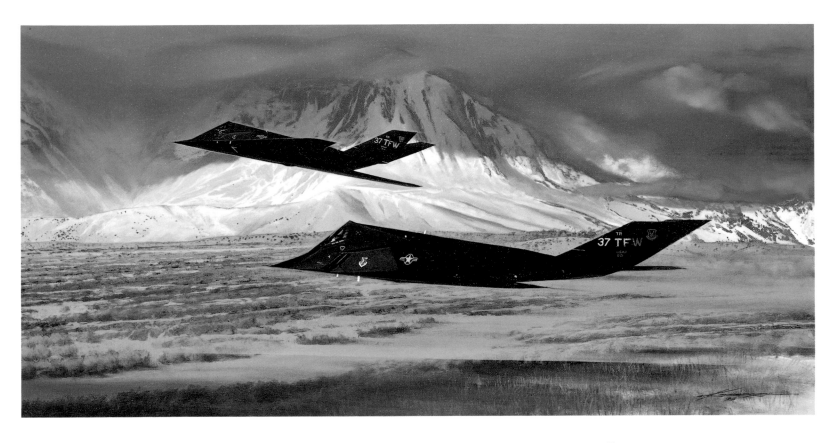

DARKNESS VISIBLE by Craig Kodera, oil, completed 1990, private collection.

Now You See It . . .

by Craig Kodera

Renowned designer Jack Northrop dreamed in the 1920s of an aerodynamically clean airplane that would incorporate all of its constituent parts into the wing. His vision took the form of a crude "flying wing" that flew in 1929. By 1940, the concept had evolved into the N-1M Jeep, the first successful genuine all-wing airplane in America. In preparation for a production flying wing bomber, in which the U.S. Army Air Force had expressed an interest, Northrop produced four one-third-scale proof-of-concept all-wing airplanes during World War II. The success of this test program led to the manufacture of full-size flying wings, the XB-35 (propeller-driven) and the YB-49 (jet-powered). Sadly, during a flight test on June 5, 1948, one of the YB-49s experienced a catastrophic structural failure, apparently due to excessive loading, and crashed, killing all five on board. In memory of USAF Capt. Glen Edwards, who was aboard the ill-fated flight, Muroc Airfield was renamed Edwards Air Force Base. Amid controversy, the air force flying wing program was canceled.

Forty years later, on November 22, 1988, a new Northrop flying wing was officially rolled out of its high-security hangar, revealing a configuration remarkably similar to the one developed during World War II. Designated the B-2 and nicknamed the "Stealth Bomber" or simply the "Stealth," today's flying wing has at its heart radar-evading characteristics.

By its very shape, conspicuously lacking vertical fins or horizontal tails, the B-2 is less prone to radar detection. Special attention to reducing the radar reflectivity of the engines is apparent in the design of the inlets, which are made to scatter incoming radar signals. The aircraft also makes extensive use of radar-absorbent material. Particularly noteworthy is the serrated, or sawtooth, trailing edge—a major departure from what many commentators had predicted. Instead of reflecting a radar wave in all directions like curved surfaces, the wing's rectilinear trailing edge scatters a radar wave in one direction away from its source. The absence of conventional control surfaces and the resultant stability problems had caused some perplexity in the 1940s. With super computers, however, engineers of the 1980s have been able to address the challenges more effectively.

For information about the artist, Craig Kodera, please see page 62.

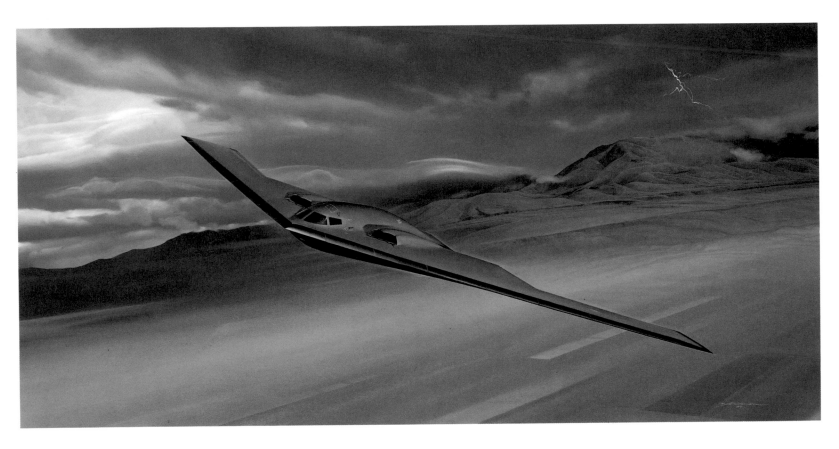

NOW YOU SEE IT . . . by Craig Kodera, oil, completed 1989,
collection of the National Air and Space Museum/Smithsonian Institution, Washington, D. C.

Summer Sail

by Charles Thompson

On summer weekends, the Lasham Gliding Club in Hampshire, on the south coast of England, is usually busy, weather permitting. The lush and tranquil countryside makes a wonderfully scenic location for the club members. In this image, a towplane is pulling a glider into a sky punctuated with innumerable puffy cumulus clouds, signaling the presence of thermals that will provide the glider with resurgent spurts of lift.

Meanwhile, a two-seat Janus C sailplane on the open grass field awaits a tow for an instructional flight. An occupant in the cockpit is probably acquainting himself with the sparse controls and instrument panel of the glider. When the towplane returns, the Janus C will get its ride into the firmament and when released, the soaring student and instructor will thrill to the purest form of flight. With the sun warming the pastures and the cumulus decks billowing as the day matures, the two passengers will doubtless revel in their summer sail.

For information about the artist, Charles Thompson, please see page 58.

SUMMER SAIL by Charles Thompson, oil, completed 1990, private collection.

Index of Artists and Paintings

Pencil Sketches